Concerning
Contemporary
Art

Concerning Contemporary Art

THE POWER LECTURES
1968–1973

EDITED BY
BERNARD SMITH

CLARENDON PRESS · OXFORD
1975

Oxford University Press

OXFORD LONDON NEW YORK
GLASGOW TORONTO MELBOURNE WELLINGTON
CAPE TOWN IBADAN NAIROBI DAR ES SALAAM LUSAKA ADDIS ABABA
DELHI BOMBAY CALCUTTA MADRAS KARACHI LAHORE DACCA
KUALA LUMPUR SINGAPORE HONG KONG TOKYO

ISBN 0 19 920062 9

© OXFORD UNIVERSITY PRESS 1974

FILMSET AND PRINTED IN GREAT BRITAIN
BY BAS PRINTERS LIMITED WALLOP HAMPSHIRE

Contents

List of Plates

Introduction

The Power Lecture in Contemporary Art is delivered annually throughout Australia in honour of John Power, the cubist artist whose bequest made possible the establishment of the Power Institute of Fine Arts in the University of Sydney. The present volume contains the first six lectures, given between 1968 and 1973, as revised for publication.

Each lecture deals with an aspect of contemporary art chosen by the lecturer concerned; no attempt having been made, in the nature of the situation, to relate the chosen aspects to a theme less general than that implied by the title of the Lecture. It will be noted however that three of the lectures, those by Greenberg, Brook and Heron are concerned with issues of a theoretical kind which have arisen directly from a consideration of the advanced art of the 1960s, whereas the lectures by Mitchell, Wollheim and Hutchings (though his examples are drawn from recent contemporary art) are concerned with issues and problems related to the advanced art of the twentieth century considered as a whole. The broad interpretation of the term contemporary art revealed by these two approaches is intentional since the main object of the Power Lectures is the promotion of theory concerning contemporary art, an objective which would obviously be prejudiced by delimiting the field of enquiry too firmly.

Contemporary art is, of course, a question-begging term. All art was once contemporary; and all art which still exists even though produced in remote antiquity is, in an important sense, contemporary. It is in the present and may be seen and admired in the present. But such larger issues are not the concern of these lectures. The meaning of the term contemporary art which has been kept in mind when arranging them is one that is still in general present usage: that which denotes the *avant garde* art of the twentieth century. Like all substantive definitions of the contemporary it is bound to go out of date one day. There is always a moment in history when the contemporary becomes gothic, and already the usage adopted here is beginning to fade

into history along its fauvist edge. But for our purpose the general present usage provides a double advantage: it allows a sufficiency of time to encourage variety of subject and the development of theory, and it remains in touch with John Power's own substantive understanding of the term contemporary art.

Nevertheless it has to be recognized that contemporary art defined thus, like the century that once conceived it in its own teen-aged womb, is now no longer new—nor is much of the art that the word contemporary now brings to mind. Art forms that were once radical and innovatory, such as cubism, dada, surrealism and many of their later variants, are now no longer new. Yet we cannot by some process of historic-aesthetic distancing separate such art forms from our own sensibilities as we can, no matter how much we may admire them, the forms of romanesque and baroque. Nevertheless, commitment to the contemporary as the visual systematization of the genuinely new seems to be less compelling for many—and for many who are young—than it once was. We appear to be living through a period during which one system of hitherto contemporary art is losing its visual grasp upon an increasingly intractable present, while another slouches towards the second millennium to be born.

The causes of this transitional situation are, of course, more complex than such metaphors suggest. But although the causes are complex the face of change has become singularly apparent. The enthusiastic advocacy of the new by its confident devotees has been replaced by attitudes which encourage the dominance of criticism if not reflection. This may well be, as Patrick Heron eloquently suggests, an inversion of the natural order of things. But it may also be a realization that the time has come to take stock of the arguments and assumptions upon which the case for *avant garde* art has rested since at least the beginning of the century.

It seems to me that this awareness of a time of transition, of a sense of impending change, inhabits and enlivens all these lectures, directing enquiry towards an elucidation of the larger issues and problems which confront *avant garde* art in the 1970s.

For Clement Greenberg it is the problem of an *avant garde* left in possession of the field with nothing to fight but its own corruption by adulation, emulation and the market. Donald Brook examines the declining interest in the work of art as an object and the possible implications of this for the future. For Charles Mitchell, who traces the history of the spectator's role in contemporary art, the problem—tossed in with a gay abandon at the very end of his lecture—lies in the more recent change of role from creative

participant to impotent *voyeur*. For Patrick Hutchings the problem lies in the refusal of the *avant garde* to understand what Aristotle realized and the general public know; that art is first and before all else, imitation. For Richard Wollheim the crisis in recent art lies—if it lies anywhere—in the substitution for style, which he argues is the artist's own generative and expressive language, for a recognizability imposed from without by pressure from dealers and clients. For Patrick Heron the problem lies in the reversal that has taken place in recent years whereby criticism determines creation and reproduction determines the nature of the original.

Taken as a whole these lectures provide from points of view which include those of the practising artist and the practising critic, the art historian and the philosopher a critique of recent visual art that is unified only by a common recognition of the overriding importance of the contemporary.

London
June 1973

I. Avant-garde attitudes: New art in the Sixties

CLEMENT GREENBERG

THE PREVALENT NOTION is that latter-day art is in a state of confusion. Painting and sculpture appear to be changing and evolving faster than ever before. Innovations follow closer and closer on one another and, because they don't make their exits as rapidly as their entrances, they pile up in a welter of eccentric styles, trends, tendencies, schools. Everything conspires, it would seem, in the interests of confusion. The different mediums are exploding: painting turns into sculpture, sculpture into architecture, engineering, theatre, environment, 'participation'. Not only the boundaries between the different arts, but the boundaries between art and everything that is not art are being obliterated. At the same time scientific technology is invading the visual arts and transforming them even as they transform one another. And to add to the confusion, high art is on the way to becoming popular art, and vice versa.

Is all this so? To judge from surface appearances, it might be so. A writer in the *Times Literary Supplement* of 14 March 1968 refers to '. . . that total confusion of all artistic values which prevails today'. But by his very words this writer betrays where the real source of confusion lies: namely, in his own mind. Artistic value is one, not many. The only artistic value anybody has yet been able to point to satisfactorily in words is simply the goodness of good art. There are, of course, degrees of artistic goodness, but these are not different values or kinds of value. Now this one and only value, in its varying degrees, is the first and supreme principle of artistic order. By the same token it is the most relevant such principle. Of order established on its basis, art today shows as much as it ever has. Surface appearances may obscure or hide this kind of order, which is *qualitative* order, but they do not negate it, they do not render it any the less present. With the

ability to tell the difference between good and bad, and between better and worse, you can find your way quite well through the apparent confusion of contemporary art. Taste, i.e., the exertions of taste, establishes artistic order—now as before, now as always.

Things that purport to be art do not function, do not exist, as art until they are experienced through taste. Until then they exist only as empirical phenomena, as aesthetically arbitrary objects or facts. These, precisely, are what a lot of contemporary art gets taken for, and what many artists want their works to be taken for—in the hope, periodically renewed since Marcel Duchamp first acted on it fifty-odd years ago, that by dint of evading the reach of taste while yet remaining in the context of art, certain kinds of contrivances will achieve unique existence and value. So far this hope has proved illusory. So far everything that enters the context of art becomes subject, inexorably, to the jurisdiction of taste—and to the ordering of taste. And so far almost all would-be non-art-in-the-context-of-art has fallen rather neatly into place in the order of inferior art. This is the order where the bulk of art production tends to find its place, in 1968 as in 1868—or 1768. Superior art continues to be something more or less exceptional. And this, this rather stable quantitative relation between the superior and inferior, offers as fundamentally relevant a kind of artistic order as you could wish.

But even so, if this were the only kind of order obtaining in new art today, its situation would be as unprecedented, still, as common opinion says it is. Unprecedented even if not confused. The good and the bad might differentiate themselves as clearly as ever, but there would still be a novel confusion of styles, schools, directions, tendencies. There would still be *phenomenal* if not aesthetic disorder. Well, even here experience tells me—and I have nothing else to rely on—that the phenomenal situation of art in this time is not all that new or unprecedented. Experience tells me that contemporary art, even when approached in purely descriptive terms, makes sense and falls into order in much the same way that art did in the past. Again, it is a question of getting through superficial appearances.

Approaching art in phenomenal and descriptive terms means approaching it, first of all, as style and as the history of style (neither of which, taken in itself, necessarily involves quality). Approached strictly as a matter of style, new art in the 1960s surprises you—if it *does* surprise you—not by its variety, but by the unity and even uniformity it betrays *underneath* all the appearances of variety. There are Assemblage, Pop, and Op; there are

Hard Edge, Color Field, and Shaped Canvas; there are Neo-Figurative, Funky, and Environmental; there are Minimal, Kinetic, and Luminous; there are Computer, Cybernetic, Systems, Participatory—and so on. (One of the really new things about art in the sixties is the rash of labels in which it has broken out, most of them devised by artists themselves—which is likewise new; art-labelling used to be the affair of journalists.) Well, there are all these manifestations in all their variegation, yet from a steady and detached look at them through their whole range some markedly common stylistic features emerge. Design or layout is almost always clear and explicit, drawing sharp and clean, shape or area geometrically simplified or at least faired and trued, colour flat and bright or at least undifferentiated in value and texture within a given hue. Amid the pullulation of novelties, advanced art in the sixties subscribes almost unanimously to these canons of style—canons that Woelfflin would call linear.

Think by contrast of the canons to which *avant-garde* art conformed in the fifties: the fluid design or layout, the 'soft' drawing, the irregular and indistinct shapes or areas, the uneven textures, the turbid colour. It is as though *avant-garde* art in the sixties set itself at every point in opposition to the common stylistic denominators of Abstract Expressionism, *art informel, tachisme*. And just as these common denominators pointed to what was one and the same period style in the latter forties and the fifties, so the common denominators of new art in the sixties point to a single, all-enveloping period style. And in both cases the period style is reflected in sculpture as well as in pictorial art.

That *avant-garde* art in the latter forties and in the fifties was one, not many, in terms of style is now pretty generally recognized. Lacking the perspective of time, we find it harder to identify a similar stylistic unity in the art of this decade. It is there all the same. All the varied and ingenious excitements and 'experiments' of the last years, large and small, significant and trivial, flow within the banks of one, just one period style. Homogeneity emerges from what seemed an excess of heterogeneity. Phenomenal, descriptive, art-historical—as well as qualitative—order supervenes where to the foreshortening eye all seemed the antithesis of order.

If this gives pause, the pause should be taken advantage of to examine more closely another popular idea about art in this time: namely, that it moves faster than ever before. The art-historical style of this period that I have so sketchily described—a style that has maintained, and maintains, its identity under a multitude of fashions, vogues, waves, fads, manias—has been with us now for

nearly a decade and seems to promise to stay with us a while longer. Would this show that art is moving and changing with unprecedented speed? How long did art-historical styles usually last in the past—even the more recent past?

In the present context I would say that the duration of an art-historical style ought to be considered the length of time during which it is a leading and dominating style, the time during which it is the vessel of the largest part of the important art being produced in a given medium within a given cultural orbit. This is also, usually, the time during which it attracts those younger artists who are most highly and seriously ambitious. With this definition as measure, it is possible to see as many as five, and maybe more, distinctly different styles or movements succeeding one another in French painting of the nineteenth century.

First there was David's and Ingres's Classicism. Then from about 1820 into the mid-1830s, Delacroix's Romanticism. Then Corot's naturalism; and then Courbet's kind. In the early 1860s Manet's flat and rapid version of naturalism led the way, to be followed within less than ten years by Impressionism. Impressionism held on as the leading manner until the early 1880s, when the Neo-Impressionism of Seurat and then the Post-Impressionism of Cézanne, Gauguin, and Van Gogh became the most advanced styles. Things get a little mixed up during the last twenty years of the century, though it may be only in seeming. At any rate Bonnard and Vuillard in their early, Nabi phase appear during the 1890s, anf Fauvism enters the competition by at least 1903. As it looks, painting moved faster between the mid-1880s and 1910 or so than at any time within the scope of this hasty survey. Cubism took the lead away from Fauvism within hardly a half a dozen years of the latter's emergence. Only then did painting slow down again to what had been its normal rate of change between 1800 and the 1880s. For Cubism stayed on top until the mid-1920s. After that came Surrealism (I say Surrealism for lack of a better term: Surrealism's identity as a *style* still remains undetermined; and some of the best *new* painting and sculpture of the latter twenties and the thirties had nothing to do with it). And by the early 1940s Abstract Expressionism and its cognates, *tachisme* and *art informel*, were on the scene.

Admittedly, this historical rundown simplifies far too much. Art never proceeds that neatly. Nor is the rundown itself that accurate even within the limits set it. (What I see as hurried stylistic change between the 1880s and 1910 may turn out under longer scrutiny to be less hurried than it now looks. Larger and

unexpected unities of style may become apparent—in fact, they already are apparent, but this is not the place to touch on them, despite all they would do to strengthen my argument here.) But, for all the exceptions that can rightly be taken to my chronological schema and what it implies, I do think that there is enough unquestionable evidence to support my point, which is that art-historical styles in painting (if not in sculpture) have tended since the beginning of the nineteenth century (if not before) to hold their positions of leadership for an average of between ten and fifteen years.

The case of Abstract Expressionism does more than bear out this average; it exceeds it, and would go to show that art actually moved and changed more closely over the last thirty years than in the hundred years previous. Abstract Expressionism in New York, along with *tachisme* and *art informel* in Paris, emerged in the early forties and by the early fifties was dominating *avant-garde* painting and sculpture to a greater extent even than Cubism had in the twenties. (You were not 'with it' at all in those days unless you lathered your paint or roughed your surfaces; and in the fifties being 'with it' began to matter ever so much more.) Well, Abstract Expressionism collapsed very suddenly back in the spring of 1962, in Paris as well as New York. It is true that it had begun to lose its vitality well before that, but nevertheless it continued to dominate the *avant-garde* scene, and by the time of its final retreat from that scene it had led art for close on twenty years. The collapse of Abstract Expressionism was as sudden as it was because it was long overdue, but even had its collapse come five or six years earlier (which is when it should have come) the span of time over which Abstract Expressionism held its leadership would still have been over the average for art styles or movements within the last century and a half.

Ironically enough, the seemingly sudden death of Abstract Expressionism in 1962 is another of the things that have contributed to the notion that art styles turn over much faster, and more abruptly, now than they used to. The fact is that the demise of Abstract Expressionism was an unusually lingering one. Nor did the art-historical style that displaced it come into view nearly so suddenly as the events of the spring of 1962 made it appear. The 'hard' style of the sixties had already emerged with Ellsworth Kelly's first New York show in 1955, and with the renaissance of geometricizing abstract art in Paris in the mid-fifties as we see it in Vasarely. Thus there was an overlapping in time. There was an overlapping or transition in terms of style too: the passage from

the 'painterly' to the 'linear' can be witnessed in the painting of Barnett Newman, for example, and in the sculpture of David Smith, and in an artist like Rauschenberg (to name only Americans). That the scene of art, as distinct from the course of art, has known abrupt changes and reversals lately should not mislead us as to what has actually happened in art itself. (It is again ironical that the overlapping, the very gradualness involved in recent stylistic change, made for the impression of confusion, at least in the first years of the sixties, as much as anything else did.)

What at first did surprise me in the new art of the sixties was that its basic homogeneity of style could embrace such a great heterogeneity of quality, that such bad art could go hand in hand with such good art. It took me a while to remember that I had already been surprised by that same thing in the fifties. Then I had forgotten that, because of the subsequent collapse of Abstract Expressionism, which seemed to me to separate the good from the bad in the art of the fifties pretty correctly. All the same, some of my surprise at the great unevenness in quality of new art in the sixties remained, and remains. Something new is there that was not there in Abstract Expressionism when it first emerged.

All art styles deteriorate and, in doing so, become usable for hollow and meretricious effects. But no style in the past seems to have become usable for such effects while it was still an up-and-coming one. That is, as best as I can remember. Not the sorriest *pasticheur* or band-wagon-jumper of Impressionism, Fauvism, or Cubism in their first years of leadership fell below a certain level of artistic probity. The vigour and the difficulty of the style at the time simply would not let them. Maybe I do not know enough of what happened in those days. I will allow for that and still maintain my point. The new 'hard' style of the sixties established itself by producing original and vigorous art. This is the way new styles have generally established themselves. But what was new, in scheme, about the way that the sixties style arrived was that it did so carrying not only genuinely fresh art but also art that *pretended* to be fresh, and was able to pretend to be that, as in times past only a style in decline would have permitted. Abstract Expressionism started out with both good and bad, but not until the early 1950s did it lend itself, as a style, to *specious* as distinct from failed art. The novel feature of the 'hard' style of the sixties is that it did this from the first. This fact says nothing necessarily compromising about the best 'hard-style' art. That best is equal to the best of Abstract Expressionism. But the fact itself would

show that something really new, *in scheme*, has happened in the new art of the sixties.

This schematically new thing is what, I feel, accounts for the greater nervousness of art opinion that marks the sixties. One knows what is 'in' at any given moment, but one is uneasy about what is 'out'. It was not that way in the fifties. The heroes of painting and sculpture in that period profiled themselves against a background of followers fairly early on, and for the most part they remained—and have remained—heroes. There was less question then than now of competing tendencies or positions within the common style. Just who and what will remain from the sixties, just which of the competing sub-styles will prove out as of lasting value—this remains far more uncertain. Or at least it does for most critics, museum people, collectors, art buffs, and artists themselves—for most, I say, if not exactly for all. This uncertainty may help explain why critics have lately begun to pay so much more attention to one another than they used to, and why even artists pay them more attention.

Another cause of the new uncertainty may be the fact that *avant-garde* opinion has since the mid-fifties lost a compass bearing that had served it reliably in the past. There used to be self-evidently academic art, the art of the *salons* and the Royal Academy, against which to take position. Everything directed against or away from academic art was in the right direction; that was once a minimal certainty. The academy was still enough there in Paris in the twenties, and perhaps even in the thirties, to assure *avant-garde* art of its own identity (André Lhote would still attack a *salon* exhibition now and then during those years). But since the war, and especially since the fifties, confessedly academic art has fallen out of sight. Today the only conspicuous fine art—the exceptions, however numerous, are irrelevant—is *avant-garde* or what looks like or refers to *avant-garde* art. The *avant-garde* is left alone with itself, and in full possession of the 'scene'.

This hardly means that the kind of impulse and ambition that once went into avowedly academic art has now become extinct. Far from it. That kind of impulse and that kind of ambition now find their way into *avant-garde*, or rather nominally *avant-garde*, art. All the sloganizing and programming of advanced art in the sixties, and the very proliferation of it, are as though designed to conceal this. In effect, the *avant-garde* is being infiltrated by the enemy, and has begun to deny itself. Where everything is advanced nothing is; when everybody is a revolutionary the revolution is over.

Not that the *avant-garde* ever really meant revolution. Only the journalism about it takes it to mean that—takes it to mean a break with the past, a new start, and all that. The *avant-garde*'s principal reason for being is, on the contrary, to maintain continuity: continuity of standards of quality—the standards, if you please, of the Old Masters. These can be maintained only through constant innovation, which is how the Old Masters had achieved standards to begin with. Until the middle of the last century innovation in Western art had not had to be startling or upsetting; since then, for reasons too complex to go into here, it has had to be that. And now in the sixties it is as though everybody had finally—finally—caught on to this: caught on not only to the necessity of innovation, but also to the necessity—or seeming necessity—of advertising innovation by making it startling and spectacular.

Today everybody innovates. Deliberately, methodically. And the innovations are deliberately and methodically made startling. Only it now turns out not to be true that all startling art is necessarily innovative or new art. This is what the sixties have finally revealed, and this revelation may indeed be the newest thing about the bulk of what passes for new art in the sixties. It has become apparent that art can have a startling impact without really being or saying anything startling—or new. The character itself of being startling, spectacular, or upsetting has become conventionalized, part of safe good taste. A corollary of this is the realization that the aspects under which almost all artistic innovation has made itself recognized these past hundred years have changed, almost radically. What is authentically and importantly new in the art of the sixties comes in softly as it were, surreptitiously—in the guises, seemingly, of the old, and the unattuned eye is taken aback as it is not by art that appears in the guises of the self-evidently new. No artistic rocketry, no blank-looking box, no art that excavates, litters, jumps, or excretes has actually startled unwary taste in these latter years as have some works of art that can be safely described as easel-paintings and some other works that define themselves as sculpture and nothing else.

Art in any medium, boiled down to what it does in the experiencing of it, creates itself through relations, proportions. The quality of art depends on inspired, felt relations or proportions as on nothing else. There is no getting around this. A simple, unadorned box can succeed as art by virtue of these things; and when it fails as art it is not because it is merely a plain box, but because its proportions, or even its size, are uninspired, unfelt. The same

applies to works in any other form of 'novelty' art: kinetic, atmospheric, light, environmental, 'earth', 'funky', etc., etc. No amount of phenomenal, describable newness avails when the internal relations of the work have not been felt, inspired, discovered. The superior work of art, whether it dances, radiates, explodes, or barely manages to be visible (or audible or decipherable), exhibits, in other words, rightness of 'form'.

To this extent art remains unchangeable. Its quality will always depend on inspiration, and it will never be able to take effect *as art* except through quality. The notion that the issue of quality could be evaded is one that never entered the mind of any academic artist or art person. It was left to what I call the 'popular' *avant-garde* to be the first to conceive it. That kind of *avant-garde* began with Marcel Duchamp and with Dada. Dada did more than express a wartime despair of traditional art and culture; it also tried to repudiate the difference between high and less than high art; and here it was a question less of wartime despair than of a revulsion against the arduousness of high art as insisted upon by the 'unpopular' *avant-garde*, which was the real and original one. Even before 1914 Duchamp had begun his counter-attack on what he called 'physical' art by which he meant what is today vulgarly termed 'formalist' art.

Duchamp apparently realized that his enterprise might look like a retreat from 'difficult' to 'easy' art, and his intention seems to have been to undercut this difference by 'transcending' the difference between good and bad in general. (I do not think I am over-interpreting him here.) Most of the Surrealist painters joined the 'popular' *avant-garde*, but they did not try to hide their own retreat from the difficult to the easy by claiming this transcendence; they apparently did not feel it was that necessary to be 'advanced'; they believed that their kind of art was simply better than the difficult kind. And it was the same with the Neo-Romantic painters of the thirties. Yet Duchamp's dream of going 'beyond' the issue of artistic quality continued to hover in the minds at least of art journalists. When Abstract Expressionism and *art informel* appeared they were widely taken to be a kind of art that had at last managed to make value discriminations irrelevant. And that seemed the most advanced, the furthest-out, the most *avant-garde* feat that art had yet been able to perform.

Not that Duchamp's ideas were particularly invoked at the time. Nor did Abstract Expressionism or *art informel* belong properly with the 'popular' *avant-garde*. Yet in their decline they did create a situation favourable to the return or revival of that kind

of avant-gardism. And return and revive it did in New York, notably with Jasper Johns in the latter fifties. Johns is—rather was—a gifted and original artist, but the best of his paintings and bas-reliefs remain 'easy' and certainly minor compared with the best of Abstract Expressionism. Yet in the context of their period, and in idea, they looked equally 'advanced'. And under cover of John's idea Pop art was able to enter and give itself out as perhaps even more 'advanced'—without, however, claiming to reach the same levels of quality that the best of Abstract Expressionism had. The art journalism of the sixties accepted the 'easiness' of Pop art implicitly, as though it did not matter, and as though such questions had become old-fashioned and obsolete. Yet in the end Pop art has not succeeded in dodging qualitative comparisons, and it suffers from them increasingly with every day that passes.

Its vulnerability to qualitative comparisons—not its 'easiness' or minor quality as such—is what is seen by many younger artists as constituting the real failure of Pop Art. This failure is what, in effect, 'novelty' art intends to remedy. (And this intention, along with other things, reveals how much 'novelty' art derives from Pop art in spirit and outlook.) The retreat to the easy from the difficult is to be more knowingly, aggressively, extravangantly masked by the guises of the difficult. The idea of the difficult—but the mere idea, not the reality or substance—is to be used against itself. By dint of evoking that idea the look of the advanced is to be achieved and at the same time the difference between good and bad overcome. The idea of the difficult is evoked by a row of boxes, by a mere rod, by a pile of litter, by projects for Cyclopean landscape architecture, by the plan for a trench dug in a straight line for hundreds of miles, by a half-open door, by the cross-section of a mountain, by stating imaginary relations between real points in real places, by a blank wall, and so forth. As though the difficulty of getting a thing into focus as art, or of gaining physical access to it, or of visualizing it, were the same as the difficulty that belonged to the first experience of a successfully new and deeply original work of art. And as if aesthetically extrinsic, merely phenomenal or conceptual difficulty could reduce the difference between good and bad in art to the point where it became irrelevant. In this context the Milky Way might be offered as a work of art too.

The trouble with the Milky Way, however, is that, as *art*, it is banal. Viewed strictly as art, the 'sublime' usually does reverse itself and turn into the banal. The eighteenth century saw the 'sublime' as transcending the difference between the aesthetically

good and the aesthetically bad. But this is precisely why the 'sub-lime' becomes aesthetically, artistically banal. And this is why the new versions of the 'sublime' offered by 'novelty' art in its latest phase, to the extent that they do 'transcend' aesthetic valuation, remain banal and trivial instead of simply unsuccessful, or minor. (In any case 'sublime' effects in art suffer from a genetic flaw: they can be *concocted*—produced, that is, without inspiration.)

Here again, the variety of nominally advanced art in the sixties shows itself to be largely superficial. Variety within the limits of the artistically insignificant, of the aesthetically banal and trivial, is itself artistically insignificant.

The lecture was first delivered at the University of Sydney on Friday 17 May 1968 and first published by the Power Institute of Fine Arts in 1969. It has also appeared in *Studio International*.

II. Flight from the object

DONALD BROOK

THERE HAS BEEN a great deal of discussion in the fine arts in the last few years, about *objects* and *objecthood*. And rather curiously, the very unclear notion of what it amounts to for a work of art to *be* an object has gone largely unexamined. As with St. Augustine on Time, the theory seems to be that we know very well what it is, so long as nobody asks.

I have not approached the problem of art and objecthood in an abstractly theoretical way, but from the actual recent literature of comment and criticism in the visual arts; and in it I distinguish seven principal senses that are given, explicitly or by implication, to the notion of 'object'. No doubt there are others—or at very least some noteworthy variants of those that I have found—but seven is an encouragingly magic number with which to conjure the secrets of an almost occult trade.

I THE PUBLIC OBJECT
(Contrast: privacy or idiosyncracy)

One thing that seems to be meant by saying that works of art are objects is that their properties, both natural and aesthetic (if these should be believed not to be natural) are, or ought to be, *public*. And that is to say that any number of people may, in principle, see and admire the same thing.

I should have thought that unless something of the sort could be promised, critics of the arts would have very little to discuss. They might have some autobiographical matter to disclose, but nothing to dispute. In spite of that, radically subjective theories are still rife, and argument remains lively if not always pointed.

Joseph Albers, a fanatical student of colour, takes appreciation to involve private objects; maintaining that if '. . . everyone focuses on the same red, each will receive the same projection on his retina', but no one can be sure whether each has the same perception'.[1] And David Smith said that he did not believe that any two people see the same sculpture '. . . simply because no two people are each other'.[2]

Wyndham Lewis made a similar claim, but gave a different reason: '. . . in looking at what he has done, the painter sees one thing, the public another; and to train up the public so that they see the *same* thing is impossible. This is because what the painter sees is in another dimension altogether'.[3]

And even without approving the reason, one must surely welcome the restraint imposed by it on the proliferation-factor for works of art: one work for the artist, and just one more for the entire public, is moderate if not absolutely equitable.

Some people (and I am one) believe that even the duplication of aesthetic entities may with patience be avoided. David Pole, for example, agrees that '. . . one spectator may see what another fails to see' but he attributes the difference to '. . . want of attention or of training in certain art forms . . .';[4] and this is surely a state of affairs that is remediable in principle.

The flight from the object into the embrace of critical subjectivism is not new: the element of contemporaneity is rather to be seen in the more frequent recent references to phantasy and dreams, that have not been much discussed since Surrealism; and in psychedelia. David Smith '. . . stressed the importance of a kind of imagery which seemed to deny the very substantiality of sculptural form; dream-image, after-image, eidetic and subconscious image, are words he repeatedly used to convey the kind of content which he sought to express'.[5]

Once they are given their concrete manifestation in sculpture, of course, Smith's dreams have to be counted public dreams; so that the clearest examples of privacy come with a stimulus that is supplied on prescription, and taken orally. Obviously it would not be to the point to lavish critical attention on the actual psychochemical substances that '. . . along with a new neurotechnology may largely displace art as a shaper of consciousness [according to recent authorities, while at the same time] . . . offering it an enormous enrichment . . . in its means of expression as well as in its content'.[6]

Whether art is in the end displaced or enriched by psychochemistry (and there does seem to be a problem of compatibility in these ambitions) it is at any rate plain enough that hallucinations are not public objects.

2 THE MATERIAL OBJECT

(Contrast: mental or ideal entities)

If one takes 'object' to imply material substance rather than public status, the flight from it is neither recent nor is there any sign of a

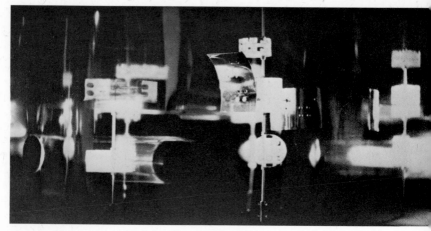

Plate 1. Nicholas Schoeffer I, *Microtime 1*. 1964.
'The "work" has become incidental, a mere means of communicating the original aesthetic "idea

rapprochement. *Ideal* theories of art entail that no work of art is a physical object, and so do presentational theories; and variants of one or the other underpin the practice of many prominent art critics in the international community.

About Schoeffer's *Microtimes*, Frank Popper writes that their idea

... is to convey an aesthetic awareness of the infinite by small particles of time ... [the] luminous and chromatic intensity makes one completely forget the sculptural construction, the materials used, the light sources, colour wheels, and even the movement itself and its mechanism. The 'work' has become incidental, a mere means of communicating the original aesthetic 'idea'.[7]

This is, of course, to go much further than would be necessary to distinguish between static *objects* and kinetic *processes*. The Idealist spirit of Croce evidently finds the electric age congenial.

Visual art is detached from its physical basis no less confidently by Charles Harrison. Writing of Morris Louis's painting, *Untitled, Spring 1962*, he says that '. . . a bright yellow line at the right hand edge is identical in tone with the unpainted canvas. The edge vibrates like a plucked string, yet it does not cut the surface as a line cuts it.'

And he goes on to claim that this painting will

... retain its power to astonish and to move us because it will never

18

quite enter into the world of physical things—a part of it will always remain outside.
. . . To see [these late paintings of Morris Louis] merely as objects is to fail to see them. The identity of the painting is obscured while we are examining its texture and substance. As soon as we stand away the painting re-emerges like a flame relit. These works come from the immortal, not the mortal part of man . . .[8]

It seems that Mr. Harrison's enthusiasm for this feature of the Louis painting depends upon his noticing that there is a boundary across which a change of hue occurs although there is no change in tone; perhaps taken together with an implication that such a state of affairs is not commonly stressed by painters. There is nothing occult about this, although it is a case that will serve to introduce my third contrast for the notion of 'object': neither the private as contrasted with the public, nor the ideal as contrasted with the physical, but the phenomenal as contrasted with the real.

3 THE REAL OBJECT
(Contrast: phenomena or 'appearances')
The Anglo-American art world has tended increasingly, in the last few years, to appeal to the European philosophical tradition of phenomenalism for the foundations of a theory of criticism that stresses 'effects, and 'appearances'. Barbara Reise writes about Robert Morris that, unlike Donald Judd, he is interested '. . . in the varieties of phenomenological experience . . . The primarily phenomenological basis to Morris's 'concepts' makes them as mutable and immaterial as the encounter between his work and humanity'.[9]

And Barbara Rose concedes some admiration to Michael Fried for having been '. . . successful in establishing a phenomenological approach to criticism'.[10] She herself claims that 'there are no literary equivalents for visual experience, and this is the heart of our dilemma as art critics';[11] and this implies plainly enough that she supposes it to be the critic's main business not to appriase *objects* (whether public or physical or real), but to translate 'visual experiences' into words. And since she affirms the belief that this is impossible, there must be a very powerful motive at work to keep her at it.

Certainly we do have a special kind of difficulty in handling those visual situations in which our usual talent for saying, on sight, just what it is that we see, is frustrated. And such cases are

not now, in art, so uncommon or marginal as they once were.

If we take the 'optical illusion' in plate 2 to be a work of art—and why should we not?—it is a very good question whether we ought to appraise it in terms of the formal (or any other) relations of those two *unequal* vertical lines, or of those two *equal* vertical lines.

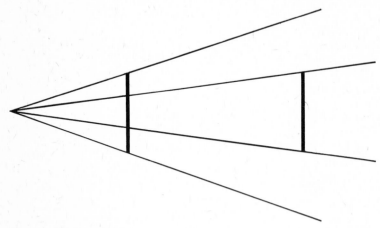

Plate 2. *Equal vertical lines*

They are, of course, *really* equal; and presumably we could learn to see—perhaps to see at once—that this is so. But as matters stand, approaching the figure with the mental set that we now have, they do not *look* equal. And aesthetic appraisal is most certainly concerned (although not *exclusively* concerned) with the looks of things.[12]

Artists have, as a matter of fact, come in the last decade to interest themselves very much in these phenomena: in the retinal fatigue effects that cause grey patches to appear at the intersections of the white grid in plate 3; and indeed in all the 'op' effects of contrast, irradiation, moiré, closure, the figure-ground relationship, reversible figures, and illusions of size and direction.[13] Op art is founded, and colourfield art is heavily dependent, on these effects—which were once considered marginal and thought to pose no serious problems for criticism. Now that they are brought to the very centre of a main strand of artistic activity, the question whether aesthetic appraisal should be given in terms of real

Plate 4. Bridget Riley, *Crest*. 1964. Reduced from 65½ in. square
'. . . *should we say that it does, or that it does not surge, or flicker* . . .?'

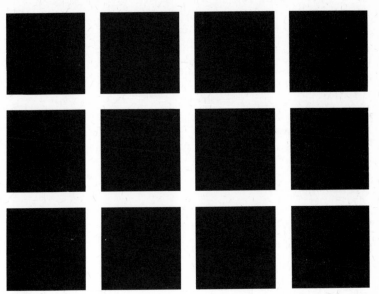

Plate 3. *'retinal fatigue' effect*

qualities or of 'phenomenal' qualities—at any rate where the descriptions compete—is newly exigent.

The answer that seems to have secured at least temporary *de facto* acceptance is that the critic should concern himself with the visual phenomenon, and not with the real object. Take a case like that of Bridget Riley's *Crest* (1964) that is illustrated in plate 4: should we say that it does, or that it does not surge, or flicker? I hope that my own answer—that the aesthetic effect depends on our capacity and willingness to say both that it does and that it does not—will not seem too paradoxical to offer incidentally, and without argument.

4 HERMETIC OBJECTS
(Contrast: context-sited and observer-related entities)

A good deal has been written since the mid-sixties about the kind of minimal work of art that is sometimes confusingly called a 'specific object'.

Robert Morris's *Untitled* (1967), illustrated (plate 5), is one— or perhaps nine—of them, and I shall simply offer, and make no

Plate 5.
Robert Morris, *Untitled*. 1967.
Metal, 48 × 36 × 36 in.

22

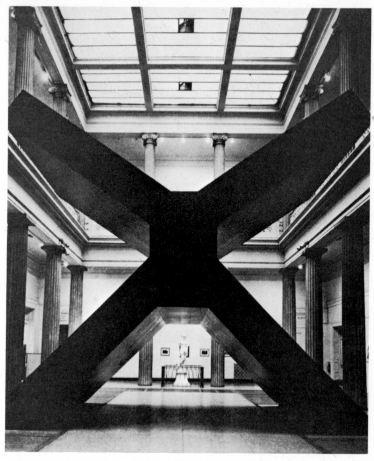

Plate 6. Ronald Bladen, *The X.* 1967.
Wood model, 344 × 294 × 150 in.

attempt to elucidate, the kind of account that is currently fashionable. In Barbara Rose's words:

Don Judd, Robert Morris, Ronald Bladen, John McCracken and Robert Grosvenor are challenging the basis of the Cubist aesthetic in sculpture. As they see it, the guiding principle of Cubist composition was the hierarchical ordering of parts. Rejecting the relational basis of Cubism, they are making works which are integral *gestalts*: bold, aggressive, volumetric structures which demand to be seen all at once, as a single image.[14]

There has been a certain amount of hostility to this enterprise, from formalistic critics. Clement Greenberg, for example, says that '. . . minimal art remains too much of a feat of ideation, and not much of anything else'.[15] And as Robert Morris himself admits 'Sculpture involving unitary forms, being bound together as it is with a kind of energy provided by the gestalt, often elicits the complaint among critics that such works are beyond analysis'.[16]

What I should like to draw out of the present state of the international discussion—without going so deeply into the matter as to challenge the highly contentious concept of 'the integral gestalt'—is the way in which 'minimal' objects, even if it be conceded for argument's sake that they have no internal parts, are seen as themselves constituting part of some larger aesthetic object or situation. On this point, if on no other, the formalists and the minimalists are agreed: minimal objects are not to be appraised in terms of their *internal* or formal relations (because they allegedly have none), but somehow in terms of their *external* relations—their contexts, settings, and viewers.

The formalists insist, of course, that this is aesthetically improper; but I am concerned at the moment only to bring out the point that these things represent a retreat—if not a flight—from the art-object that is conceived of as hermetic, isolated, and aesthetically self-sufficient. The propriety of the withdrawal is another question.

Michael Fried's pejorative way of putting it is to say that works of this sort (and perhaps Ronald Bladen's *The X* (plate 6) would be a clear case) are *theatrical*;[17] that their effect depends, for example, on the relation of scale that they bear to the viewer. And Robert Morris concedes the fact—although not, of course, the dismissive implication that Fried attaches to it:

. . . it is now possible [he writes] to separate . . . decisions, which are relevant to the object as a thing in itself, from those decisions external to its physical presence . . . placement becomes critical as it never was before in establishing the particular quality of the work. A beam on its end is not the same as the same beam on its side.

It is not surprising that some of the new sculpture which avoids varying parts, polychrome etc., has been called negative, boring, nihilistic. These judgements arise from confronting the work with expectations structured by a Cubist aesthetic in which what is to be had from the work is located strictly within the specific object. The situation is now more complex and expanded.[18]

Whatever the minimal sculpture may be, it is evidently not an *isolated* or *hermetic* object—an object independent of contexts.

5 ELEVATED OBJECTS

(Contrast: commonplace things)

A fifth, and very conservative notion of what it might be for a work of art to be *an object*, is enshrined in the idea that the work of art is somehow special, distinctive, extraordinary, and both metaphorically and literally elevated above common things. The flight from this elevated object takes the form of a conviction that works of art should not be marked off clearly from other, more ordinary, things.

William Tucker, who has been characterized as 'the most articulate sculptor of his generation'[19] is presently wrestling with the paradox that is so easily generated by competing impulses:

It was not until the last few years [Tucker writes] that a sculpture started to emerge that disowned the monumental, the precious, the animate—all those qualities that tend to remove sculpture from the object world. It rested directly on the ground—was not elevated on a pedestal—and was made from inexpensive, easily available material, the quality of which was unimportant. . . . The sculpture object was finally freed . . . it could be an object among objects . . .[20] [although, he allows, a conspicuously useless one].

The programme, Tucker says, has led to certain misunderstandings, and he ruefully remarks that '. . . the pedestal, tired old convention as it was, did at least secure the "internality" of the object';[21] and this evidently means that the pedestal marked off works of art from other things, for a special kind of attention: an attention appropriate to works of art, but not to common objects.

The flight from the idea of works of art as peculiarly elevated objects is most yearningly expressed in the demands, more and more frequently heard, that art should abandon its ideologically distasteful association with economic, social, and cultural privilege —that it should not pander to a minority taste and an investment market, but make of itself an effective instrument for the enrichment of all human life. And the view that art is distinct from, but serviceable to all life, shades almost imperceptibly into the view that life—or at any rate some of its more complex forms—is already generating all the art that is necessary, without the intervention of pseudo-specialists called artists. Jack Burnham avoids this dangerous transition by giving the artist new functions. He writes: '. . . the long held idea that a tiny output of art objects could somehow "beautify" or even modify the environment was naïve'.[22]

And he envisages massive public arts—but not of the ready-made kind, that are unmediated by conscious aesthetic deliberation:

> ... any urban airport runway at night dwarfs all aesthetic attempts to use light on a meaningful scale. The configurations and timing sequences on the flight aprons at Newark airport are truly awe-inspiring, as are the oil cracking stations in eastern New Jersey. ... It must be of little consolation to the artist that bad industrial ecology produces spectacular light art. However, this does highlight the fact that in the face of such competition, the artist is virtually impotent ... the alternative may be for the artist somehow to influence and synchronize existing phenomena. ... A few ideas may filter through from gallery art, but many of the concepts will have to be worked out afresh with professional planners.[23]

But I am on the verge of anticipating something I shall have to say in connection with the flight from *objects* towards *processes* or *systems*, and shall include this section with a brief quotation from Alan Watts, to illustrate the limiting demotion of elevated art—

Plate 7
Dan Flavin, *Installation Shot*. 1968. Blue and ultraviolet fluorescent tubes.
'... *the paintings are vanishing into the walls, but they will be marvellous walls* ...'

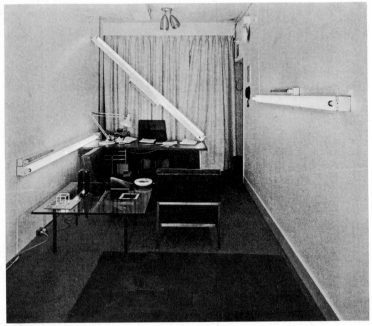

its total absorption into life. The Dan Flavin *Installation Shot* (plate 7) indicates the direction of progress, although it still falls considerably short of the limit envisaged by Watts:

> . . . the ear-clearing and eye-washing that is now going on in the concert halls, galleries and museums is in preparation for a return to the inseparability of art and everyday life. The paintings are vanishing into the walls; but they will be marvellous walls. In turn, the walls will vanish into the landscape: but the views will be ecstatic. And after that the viewer will vanish into the view.[24]

It is difficult to resist the impulse to protest that one would prefer to halt the process a little short of self-immolation.

6 PROPER OBJECTS

(Contrast: dimensional illusion or deceit)

A proposal that has been much canvassed in the last decade is that works of art should be *proper* objects—and that is to say, proper to their dimensional kind: sculptures should be somehow *essentially* three-dimensional, and paintings *essentially* two-dimensional.

I suppose that the history of this goes back to Lessing's absurd notion of proper genres—that, for example, because painting does not *embody* actual movement, it should never even seek to represent movement. The topic is far too complex to argue summarily, and I shall simply refer to it as an important and contentious one in which it is not at all clear which is the present direction of flight —towards or away from dimensionally proper objects. Typical claims are like Robert Morris's, that '. . . the concerns of sculpture have been for some time not only distinct but hostile to those of painting'.[25] And Sir Herbert Read was saying something of the sort many years ago, although with somewhat different paradigms of sculpture in mind.[26]

In painting, the recent literature has been dominated by a figment called 'the integrity of the picture plane'; and a characteristic claim put in terms of pictorial propriety, is Charles Harrison's: 'The development of Modernist Painting is a concept sustained by the belief that the two kinds of picture space, the illusory and the optical, are mutually exclusive. Much of the recent history of painting has been interpreted in terms of a need to close off the first before exploiting the second'.[27]

In other words, although Modernist Painting may be optical, it must not be illusory. There is a good deal of confusion abroad about all this, and I do not think that it is possible to assert with

confidence that theories of dimensionally proper kinds are losing ground at the end of the sixties. I do not rely on the intuition that they are, and include the matter in this schema only in case its omission should seem careless.

7 IMMUTABLE OBJECTS
(Contrast: processes)

Finally, there is that sense of 'object' in which the stress lies on permanency, on obduracy, or imperishable stability. Ozymandias notwithstanding, there is a paradigm of the work of fine art that would have it a public object, a physical object; a perceptually unambiguous object; hermetically indifferent as to context; specially attractive of reverence; dimensionally proper *and* immutable. The Great Pyramid probably fits on all counts.

And in contrast, there are transient *processes*, ranging from the natural corruption of time that is artfully accelerated in auto-destructive art, to the articulate temporal structuring of all the kinetic forms.

There have, of course, always been process arts: conspicuously, music, theatre, and dance—and more recently cinema. What we are now witnessing is odd, and conceptually disruptive: the flight of painters and sculptors from objects toward processes that deny one, or most, or even all of the characteristics of the Cheops paradigm—and in extreme cases that deny even the condition that some part of the action or the product shall be visible. And for the *visual* arts this is highly paradoxical, and perhaps even—except as a limiting case—conceptually intolerable.

John Cage says that 'Art's enemy is the object. Reality is events, not objects. Static structures are anachronisms. It's idiotic and immoral to make such objects now'.[28]

The same point is made in jargon, by Roy Ascott: 'My artifacts come out of a process of random behaviour interacting with pre-established conditions. The Cybernetic Art Matrix is seen as a process in which anarchic group behaviour interacts with pre-established systems of communications, hardware and learning nets'.[29]

Not only the real dimension of time, but the contribution of all the sensory modes is invoked in the process arts, without any overwhelming dominance of the visual. And that largely bogus institution called art education is already responding to the idea that processes may be fundamental, and products incidental. In an article on the lively school at Leeds, Meryle Secrest remarks that

What is being attempted here is a way of putting the student back in touch with those wellsprings of his creative being which . . . are bound to be dammed up in a society where conformity and emotional control are the values which are prized.

Everything depends on how well this goal is achieved and very little on what comes out of the process; a point of view which runs directly counter to traditional art education thinking in Britain and the United States.[30]

And if the new biologists are anything like right about the function of art as exploration, this emphasis on activity deserves to be taken very seriously.[31]

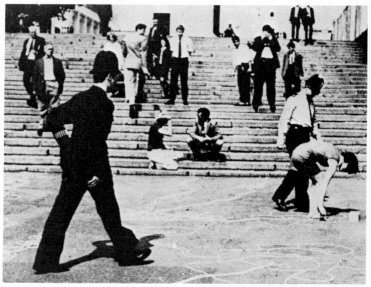

Plate 8.
'. . . obstruction and defacement of the Queen's property . . .'

The human art-exploratory processes do sometimes have serio-comic consequences. In 1967 a group of Dutch teenage girls who had been drawing a chalk line from Amsterdam to the Institute of Contemporary Art in London (plate 8) spent most of their time in England locked up at Bow Street. They were eventually charged with 'obstruction coupled with defacement of the Queen's property'.[32]

And a Czech philosophy student

. . . fell foul of the Czech police on account of his third happening . . .

In July 1967, hundreds of students . . . each carrying a loaf of bread, descended upon one of the city's squares and built a pyramid of bread [shades of Cheops!] over the body of his girl friend. Brickius was held in custody for over a week while suitable charges were being worked out. At his trial he was sentenced to three months in prison for 'insulting the People and misuse of bread'.[33]

But I shall give Jack Burnham the last word of summary on processes, because it is his distinction to have produced the first important general text on a putative new future for the fine arts.[34] He contends that 'we are now in transition from an *object-oriented* to a *systems-oriented* culture. Here change emanates, not from things, but from *the way things are done*. The priorities of the present age revolve around the problem of organisation'.[35]

Whether he is in the end right or wrong in his analysis of trends and drawing of implications, he is certainly the articulate spokesman for an increasingly popular point of view among artists.

Nearly all discussion within and about the arts is in some respects, and to some degree, exhortatory; and this paper is no exception. I shall conclude by sketching, very approximately indeed, two principles in the light of which we may begin to find some aspects of the flight from the object commendable, and others not.

But first let me reject two false proposals for assessing the worth of artistic movements, both of which are more popular among critics than they should be. I have in mind, first, the sort of historicism that sees movements in the arts as fulfilling some inexorable, pre-ordained design: for example, an alternation of linearity and painterliness. Artists, it is clear, are directed by many constraints, not all of them consciously felt; but I do not believe that any hypostatized entity called History holds a gun in their backs.

And the second critical practice that I should like to discredit is that of attributing excellence by concealed circularity. What I have in mind is this: Clement Greenberg (for example) says that '. . . the duration of an art-historical style ought to be considered the length of time during which it is a leading and dominating style . . . This is also, usually, the time during which it attracts those younger artists who are most highly and seriously ambitious'.[36]

It seems all too likely that the critic's assessment of the altitude and gravity of these young artists' ambitions will tend to be determined by, rather than to determine which is, the 'dominating' style. Indeed, artists whose inclinations fall outside what is claimed to be the mainstream, often propose a less flattering characteriza-

tion of their approved colleagues' felicity: 'bandwaggoners!', they say; not 'what high and serious ambition!'

Appeals to artists' powers and talents as evidence of the importance of new directions and movements are not *necessarily* circular, but even if they are not, they may still be uncoercive. Barbara Rose, for instance, thinks that various 'Novelty Art' manifestations that she would otherwise feel tempted to write off, are after all worth taking seriously '. . . because at the moment some of the strongest and most original young artists have chosen . . . to express themselves in a fashion that does not conform to the traditional art definitions'.[37]

One wonders how they secured the reputation for personal strength and originality on which the claim of their new work to attention rests. If on the evidence on *that* work, then there is circularity; and if on the evidence of previous work (assuming the new work to be *radically* different), there is an open question of relevance, and a loaded game against new starters.

I should like to propose two general principles that do not derive from any supposed historical necessities—nor do they depend on artists' personal credentials—in the light of which one might begin to assess the various aspects of the current flight from the object. Some important consequences will follow from their acceptance, even though they are not here stated and perhaps cannot be stated with very great precision, for they are more like policies than prescriptions. They are:

(i) *The Principle of Publicity*
that whatever the artist, as such, makes or does should be in principle a public entity; because only that which is (in principle) available to anyone is capable of supporting a common language, a common understanding, a community of values. We may enjoy private dreams, but it is only our public versions of them—the stories we tell, the pictures we make and the things we do in the world—that ultimately mediate between us, and upon which we found a form of life and a set or sets of values.

From which it follows that the flight from perceptible objects (or from publicly perceptible processes) towards inner, theoretically or practically incommunicable private experiences, is a flight in the wrong direction. We should not, for example, blur the difference between publicly visible 'psychedelic' paintings and the private consequences of ingesting psychedelic drugs; or between the appraisal of psychedelic art—or indeed any other sort of art—as it is enjoyed in a normal perceptual state, and in a disordered perceptual state.

31

This is not to pronounce for or against hallucinatory drugs: it is only to insist that hallucinations—no matter how interesting or pleasurable—are not art.

And the second principle is

(ii) *The Principle of Exploration*
that art activities are most properly thought of as the locus of free exploration, invention, and creative imagination. The arts are chronically prone to sclerosis, and they should constantly be encouraged to resist the inflexibilities that are threatened by exclusivist aesthetic doctrines of prescribed forms and styles, of alleged historical necessities, and of absolute aesthetic judgements. There is a perpetual temptation to assimilate the concept of art to that skill, because skills do not generate the same nagging anxieties of uncertainty about standards. And the price paid for the confidence in stable values that comes with settled and determinate systems, is the deterioration of arts into crafts.

From which it follows that inasmuch as the flight from the object is a flight away from the clearly defined, the well under-stood, the domesticated, the traditional, and towards the stuff of fresh definitions, new understandings, and new domestications, it is likely to be in the right direction: given that the principle of publicity is also honoured. For a lively art these conditions are surely necessary. They are not sufficient, for no specifiable con-ditions would be sufficient to guarantee the viability and worth of an art.

It is a very good question how one is to know which novel consequences of exploration, invention, and imagination are valuable and fruitful, or to be commended for whatever reason, and which are merely arbitrary, capricious, and trivial. And it is a very good answer indeed to say that we do not.

The main function of criticism is not so much to *detect* aesthetic value in new things, on some such model as the determination of acidity by litmus, as conservative formalists seem to suppose. It is rather to help *determine* the value of new things by assigning them to a place in our general structure of values, and arguing for that disposition. This is a more realistic challenge because for one thing it is a more plausible enterprise; and for another, it admits responsibility. The critic is no ideally detached observer: he is willy-nilly a participant in the cultural action of his time.

NOTES
 [1] Joseph Albers, *Interaction of Colour* (Yale, 1963), p. 13.
 [2] David Smith, 'Thoughts on Sculpture', *College Art Journal*, Vol. XIII, No. 2, Winter 1954, p. 97.

[3] Wyndham Lewis, *The Demon of Progress in the Arts* (London, 1954), p. 82.

[4] David Pole, 'What makes a Situation Aesthetic?', *Proceedings of The Artistotelian Society*, Supplementary Vol. XXXI, 1957, p. 105.

[5] Jane Harrison Cone, catalogue introduction *David Smith 1906–1965* at the Fogg Art Museum (Harvard, 1966), p. 3.

[6] Masters and Houston, *Psychedelic Art* (London, 1968), p. 81.

[7] Frank Popper, 'Nicholas Schoeffer: the Creative Idea and the Direct Effect', *Art International*, Vol. XII, No. 1, 1968, p. 26.

[8] Charles Harrison, 'London Commentary', *Studio International*, Vol. CLXXVII, No. 910, Apr. 1969, pp. 190–2.

[9] Barbara Reise, '"untitled, 1969": a Footnote on Minimal Stylehood', *Studio International*, Vol. XVII, No. 910, Apr. 1969, p. 168.

[10] Barbara Rose, 'Problems of Criticism, VI: The politics of Art Part III', *Artforum*, Vol. VII, No. 9, May 1969, n. 2, p. 51.

[11] Barbara Rose, in a contribution to a Brandeis Symposium, *Art Criticism in the Sixties* (October House, New York, 1967).

[12] See e.g. Frank Sibley, 'Aesthetics and the Looks of Things', *The Journal of Philosophy*, Vol. LVI, 1959, for a useful discussion.

[13] A useful text for artists and critics is R. G. Garraher and J. B. Thurston, *Optical Illusions in the Visual Arts* (London, 1964).

[14] Barbara Rose, 'Post-Cubist Sculpture', in Tuchman (ed.), *American Sculpture of the Sixties* (Los Angeles, 1967).

[15] Clement Greenberg, 'Recentness of Sculpture', in Tuchman (1967), p. 183.

[16] Robert Morris, 'Notes on Sculpture: Part I', *Artforum*, Vol. IV, Feb. 1966, p. 44.

[17] Michael Fried, 'Art and Objecthood', in Battcock (ed.), *Minimal Art* (London, 1969) (fp.N.Y., 1968), pp. 116–47.

[18] Robert Morris, 'Notes on Sculpture: Part II', *Artforum*, Vol. V, Oct. 1966, p. 23.

[19] By Charles Harrison, in 'Some Recent Sculpture in Britain,' *Studio International*, Vol. CLXXVII, No. 907, Jan. 1969, p. 26.

[20] William Tucker, 'An Essay on Sculpture', *Studio International*, Vol. CLXXVII, No. 907, Jan. 1969, pp. 12–13.

[21] Ibid.

[22] Jack Burnham, 'Systems Aesthetics', *Artforum*, Vol. VIII, No. 1, Sept. 1968, p. 31.

[23] Jack Burnham, 'Six Canonical Variations on the Future of Light Art', in the catalogue *Electric Art* at UCLA Galleries, Jan.–Mar. 1969.

[24] Alan Watts, An Introductory Note to the catalogue *Electric Art*, UCLA Galleries. Jan.–Mar. 1969.

[25] Robert Morris, 'Notes on Sculpture: Part I', p. 43.

[26] For an account of the perceptual aspect of the 'dimensionally proper object' theory, see my 'Perception and the Appraisal of Sculpture', *Journal of Aesthetics and Art Criticism*, Vol. XXVII, No. 3, Spring 1969, pp. 323–30.

[27] Charles Harrison, 'London Commentary', *Studio International*, Vol. CLXXVII, No. 911, May 1969, p. 238.

[28] John Cage, as quoted by Willoughby Sharp, in 'Air Art', *Studio International*, Vol. CLXXV, No. 900, May 1968, p. 262.

[29] Roy Ascott, 'The Cybernetic Stance: My Process and Purpose', *Leonardo*, Vol. I, No. 2, 1968, p. 105.

[30] Meryle Secrest, 'An American at Leeds', *Studio International*, Vol. CLXXVII, No. 911, May 1969, pp. 206–7.

[31] See e.g. Desmond Morris, *The Biology of Art* (London, 1962), *passim*, and also *The Naked Ape* (London, 1967), esp. ch. 4, 'Exploration'.

[32] Sheldon Williams, 'Scapegoats: the Non-Conforming Artist', *Help*, No. 7, Dec. 1968, pp. 30–5.

[33] Ibid.

[34] Jack Burnham, *Beyond Modern Sculpture* (London and New York, 1968).

[35] Jack Burnham, 'Systems Aesthetics', *Artforum*, Vol. VII, No. 1, Sept. 1968, p. 31.

[36] See above, p. 8.

[37] Barbara Rose, 'The Politics of Art: Part III', p. 48.

The lecture was first delivered at the University of Sydney on Wednesday 10 September 1969 and was first published by the Power Institute of Fine Arts in 1970.

III. 'Very like a whale': the spectator's role in modern art

CHARLES MITCHELL

MY TEXT, of course, comes from *Hamlet*:

Hamlet. Do you see yonder cloud almost in shape of a camel?
Polonius. By the mass, and 'tis like a camel indeed.
Hamlet. Methinks it is like a weasel.
Polonius. It is backed like a weasel . . .
Hamlet. Or like a whale.
Polonius. Very like a whale . . .

And to introduce the theme of this lecture I take first a lithograph by Joan Miró (plate 9) which usually hangs in my sitting-room at home. He is a pathetic figure. They have bitten a hole out of his head because he has stupidly dropped his star, and he is always getting into some kind of scrape, and having to answer for it to those dreadful storm-trooper types who stand around him. The identity of these guards changes with the times and with one's mood. Years ago, when the little man first arrived in our house, they were Mr. Bulganin, Mr. Kruschev (the beady-eyed little one at the bottom), and an eminent English trade union leader whom I shall not name. Nowadays they get identified with other worthies who infest several continents. But still, whoever they are, they never quite succeed in getting him down. 'What else *can* you expect of people like these?', he says, helplessly spreading out his hands. 'You've got to take democracy on the chin and like it.' Sometimes, like me, he is forgetful and misses an appointment. He knows that nobody will believe him when he protests that he was detained by circumstances beyond his control, meaning that he got his feet tied up in the kite-strings. But whatever the times, whatever one's mood, he always gives one a salutary warning. You must never on any account answer back or lose your temper with the pompous mandarins who rule our lives in this free world of ours. They know how we ought to live—or die—

Plate 9. Miró, *Personnage*. Lithograph, 1948. 26½ × 20½ in.

much better than we do. If we cannot be grateful to them, we can
at least ignore them—pretend they do not exist, look the other
way, twirling our stick like Charlie Chaplin, or strumming a
tune to ourselves on the celeste of blobs in the sky—pom, pom,
pom, POM, pom, pom—even if it does have a dying fall. That
is how we can preserve for ourselves a refuge—asylum is perhaps

the better word: an asylum of immunity behind our own vulnerable skins. After all, they are only paper kites, even if they do pester our lives. So you see why Miró's sad cheerful little 'personage' (as Miró non-committally christened him, leaving us to identify him as we like)—why, with his absurd air of indomitable and quite irrational hopefulness in a horrid world, he is such good company and such a comfort. It is because he is all things to all men. He is like the Teddy Bear in *Look Back in Anger*, snuggling up and fitting every mood.

How does he manage it? Partly, by not being a man at all. His ambiguous existence lies somewhere between the world of Nature and the world of Imagination; and though created by the artist, he does not take full life and shape until each beholder of him, out of his own imagination, puts his own interpretation upon him. What is more, the artist, far from resenting this interpretative freedom on the part of his spectators, positively relishes it, as witness this conversation which Miró himself had with an enquiring friend in front of a painting he made in 1927 and labelled *Cheval* (plate 10):

'C'est un cheval, n'est-ce pas?'
'Oui, oui.'
'Mais non, c'est un oiseau.'
'Oui, oui.'

Plate 10. Miró, *Le cheval*. Tempera, 1927. $9\frac{1}{2} \times 13$ in.

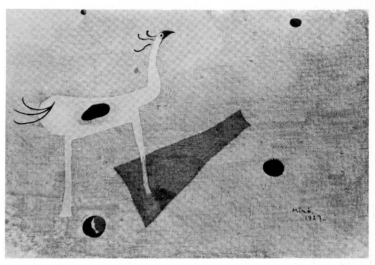

37

Admittedly, Miró's politeness in accepting the title 'Bird' instead of his own 'Horse' does not entirely conceal the lordly and perennial disdain of artists in face of lay criticism. But at the same time Miró's response was serious, though mingled with a touch of the irony which is always part of his artistic purpose. For he knew that the artist who invents images in this no-man's-land between Nature and Imagination, vision and dream, does not by any means necessarily recognize what comes to form under his hand, even when he has finished it. The spectator's interpretation of it is no less valid than his own, and indeed may be more penetrating, more apposite, more truly revealing. T. S. Eliot made the same point—beyond mere cautious avoidance of the Intentional Fallacy —when some years ago at the Poetry Centre in New York he introduced a reading of his own poems with the remark: 'Some of you have asked me if I would make some comment on my poetry, but I am well aware that there are many of you here who understand it infinitely better than I do.'

This intentionally ambiguous 'camel–whale' kind of art (if I may call it so) is a modern phenomenon which finds its most characteristic expression in Surrealism. But it did not begin with Surrealism and it has had its after-effects. The 'camel–whale' revolution has emancipated the spectator of contemporary art. He can no longer—at least with any art that claims to be novel and original—take the old academic line of judging a work primarily by *a priori* commonly accepted rules: applying canonical rules, shared by the artist, and then deciding whether the artist has properly obeyed them. Nor—even in the post-war era of 'objective' art—is he often entitled to take a purely passive role in contemplating and judging a proffered new work. His part, no less than the artist's, is apt to be an individually active one— though I cannot, of course, predict what will happen in years to come. In this lecture, therefore, my first aim is to try to indicate the prehistory of 'camel–whale' art before Surrealism, to show how it emerged, plotting its bearings particularly with regard to Cubism on one hand and so-called Abstract art on the other. Then I shall say something about the role of the spectator in the last few decades. And finally, by way of antithesis, I shall show how the spectator, basking in his supposed new freedom, meets his nemesis in Marcel Duchamp's second *magnum opus* which recently arrived in Philadelphia.

The Cubist revolution is a portmanteau term to cover a number of convulsive efforts to free art from the grip of conceptual natural-

ism. The first spasm resulted in the *Demoiselles d'Avignon* of 1907 (plate 11). Picasso started the picture—and indeed carried it through to the end—as his challenging response to the Fauves, and particularly to Matisse, the contemporary artist whom, from his early days in the Bateau Lavoir down to Matisse's death, he regarded as his most serious rival. This was how a Fauve picture, carrying Fauvism as far as it could go, really ought to be constructed; and the early sketch (plate 12)—a group-portrait of naked women with a clothed man, a sailor it is said, in the centre and another man to the left—shows *repoussoirs* and fluid voluptuous

Plate 11. Picasso, *Demoiselles d'Avignon*. Oil, 1907. $96\frac{1}{2} \times 92\frac{1}{2}$ in.

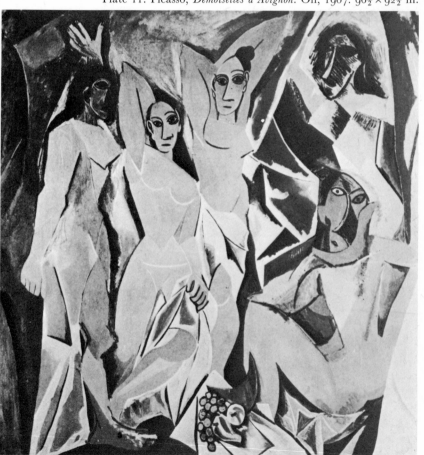

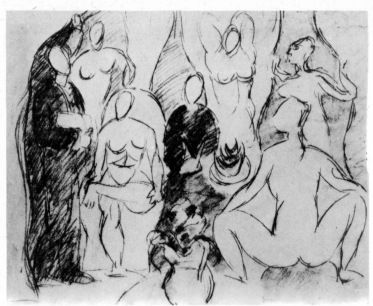

Plate 12. Picasso, study for the *Demoiselles d'Avignon*. Crayon and pastel, 1907. 24½ × 18½ in.

Plate 13. Matisse, *Bonheur de vivre*. Oil, 1905–6. 68½ × 93¾ in. (Copyright 1975 The Barnes Foundation.)

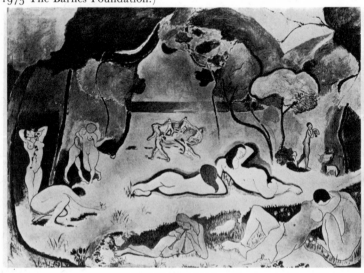

curves clearly rivalling those of Matisse's *Bonheur de vivre* of the
previous year (plate 13). Then, as the composition evolved,
Picasso progressively drew structural consequences from the late
Cézanne, and from Negro and Iberian sculpture, until by some
structural alchemy he adumbrated the formal premises of
Cubism proper. Even Braque, at first, was shocked.

The next liberating spasm came in 1908, when Braque at
L'Estaque (plate 14) and Picasso a little later at La Rue des Bois
(plate 15) each began to paint landscapes in subdued colours

Plate 14. Braque, *Houses at L'Estaque*. Oil, 1968. 28¾ × 23¾ in.

with structural chiaroscuro that emphasized the recession of forms and the interlocking of planes close to the surface of the picture. The chromatic luxuries of Fauvism were abandoned, and the structural constituents were made simple to keep them manageable. What Picasso and Braque each brought back to Paris in the late summer of 1908 was astonishingly similar. Kahnweiler, Picasso's prescient early dealer, asserts that the two men arrived independently at their solutions, explaining the coincidence

Plate 15. Picasso, *Houses and Trees at La Rue des Bois*. Oil, 1908. $36\frac{1}{2} \times 29\frac{1}{4}$ in.

in the mystic and dubious terms—he was a trained art-historian—of *Geistesgeschichte*. Fernande Olivier, Picasso's companion in the Bateau Lavoir, more credibly claims that Braque derived the principles, before he left for L'Estaque, from previous discussions with Picasso himself.

What *was* the formal problem? It was undoubtedly the problem posed by Cézanne's late works which both Picasso and Braque saw at his big retrospective in 1907. Cézanne's mature aim—thwarted only when his canvas was too big to carry out of doors—was to paint what he saw. His end-result was purely pictorial, but his instrument was sight, and his subject was the natural motif before his eyes. So too with Picasso. Apollinaire, his Vasari, misunderstood his and Braque's efforts: he thought they were rejecting sight for insight in order to produce conceptual images. They were doing nothing of the sort. They were striving, like Cézanne, to depict what they saw accurately: to emancipate their vision from the distorting screen interposed by Renaissance perspective, from which the Impressionists never broke free—one of the most artificial pictorial devices ever excogitated. Gertrude Stein, as usual, told the truth about the matter, remembering what she had gathered from Picasso himself as one of his earliest patrons.

And so Picasso [she wrote in her 1938 book on Picasso] commenced his long struggle to express heads and faces and bodies [for soon he turned from landscape to still life and to the harder task of portraiture] of men and women in the composition which is his composition. The beginning of this struggle was hard and his struggle is still a hard struggle, the souls of people do not interest him, that is to say for him the reality of life is in the head, the face and the body and this is for him so important, so persistent, so complete that it is not necessary to think of any other thing and the soul is another thing.

Then she comes to the precise point.

Really most of the time one sees only a feature of a person with whom one is, the other features are covered by a hat, by the light, by clothes for sport and everybody is accustomed to complete the whole entirely from their knowledge, but Picasso when he saw an eye, the other did not exist for him and as a painter, particularly as a Spanish painter, he was right, one sees what one sees, the rest is reconstruction from memory and painters have nothing to do with memory, they concern themselves only with visible things and so the cubism of Picasso was an effort to make a picture of these visible things and the result was disconcerting for him and for the others. . . .

Such is Picasso's portrait of Kahnweiler of 1910 (plate 16).

43

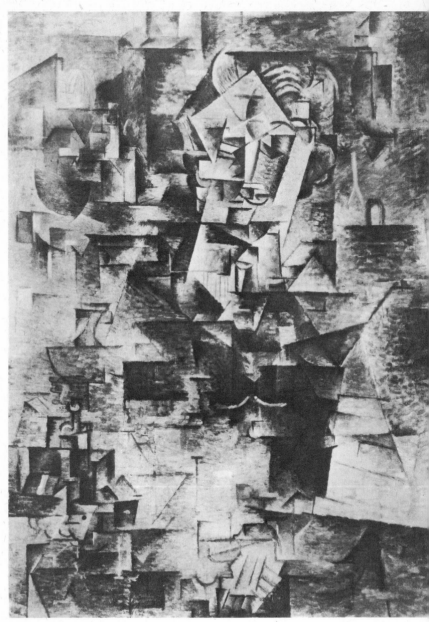

Plate 16. Picasso, *Portrait of Henry Kahnweiler*. Oil, 1910. $39\frac{1}{4} \times 28\frac{1}{4}$ in.

Early Cubism, then, was a structural art based on the data of sight by the moving eye. And we can confirm this from other evidences. As the new pictorial structure made it harder and harder for the spectator, befuddled by the mental set implanted in him by traditional Renaissance-type perspective, to read the rescript of visible reality as the moving eye sees it, both Braque and Picasso went on to employ devices—shadowed nails, collage, bits of brute fact incorporated into the structure—which would help the spectator to anchor the picture to the visible reality depicted. Or again, we have Gertrude Stein's reminiscence of how she and Picasso were walking along the Boulevard Raspail one day early in the First World War, and a big camouflaged cannon came down the street. 'C'est nous qui avons fait ça', Picasso exclaimed. It is true. To the culturally deluded eye nothing might appear further removed from natural appearance than the jazzy triangles and edgy intersecting planes of camouflage. The military knew better. They wanted their guns to merge into the landscape to deceive enemy spotters, and the way they did it was to paint them in the fashion of the Cubists who, for the first time in the history of art, wanted to show both what we see in Nature and how we see it in one and same picture.

Cubism—the product of sight—was one headland through which camel-whale art sailed into the modern world. An opposite headland was the product of thought—Abstract art, if you like; and it divided into two promontories. One, if we must choose a single representative figure, was commanded by Piet Mondrian. Mondrian's objective, as he wrote in 1942, looking back on his career, was always realism; and he came progressively to see that this must be achieved by abstraction—by the use of increasingly pure plastic means to represent an increasingly purely conceived reality. To start with he painted Dutch landscape—subjects like Ruysdael's or Cuyp's immobilized in static impressionist or, more characteristically, *art nouveau* forms (plate 17). Then in 1910 he went to Paris and was immediately drawn to the Cubists, especially Picasso and Léger, whom he regarded as abstractionists, feeling, as time went on, that they had found the truer path towards abstraction than Kandinsky and the Futurists. And so he painted landscapes (plate 18) subdued and opalescent in colour with tentative overlapping forms—more abstract than French Cubism. But he soon recognized that, from his point of view, both the Cubists and he himself had not been abstract enough: accordingly he reduced the colour-variations and his forms, which were still

Plate 17. Mondrian,
Farm near Duivendrecht.
Oil, before 1908.
34 ¾ × 42½ in.

Plate 18. Mondrian,
Composition, No. 11. Oil,
c. 1912. 29 × 21¾ in.

46

Plate 19. Mondrian, *Composition*. Oil, 1916. $47\frac{1}{4} \times 29\frac{1}{2}$ in.
(The Solomon R. Guggenheim Museum, New York)

Plate 20. Mondrian, *Composition in Grey*. Oil, 1919. $37\frac{1}{2} \times 24$ in.

too closely tied to phenomenal appearances, to simple crosses and rectangles, as in his *Composition* of 1916 (plate 19). So far he had been preoccupied with the representation of forms in isolation. But reality did not consist of isolated forms; it consisted of forms in space. So he purified his lines by straightening them and by closing them up to represent the continuum of space, as in his austere composition *Composition in Grey* (plate 20) of 1919. Later on he developed his abstract realism to its logical conclusion: rectangular areas of white or grey representing pure space, rectangular areas of primary colours, blue, red, yellow, and sometimes of black representing pure form, and a grid of straight

Plate 21. Mondrian, *Tableau II*. Oil, 1921–5. $29\frac{1}{2} \times 25\frac{1}{2}$ in.

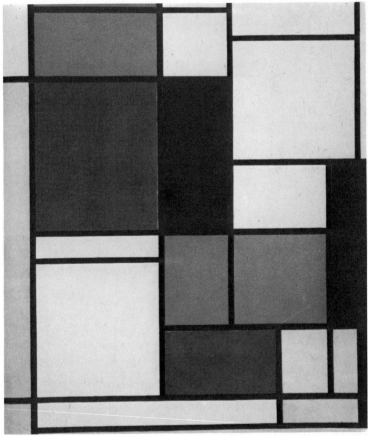

Plate 22. Mondrian, *Victory Boogie-Woogie*. Oil, 1943–4. $49\frac{1}{2} \times 49\frac{1}{2}$ in.

lines locking them together in a closed continuum analogous to the spatial continuum of the conceptually real world (plate 21). Such constructions he regarded as perfect microcosms corresponding to the macrocosm of the real world. And finally, towards the end of his career, having long ago discovered pure plastic means of representing pure reality, he admitted into his paintings the mobility which he had hitherto excluded. The dynamic equilibrium of a work like the *Victory Boogie-Woogie* of 1943–4 (plate 22), he argued, exactly met the needs and matched the

spirit of modern life; and he convinced his spectators. The lords of the modern world—the whisky-distillers, bankers, insurance men, and motor-car manufacturers of our big cities—prefer to house themselves in Mondrian machines.

The abstract and increasingly conceptual art of Mondrian, then, was realist like Cubism, but it was a realism of the mind rather than the eye. It wanted to divorce art from the particular appearances of the visible world: to make art pure. And it did so by means of the conceptual forms of geometry and the pure primary colours never to be seen in nature. The whole argument, of course, is Platonic (partly, perhaps, via Theosophy) in theory and morality. A godlike geometer, Mondrian would banish from his ideal republic all voluptuaries who were deceived by the broken lights and inconstant forms of the phenomenal world and corrupted by the lusts of the eye and the senses.

The other promontory of Abstract art—again if we must take a single representative—was dominated by Wassily Kandinsky, a very different type of mind. For Kandinsky the highest goal of art was to express and communicate the spiritual—the vibrations of the artist's soul musically transposed by inner necessity, not mere decorative fantasy, into colours and forms which would, in turn, set up corresponding vibrations in the soul of the beholder (plate 23). 'The artist', he wrote, 'must train not only his eye but also his soul, so that the soul can weigh colours in its own scale and thus become a determinant in artistic creation.' This is a far cry from Mondrian's conceptualist abstraction; and equally far from the underlying materialism which, with acute insight, Kandinsky detected in Cubism. 'In Picasso's latest works of 1911', he wrote, 'he reaches through logic to annihilation of materiality; not, however, by dissolution of it, but through a kind of fragmentation of its separate parts and a constructive dispersal of those fragments over the canvas.' For Kandinsky was a Russian, and like many Russians, something of a mystic and a Manichee. It was this Manichean cast of mind, along with his understanding of music, that inclined him to dissociate the spiritual element in art from contaminating matter. That is why he was attracted to the dematerialized art of Russian icons, and why his pictures concentrate on vibrant colour and diffused shapes rather than on the tangible forms and spatial recessions of observed nature. 'Spiritual art', he wrote, 'created alongside the real world a new world which has nothing *externally* to do with reality. It is subordinate *internally* to cosmic laws.' Thus, if Mondrian was a sort of Platonist, deliberately reconstructing the regular geometric

51

Plate 23. Kandinsky, *Composition VII, Fragment I*. Oil, 1913

figures of Pythagorean cosmology, Kandinsky was a sort of Neo-Platonist, allowing his soul to vibrate to the impulses of the spiritual world. 'Never was I able to contrive a form', he once said; 'any consciously planned form was repellent to me.' So he described his non-objective 'Improvisations' as 'a graphic representation of a mood, not a representation of objects'.

There, roughly charted, are the two great headlands—Cubism and Abstract art, the new art of Nature and the new art of Mind or Soul—between which camel–whale notions entered into the art of the early twenties. To understand where they began we must go back to Baudelaire and the Symbolists. 'What is our art according to the modern conception?', asked Baudelaire in a fragmentary paper on 'L'Art philosophique'. 'It is to create a suggestive magic containing at one and the same time the object and the subject, the external world and the artist himself.' And

the term 'suggestive'—the watchword of Symbolism—conceals a
third agent: the reader or spectator who consummates the inter-
pretation of the work. We remember Rimbaud's haunting lines
in the *Saison en enfer* of 1873:

> O saisons, ô châteaux!
> Quelle âme est sans défauts?
>
> J'ai fait la magique étude
> Du bonheur qu'aucun n'élude.
>
> Salut à lui chaque fois
> Que chante le coq gaulois.
>
> Ah! je n'aurai plus d'envie:
> Il est chargé de ma vie.
>
> Ce charme a pris âme et corps
> Et dispersé les efforts.
>
> O saisons, ô châteaux!
>
> L'heure de sa fuite, hélas!
>
> Sera l'heure du trépas.
>
> O saisons, ô châteaux!

Seasons, castles, the Gallic cock—what do they convey? They
induce a mood. And what do they mean? They mean nothing
until the reader interprets them for himself; until his own response
gives these precisely visualized, but logically disconnected, images
a synthetic resonance in his own consciousness. Or in 1922:

> At the violet hour, when the eyes and back
> Turn upward from the desk, when the human engine waits
> Like a taxi throbbing, waiting,
> I Tiresias, though blind, throbbing between two lives,
> Old men with wrinkled breasts, can see
> At the violet hour, the evening hour that strives
> Homeward, and brings the sailor home from sea,
> The typist at teatime, clears her breakfast, lights
> Her stove, and lays out food in tins . . .

Eliot's disjunct images have no logic unless the associations they
evoke cohere in the reader's mind to give the passage a unified
significance of his own making.

Of course, at least in the old days, the reader sometimes bucked.

The great novelty [Anatole France said of the Symbolists] is the word
'suggest'. It is terribly modern, modernistic . . . something new, mys-
terious, and ill-defined. Suggestion is the latest fashion. Poets today

want to be suggestive. But suggestive of what? Of what cannot be expressed. In the old barbaric Gothic days words used to mean something definite; in those days words expressed thoughts. Nowadays, in the new school of poetry, words have no meaning of their own at all, no necessary interconnectiong. They are void of sense and syntax.

Now for two examples from later nineteenth-century symbolist art. 'My originality', wrote Odilon Redon, 'consists of putting the visible to the service of the invisible.' One of his illustrations of Flaubert's *Tentation de Saint Antoine* (plate 24) shows the temptation of St. Anthony by horrible devils and lascivious shapes, always a

Plate 24. Redon, from *Tentation de Saint Antoine*. Lithograph, 1896

25. Méryon, *La rue des mauvais garçons*. Etching, 5 × 4 in.

favourite theme with fantastic artists, Bosch, Brueghel, Grünewald among the ancients down to Ensor and Rouault among the moderns. It is not surprising that the symbolic *diableries* of Bosch or Grünewald so often baffle us, because they are not explained unless we hit on the commonly recognized, however recondite, symbols they illustrate. Those of the moderns are easier for us to appreciate because we can look inside our own imaginations for their meaning. Redon's image is a *suggestion* of wickedness—a

55

squirming octopus (*art nouveau* in form like the forms, so often, of Beardsley, Gaudi, van Gogh, or Vuillard), a nightmare jelly-fish, an obscene tropical growth waving in shadowy moonlight. This symbol is as precisely evil, and as precise in its meaning, as the heart of the beholder secretly makes it. Or for another example, we can take Charles Méryon's wonderful print of *La Rue des mauvais garçons* (plate 25) that fascinated Baudelaire himself, etched in the fifties some years before Méryon died insane. His own verses are written on the plate. 'What mortal', he asks, 'used to inhabit this dark tenement? Who hid here in the shadows and the night? Was it virtue? Or vice?' Méryon himself gives no answer, leaving us to supply it from our working imaginations. And from Méryon's *Rue des mauvais garçons* it is only a short step in sentiment—though a jump in time across fifty years—to de Chirico's haunting, disturbing *Melancholy and Mystery of a Street*, painted in 1914 (plate 26). This is no longer Renaissance perspective like Méryon's. The Cubist revolution and Futurism have supervened to disrupt it. But de Chirico still, in symbolist fashion, lures the spectator's fancy to explore *beyond* the exaggerated vista and the obtruded objects in the scene—to wonder why the truck, pushed contrariwise into the front, stands empty; what mystery lurks under that dark portico; what nameless experience awaits that little girl who bowls her innocent hoop towards the forbidding shadow with the stick. The answer lies just round the corner— for us, with indrawn breath, to supply.

The next cardinal figure is Guillaume Apollinaire. We are now in those marvellous fecund years on the eve of the First World War, when new artistic movements were corruscating on all sides—advanced synthetic Cubism in France, machine-drunk Futurism in Italy, the Blue Riders in Germany, Constructivism in Russia, the Stijl in Holland, the outrageous sallies of pre-Dada in New York both before and after the 1913 Armory Show. And at the centre of it all, with antennae responsive to every wave-length, stood Apollinaire, who knew and encouraged—however cagily at times—the whole *avant-garde* and bathed all their endeavours in an aura of lyricism. He knew Picasso and Max Jacob from their early days in the Bateau Lavoir; he knew Delaunay, Archipenko, Marinetti, Boccioni, Severini, Soffici; he knew Modigliani, Léger, André Salmon, Picabia, Duchamp, de Chirico. Apollinaire, in fact, may himself have given its title to de Chirico's *Melancholy and Mystery of a Street*, for he often (it is said) named de Chirico's pictures for him. It was typical of

incipient camel–whale art that a neo-symbolist painter should make a neo-symbolist poet responsible for interpreting his own creations for him.

Apollinaire called himself a 'surrealist', but in truth he was neither a Surrealist of the 1924 kind, nor a real Dadaist, though he was to inspire some of the leaders of both movements, André Breton and Tristan Tzara among them. Hardly surprisingly, however, his lyric innovations did not fail to rile the stuffier critics, even some of the Cubists. Thus, just as Anatole France

Plate 26. De Chirico, *The mystery and melancholy of a street*. Oil, 1914. $33\frac{1}{2} \times 27\frac{1}{4}$ in.

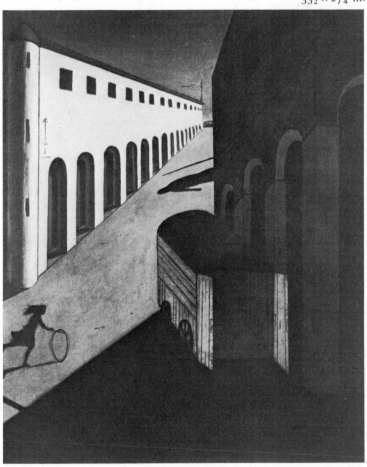

L'ANTITRADITION FUTURISTE

Manifeste-synthèse

MER......... DE.........

aux

ABAS LEP*ominir* A*liminé* SS*korsuau*
otalo EIS*oramir* ME *nigmo*

ce moteur à toutes tendances impressionnisme fauvisme cubisme expressionnisme pathétisme dramatisme orphisme paroxysme **DYNAMISME PLASTIQUE MOTS EN LIBERTÉ INVENTION DE MOTS**

DESTRUCTION

Suppression de la douleur poétique
des exotismes snobs
de la copie en art
des syntaxes *déjà condamnées par l'usage dans toutes les langues*
de l'adjectif
de la ponctuation
de l'harmonie typographique
des temps et personnes des verbes
de l'orchestre
de la forme théâtrale
du sublime artiste
du vers et de la strophe
des maisons
de la critique et de la satire
de l'intrigue dans les récits
de l'ennui

Pas de regrets

SUPPRESSION DE L'HISTOIRE

INFINITIF

Critiques
Pédagogues
Professeurs
Musées
Quattrocentistes
Septcentistes *etc*
Ruines
Patines
Historiens
Venise Versailles Pompei Bruges Oxford Nuremberg Tolède Benarès etc
Défenseurs de paysages
Philologues

Essayistes
Néo et post
Bayreuth Florence Montmartre et Munich
Lexiques
Bergsonismes
Orientalismes
Dandysmes
Spiritualistes ou réalistes (sans sentiment de la réalité et de l'esprit)
Académismes

Les frères siamois
D'Annunzio et Rostand
Dante Shakespeare Tolstoï Goethe
Dilettantismes merdoyants
Eschyle et théâtre d'Orange
Inde Égypte Fiesole et la théosophie
Scientisme
Montaigne Wagner (Beethoven Edgard Poe Walt Whitman et Baudelaire)

ROSE

aux

Marinetti Picasso Boccioni Apollinaire Paul Fort Mercereau Max Jacob Carrà Delaunay Henri-Matisse Braque Depaquit Séverine Severini Derain Russolo Archipenko Pratella Balla F. Divoire N. Beauduin T. Varlet Buzzi Palazzeschi Maquaire Papini Soffici Folgore Govoni Montfort R. Fry Cavacchioli D'Alba Altomare Tridon Metzinger Gleizes Jastrebzoff Royère Canudo Salmon Castiaux Laurencin Aurel Agero Léger Valentine de Saint-Point Delmarle Kandinsky Strawinsky Herbin A. Billy G. Sauvebois Picabia Marcel Duchamp B. Cendrars Jouve H. M. Barzun G. Polti Mac Orlan F. Fleuret Jaudon Mandin R. Dalize M. Brésil F. Carco Rubiner Bétuda Manzella-Frontini A. Mazza T. Derème Giannattasio Tavolato De Gonzagues-Friek C. Larronde etc.

GUILLAUME APOLLINAIRE.

PARIS, le 29 Juin 1913, jour du Grand Prix, à 65 mètres au-dessus du Boul. S. Germain

DIRECTION DU MOUVEMENT FUTURISTE
Corso Venezia, 61 - MILAN

Plate 27. Apollinaire, *L'antitradition futuriste*. Paris, 1913

Plate 28. Delaunay, *Homage à Blériot*. Tempera, 1914. 98½ × 98½ in

had tried to pillory the Symbolists, so Georges Duhamel tried to pillory Apollinaire for insincerity and hoaxing (though some years later, after Apollinaire's death, he turned coat and became President of the Guillaume Apollinaire Prize Committee). 'M.Apollinaire', Duhamel wrote in 1913, 'is not lacking in erudition. But he constantly gives the impression of telling everything he knows, and flouts the rules of decorum and taste. Instead of letting himself be led by analogy, he lets himself be seduced by words. He tries after the event to establish arbitrary analogies and this no doubt gives him pleasure.' '*After* the event'—this charge of doodling first and judging the outcome afterwards, though intended to be pejorative, was very acute and came pretty near the mark; but it failed to hit it squarely, as Apollinaire himself justly protested. 'I have never played jokes or hoaxed', he wrote, 'as regards my own work or that of others.' For Apollinaire, a good French man of letters, remained to the end a traditionalist: in all his mercurial imaginative devices to spark 'la vie moderne' into lively and contemporary actuality his ideal was always the controlled order of classic art. He wanted to achieve, as he said, 'a new poetic realism that would not be inferior to the realism— so poetic and learned—of ancient Greece'.

At the same time Apollinaire pioneered many of the technical devices that made fully developed camel–whale art possible. In his salacious, riotous, absurd fantasy *Les Mamelles de Tirésias* of 1917—the lyric step-child of Jarry's *Ubu roi*—he exploited the device of what one might call spectator-participation in the work of art. He launched Tiresias' monstrous balloon-breasts into the auditorium. His *L'Antitradition futuriste* of 1913 (plate 27) was a flagrantly anti-art manifesto, awarding roses—the bridal flowers of Rose Sélavy—to all the vanguard of what he called 'l'esprit nouveau', to Marinetti, Picasso, Stravinsky, Duchamp, Roger Fry, and a score of others; while at the top of the sheet—in tuneful homage to the revered shade of Jarry, who died in 1907—he hurled the *mot de Cambronne* at all professors, quattrocentists, academicians, antiquaries, Aeschylus, Shakespeare, Walt Whitman, and *hoc genus omne*. *Passéisme* was for the jakes. In his punctuationless verse and disjunct syntax he developed something analogous to the broken shapes of Cubist painting which, by means of active jumps from form to form, the spectator himself could apprehend as a coherent whole. His *Ideograms*, seventeenth century in inspiration, adumbrate the crazy typography of Dada. And like his friend Delaunay in his *Homage à Blériot* of 1914 (plate 28), Apollinaire positively relished mechanistic and conventionally

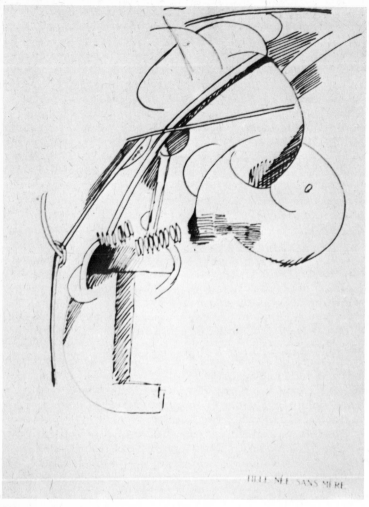

Plate 29. Picabia, *Fille née sans mère*. Stieglitz's '291', New York, 1915.
12½ × 18½ in.

unaesthetic subject-matter. 'The air', he wrote in his *L'Esprit
nouveau et les poètes* of 1917, his last confession of artistic faith, 'is
peopled with birds strangely human. Machines, daughters of men
with no mother [and here he recalled Picabia's 1915 New York
drawing for Stieglitz (plate 29)], live a life from which passions
and sentiments are absent.' And he went on to say that the new

poets would one day 'machiner la poésie comme on a machiné le monde'.

The final stage of the voyage of camel–whale art into the modern world, when it shed all its symbolist and neo-symbolist ethos, was through the perilous seas of chance. It now (to change the metaphor) took its hands right off the handle-bars—a thing the circumspect Apollinaire never did—and rode blindfold hell-for-leather, not knowing its destination until after the crash. Then it took the bandage off and looked round to see what a lovely ditch it had landed itself in.

This brings us to Dada proper, which was mostly destructive and self-destructive. While the guns of 1914–18 were smashing up people, the Dadaists of Zurich, Berlin, Cologne, New York, and elsewhere were throwing every spanner they could find into the works of respectable—including Cubist—art. But the noisy racket of the Café Voltaire in Zurich, presided over by the gentle Hugo Ball, was at the same time the catalytic milieu in which Hans Arp began to construct what he called 'essential pictures' according to the laws of chance. He made automatic drawings, cutting out bits of paper into simple shapes, shuffling them, dropping them at random, and then fixing them as they fell into collages (plate 30); and later on he made reliefs in the same way (plate 31). Arp was never reckless or violent. He turned his back on illusionism, but he loved Nature. He let Nature, as it were, work through him, though his selective judgement, at least after the event, must also have been operative (how many unsatisfactory results, we wonder, did he discard?) to produce such elegant and sometimes *art nouveau* forms. He is akin to Paul Klee, who likened the artist to the trunk of a tree through which the sap rises to put out sprouting leaves. 'Standing at his appointed place', wrote Klee, 'the artist does nothing other than gather and pass on what comes to him from the depths. He neither serves nor rules—he transmits.' Such were Arp's and Klee's devotion to Nature that they willingly surrendered themselves to her chance gifts in order to be like her. As Aristotle had prescribed in his *Poetics*, at least according to one reading of his text, they imitated not Nature's products but her processes.

Secondly, all through his later life, Arp devised biomorphic forms of a kind very simply exemplified (he often made others susceptible to more numerous and subtle concurrent interpretations on the part of the spectator) in his *Femme Amphore* of 1962 (plate 32). This is camel–whale art in its purest form. The simplified

Plate 30. Arp, *Collage. Coloured papers*, c. 1917. $12\frac{3}{4} \times 10\frac{1}{2}$ in.

Plate 31. Arp, *Objects placed according to the Laws of chance* Wood and plaster, 1931

Plate 32. Arp, *Femme Amphore*.
Marble, 1962. 41¾ × 6¾ × 9½ in.

Plate 33. Brancusi, *Bird*. Marble,
1912. 24½ in high.

shape of a girl and the simplified shape of a vase are perfectly
melted together into a single form which Arp gently invites the
spectator to interpret either as a woman, or as an amphora, or
concurrently as both. (Here again, as with his automatic drawings
and cut-outs, Arp could not escape his own culture, and his
piece reflects, one suspects, the taste for Cycladic idols and pots
aroused by Zervos's beautiful book of 1957—a book which itself
chimes perfectly, incidentally, with the ceramics of Picasso.)
Arp's *Femme Amphore*, in its abstract form, has an obvious affinity
with the work of Arp's friend Brancusi; but it is fundamentally
different. A sculpture like Brancusi's *Bird* of 1912 (plate 33) is

not camel–whale art: it is a pure abstraction of a bird's shape of which only one reading is possible or permissible. Nor—to make another distinction—is it to be confused with a thing like Picasso's *Bull's Head* of 1943 (plate 34). Here there is no ambiguous or ambivalent melting together of two imagined forms which the spectator is free to interpret at will. It is the outcome of Picasso's sudden recognition that two pieces of junk, fastened together, make a bull's head. The spectator has no choice before him except to take one alternative or the other. He can either see the thing as two bits of a bike which, if he likes, he can take apart and, by adding more bits, recompose as a purely utilitarian

Plate 34. Picasso, *The Bull*. Assemblage, 1943. $16\frac{1}{2} \times 16 \times 6$ in.

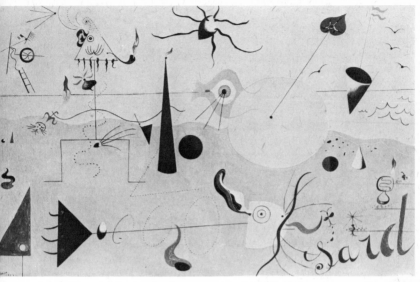

Plate 35. Miró, *Catalan Landscape (the Hunter)*. Oil, 1923–4. $25\frac{1}{2} \times 39\frac{1}{2}$ in.

machine and ride away on. Or, switching to Picasso's point of view, he can see it at once as a pure work of representational art — a beautiful bull's head as classically formed and as unridable as a bucranion on a Roman temple-front. Picasso himself called it a 'visual metaphor'.

Now we come back to Surrealism, which is an obvious high point in the story I have been trying to trace. Surrealism was defined *a priori* by André Breton in 1924, before there were many canonical works of art in existence to exemplify his doctrine, as 'pure psychic automatism, by which one intends to express verbally, in writing or by any other method, the real functioning of the mind. Dictation by thought, in the absence of any control exercised by reason, and beyond any aesthetic or moral preoccupation'. Looking back on the extraordinarily various products of the movement over the following forty years or so, while Breton was its imperious *vates* and exegete, I am sceptical about the purity of the 'automatism' that in one way or another underlies them all. Of the subconscious, by definition, we are unconscious; and the laborious execution of a finished painting or sculpture, however surprising and disparate its imagery, is a very different thing from the

spontaneous free associations of a dream or the analyst's couch. Nevertheless, in every manifestation of Surrealism, there is always the character, so to say, of a one-man 'exquisite corpse' which is then consciously tidied up after the paper is unfolded: this is true of the dreamy poetic biomorphs of Miró, the dead-pan night-mares of Magritte, the soft evocative arabesques of Masson, or the elaborately contrived, sharply focused, and highly cerebral biomorphic 'materialized images of concrete irrationality' of Dali. Miró himself, for example, reported in the early twenties that he habitually started his pictures in a state of hallucination which presented him with images for which he was entirely irresponsible, the next stage in his picture-making, however, being one of calculation. His famous calligraphic *Catalan Landscape* —*the Hunter* of 1923–4 (plate 35) is just such a contrived 'exquisite corpse' as I have described.

Here I must leave Surrealism, except for two further points. The first point is that the initial hallucinatory moment in the Surrealists' image-making was not radically new, though Dada, Freudian psychology, anti-art aesthetics, etc., suggested more up-to-date and sophisticated procedures for achieving or simulating it than their predecessors had enjoyed. At bottom it was in the good Symbolist tradition of the *dérangement des sens*, which takes us back to Rimbaud and beyond. Secondly, the essential camel– whale thing about Surrealist art, in all its various forms, is its open-endedness both for the artist himself and his spectators. It confronted them with surprises (Man Ray once declared that, while he scorned the idea that he was ever out to shock others, he loved to shock himself) which revealed to the artist the un-expected contents of his own mind and challenged him to explore them further, and at the same time compelled the spectator to explore the recesses of *his* mind, no less than the imagery of the work before him, in order to discover its potentialities of meaning. 'I liked Surrealism', wrote Miró to Yvon Taillandier some years after he painted his *Catalan Landscape*, 'because it didn't consider painting as an end. In painting, in fact, we shouldn't care whether it remains as it is, but rather whether it sets germs for growth, whether it sows seeds from which other things will spring.' It was, incidentally, in clean rejection of this creative procedure that Picasso pronounced his celebrated dictum: 'I do not seek; I find.'

Let me close this part of my talk with one of the grandest Surrealist pieces ever made—Miró's sculpture *Oiseau lunaire* of 1966 (plate 36)—the companion of an equally evocative piece,

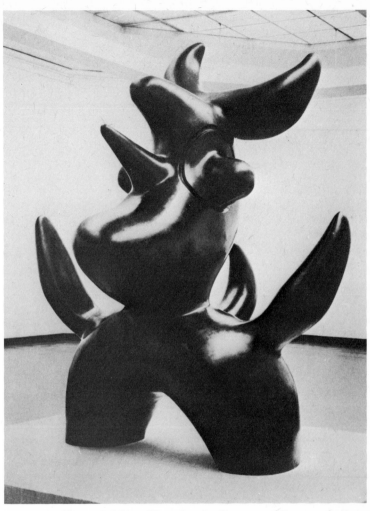

Plate 36. Miró, *Oiseau Lunaire*. Bronze, 1966. 90 × 90 × 63 in.

Oiseau solaire. The outcome of more than twenty years of medita-
tion, it is over seven feet high. It is semi-natural and semi-abstract
in the way of all true camel–whale art: a metamorphic biomorph.
You can interpret the crescent on its head as a sort of cock's
comb; the knobs either side as eyes; the mouth and tongue
(Picasso comes in here) as those of a crowning cock, the thing

behind as a perky tail, the things either side as flapping wings, the half doughnut-ring base as a crowing cock's sturdy legs. Or you can read the crescent on top as a moon, and think of Selene, and hence interpret the tongue-like thing and the orifice from which it protrudes as cystic, the eye-like things as woman's breasts, the wings as arms, the doughnut things as opened legs. I do not know what you do with the thing behind. These interpretations are by no means, *ex hypothesi*, exhaustive, but they are justified by the imagery of the work and the cultural context shared by artist and spectator alike—a necessary condition of valid camel–whale interpretation if one is not to indulge in mere idle and irrelevant fancy. Both the interpretations, moreover, which *Oiseau lunaire* suggests to my mind, as one observer, come well within the orbit of Miró's mentality and chime with the frequent sexual connotations of much of his work, especially in his middle and later periods; and they look back to his *Woman and Birds in front of the Sun* of 1942 in Chicago and his *Woman and Bird under the Moon* of 1944 in Baltimore.

'Two very distinct attitudes', wrote Ozenfant in the early hey-day of Surrealism, 'have so far shared the universe of art between them: the trend towards objectivity and the trend towards symbolism', the former imposing 'its imperious edicts upon us' and 'moulding us to its shape', while the latter is 'ready to take on ours'. Camel–whale art, originating (as I have tried to show) in Symbolism and reaching a high point in the various modes of Surrealism, was a liberating movement: 'a web of art (as Ozenfant went on to phrase it) governed by ourselves, instead of governing us. It made the spectator, in particular, free to enjoy a wider range of appreciation and interpretation than any spectators of works of art had ever previously enjoyed. My chief purpose has been to indicate some of the earlier stages in this liberating move-ment and not to deal with Surrealism in any detail; but before I come to my last topic—the role, or rather the non-role, of the spectator confronted with Marcel Duchamp's second *magnum opus*—I should like briefly to address a further and necessary question. Did the camel-whale movement end with Surrealism, or has it had a *fortuna* in the art of the last three decades or so?

In the thirties, with the ferment of Surrealism all around then, many people felt that it would carry all before it. But that is not what has happened: the main trend of post-war art everywhere has been a return to the objective—to the work of art as an autonomous *Ding an sich*. On the face of it, Abstract Expressionism

ought to have been a camel-whale kind of art. The early Rothko, for example, came out of Surrealism, and the early Guston owed a good deal to de Chirico. Some of de Kooning's semi-figurative, semi-abstract canvases of the forties, suffused with Dutch *art nouveau* sentiment, might be supposed to have camel–whale potentialities too, as de Stael's abstractionist landscapes certainly do. The early Pollock had clear affinities with Gorky, whose forms have unquestionable roots in Surrealism. But in truth the Abstract Expressionists were none of them camel-whale men, despite the often highly suggestive and emotive quality of their paintings and the fact that they would sometimes declare the liberty of the spectator to find in them what meaning he liked. They probably did not care a hoot what the spectator thought. For their works were the outcome of very private solipist en-counters—sometimes contemplative, sometimes in-fighting—with the canvas. 'When I want to see how my picture is going', Guston once declared, 'I don't stand back: I go in.' They were, after all, not so much painting pictures as making objects. The temptation to find Leonardesque images in the clouds, allusive romantic sublimities, or figurative analogies in the work, say, of Clyfford Still (plate 37) or Jackson Pollock (plate 38) is a delusive lure. When the mature Pollock dripped paint from the can on to his floored canvas, and tensed himself to 'keep contact' with it, he was anxious to keep the structure of the thing taut, not to exploit (although they occasionally crept in) any phenomenological or visually ambiguous accidents. At the same time, however, the spectator was not left impotently outside. He had to act too. For, as Harold Rosenberg put it, when the artist becomes an actor, the spectator has to 'think in a vocabulary of action: its inception, duration, direction—psychic state, concentration and relaxation of the will, passivity, alert waiting': to 'become a connoisseur of the gradations among the automatic, the spontaneous, the evoked'. These *notanda*, as we have seen, have their 'camel–whale' ante-cedents.

And what of the sixties? Could the artist, in this decade (an era of 'happenings'), ever assert, as Paul Valéry (according to Picasso) is reported to have said: 'I write half the poem; the reader writes the other half'? In the sixties we still have on the one hand, as one headland, an epoch of naturalism—of Pop, for example, like Lichtenstein's: Lichtenstein who gives us observed nature idealized by artistry as Raphael or Poussin did, except that now the world of sight is no longer the vanished pastoral countryside, but the present environment of Main Street and the comic

Plate 37. Still,
1955-G. Oil
92 × 79 in.

Plate 38. Pollock,
White light. Oil and
enamel, 1954.
$48\frac{1}{2}$ × 38 in.

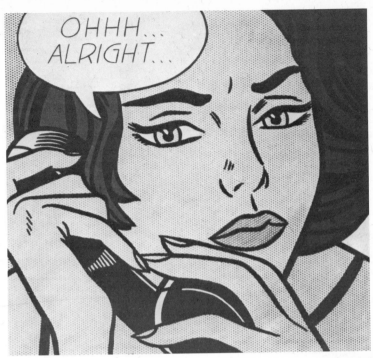

Plate 39. Lichtenstein, *Ohhh Alright*. Oil, 1964. 38 × 38 in.

Plate 40. Judd, *Untitled*, Iron and aluminium, 1966. 40 × 190 × 40 in.

strip (plate 39). And on the other hand, at the other limiting extreme, it was a decade, pre-eminently, of the abstract and the non-figurative, occasionally soft, but mostly hard-edged and minimal (plate 40). Was there sea-room, in the sixties, for ambiguous, subjective, symbolistic camel-whale imagery, inviting

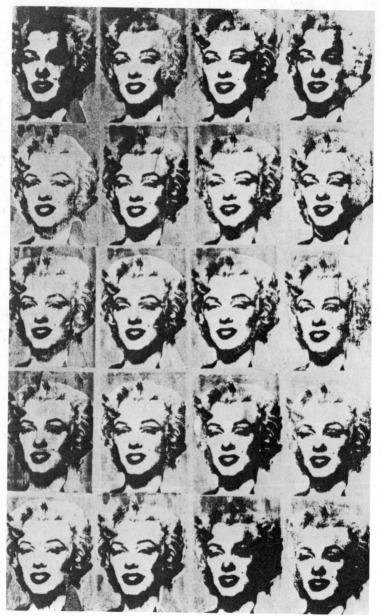

Plate 41. Warhol, *Marylin Monroe*. Silk screen on canvas, 1962.
$81\frac{3}{4} \times 66\frac{3}{4}$ in.

camel-whale interpretations, to sail in between the two headlands?
Such a question might well be prompted, for example, by the
participatory art—all things, apparently, to all men—of Andy
Warhol (plate 41); by the evocative—patriotic? satirical?—
American maps of Jasper Johns (plate 42); or by some, at least,

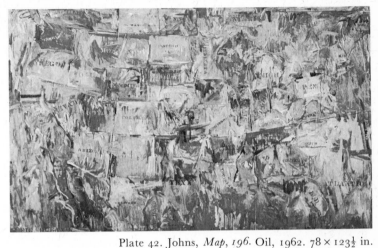

Plate 42. Johns, *Map, 196*. Oil, 1962. 78 × 123½ in.

Plate 43. Oldenburg, *Soft Typewriter*. Vinyl, plastic and kapok, 1963

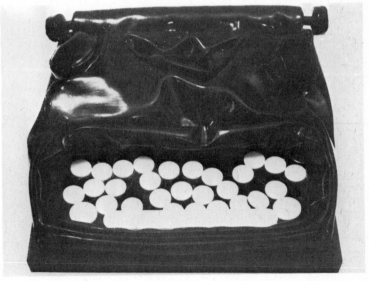

73

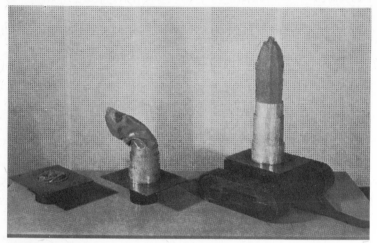

Plate 44. Oldenburg, model for Yale *Lipstick monument*, 1969. Painted cardboard and canvas, tractor. $5\frac{1}{2} \times 25 \times 16\frac{1}{4}$ in.

Plate 45. Oldenburg, *Lipstick monument* at Yale University, 1969. Painted steel and wood, $24 \times 21 \times 17$ ft.

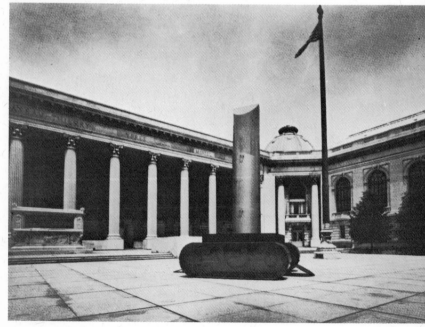

of the genial inventions of Claes Oldenburg—his soft typewriters, for example (plate 43), or the progressively tumescent *maquettes* for his 1969 Yale *Lipstick Monument* (plates 44, 45), whose obviously biomorphic implications were emphasized by the artist himself when in 1966 he had himself photographed in Piccadilly Circus in London holding up a lipstick—so that one masked the other— in front of the statue of Eros.

Plate 46. Morris, *Limp Felts*. 1968

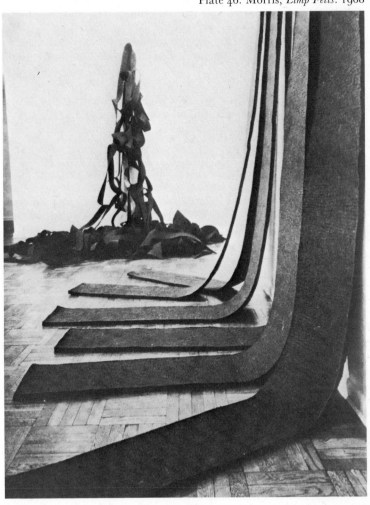

But once again, as with Abstract Expressionism, the answer, if not a flat 'no', must be strictly qualified. The new and memorable art of the sixties—leaving aside all the humourless triflings of the minor people with neo-Dada, neo-Surrealism, and simian Duchampesque conceptualism—was an art of the objective: of the making of autonomous objects. The very softness of Oldenburg's typewriters impresses on us all the more the hardness of the thing itself; and there is a world of difference between the chance-falls of Arp's automatic paper cut-outs and the chance-folds—however you let them fall—of, say, Robert Morris's draped felts (plate 46). Morris's felt affords the spectator no scope at all for personal and imaginative interpretations. Throughout all the experience of contemplating it, the thing always remains exactly what it is—a piece of felt such as you can buy by the yard in any draper's shop.

Nevertheless, for all the inviolate objective integrity of the best artifacts of the sixties, there is a sense in which Paul Valéry's dictum can properly be applied to them, though the sense is not his symbolist one. Take a canvas by a man who may well turn out to have been the profoundest Old Master of modern American art, a man who, like Braque in France, after early glories, rose to supreme height in his maturest years—Barnett Newman (plate 47). Materially, structurally, and iconographically this work is drained of all extraneous references, representative, allusive, or symbolic. There is nothing in it—not even its title *Stations of the Cross, No. 5*—that authorizes the spectator to 'mould it to his shape': it always remains, in Bishop Butler's phrase, 'what it is, and not another thing'. And however publicly it is displayed, and whoever else happens to be looking at it at the same time, the spectator and the canvas—one sundered from the other— are utterly alone together, face to face. Then the spectator under- goes his test. If he is light-minded and shallow-hearted, he may miss and dismiss it (if such a depth of inhumanity is possible) as a public bill-board or a piece of furniture like a chair or table in the room. Or, more modestly, savouring the care and painterly beauty of its craftsmanship, he can simply stand in front of the canvas and regard it for a long time in passive contemplation. In this case he will fare better, because he will be enjoying the analysable perfection of its formal qualities—its drawing, its colour, its tonality and textures, its clear and balanced triadic composition, its resonantly harmonious proportions—its con- formity with all the canons of classic art that have stood the test of time. But that is still not enough. For what he ultimately has to

Plate 47. Newman, *Stations of the Cross, No. 5*. Oil on raw canvas.
78 × 60 in.

do, without reading himself into the painting or expecting the painting to convey some verbally translatable message to him, is again and again, more and more attentively, to make a *tour d'horizon* of his own humanity as he looks at the canvas—often for weeks and weeks afterwards while it vibrates in his memory— until suddenly he finds himself 'tuned in' (as it were) to the wavelength of Barnett Newman's humanity, when the work will begin

to change and go on enriching his life: a life-enhancing experience that will be different for every spectator, because no two men are made alike. It is this privacy and necessary uniqueness of response on the part of each individual spectator that sets the work of Newman apart from the more publicly appealing life-enhancing classic art of the past; and sets it—with a difference—in our camel-whale tradition.

Finally, I come to Duchamp. For fifty-five years or so, till his death five years ago, Marchel Duchamp's known career was a false legend, which he himself (in his Dada, all-accepting way—the only way to preserve his own absolute freedom) did nothing vocally to dispel. From the early days of this century his central theme was the female nude—a perverse perpetuation of the French academic *beaux-arts* tradition in face of his Cubist and Orphist contemporaries. His multiple portrait of *Dulcinea* of 1911 was a melting succession of diaphanous images on a single canvas (an independent analogue of the way the Futurists depicted 'states of mind') of a lady becoming at each stage, from right to left, more naked, until she wears nothing but her hat (plate 48). In 1912 he painted his *Nude Descending a Staircase* (plate 49) in dissolving stroboscopic motion, with a clicking of plates and a whirr of revolving cog-wheels; and in the same year he painted *The Passage of the Virgin to the Bride* and the *Bride* herself—obscene (at that time) contraptions of metal vessels, conduits, and pipes executed with a most delicate and sensuous feeling for painterly *matière*. Then he turned to ready-mades, untouched (except sometimes for a signature) or assisted, and a number of studies—documents of his preoccupation with 'art about art' and 'art about reality'—which led to his Large Glass, *The Bride stripped bare by her bachelors, even*, which occupied him from 1915 to 1923 and remained unfinished (plate 50).

This love-machine—totally transparent and neither painting, sculpture, nor architecture (henceforward Duchamp almost renounced orthodox painting)—shows the bride above, with her weak pistons, failing to receive an adequate charge of love-gas, while the malic moulds of the nine bachelors below ('malic' punning on 'male' and 'phallic') fail to strip the bride completely bare. This, as the legend went, was Duchamp's last major work. After that he made a few more optical demonstrations with Rotoreliefs, and he occasionally produced apparently disconnected and arbitrary objects which told the world little of the way his mind was going while he spent so much of his time, when

he was not obligingly receiving eager interviewers who went away delighted with the precise dusty answers he gave to their questions, playing chess or meditating with his pipe in his bare studio on 14th Street in New York: no more a practising artist, but (as he described himself) a 'respirateur'.

But now the truth has come out; and all the hitherto apparently *disjecta membra* of Duchamp's very considerable later output have

Plate 48. Duchamp, *Portrait (Dulcinea)*. Oil, 1911. $57\frac{1}{2} \times 45$ in.

Plate 49. Duchamp, *Nude descending a staircase*. Oil, 1912. $57\frac{1}{2} \times 35$ in.

Plate 50. Duchamp, *The Bride stripped bare by her bachelors, even*. Mixed media, 1915–23. $109\frac{1}{4} \times 69\frac{1}{4} \times 70$ in.

Plate 51. Duchamp, *Étant donnés*; *Door*, wood and brick, 1946–66. 95 in. high

Plate 52. Duchamp, maquette for *Étant donnés* Mixed media, $9\frac{3}{4} \times 12\frac{1}{4}$ in.

come together to attest to an extraordinarily single-minded, consistent, and original artistic and intellectual career. For in 1969 the Cassandra Foundation presented Duchamp's second major work—which occupied him from 1946 to 1966 and was the complement in his mind of the *Large Glass* from the start—to the Philadelphia Museum of Art, so that it could stand displayed, as Duchamp always intended, alongside the bulk of his other work in the Arensberg Collection.

You leave the Gallery where the *Large Glass* stands in front of a window, with a fountain playing outside, and you go into a dark adjoining chamber, at the end of which is an old battered wooden door, personally selected by Duchamp in Spain, which is walled in with a weathered red-brick surround (plate 51). Two-thirds of the way up the door is a pair of holes to which you apply your eyes. What you see through them must never, by Duchamp's express desire, be photographed: you must either see it for yourself or never see it at all. But one is permitted to describe the sight. You see a brick wall, quite near, with a broken Pyramus–Thisbe opening in it. Beyond the opening you see a brightly lit

Plate 53.
Duchamp, *The
Bec Auer*. Etching,
1968. 16½ × 9¼ in.

landscape; and in the foreground, lying on a bed of twigs, is a
naked woman, realistically and sleazily made of pig-skin, with
her legs wide open. Two of the *maquettes* for her survive (plate 52).
Lie her on her back, with her open legs towards you, and you
have her pose in the peep-show. Her head is turned to the left
and her face is obscured by the jagged edge of the breached brick
wall. However hard you try, you cannot see her face; but her
yellow hair is swathed over the twigs. Nor can you see her right
arm, though you can see her left arm; and this holds aloft a
smouldering well-lit gas-burner. Take away the figure of the
young man with his arms behind his head in a hitherto enigmatic
etching of 1968 (plate 53), and you have the position of the Lady
with the Lamp. In the foreground, with a piece of shimmering
water between it and the woman, is a wooded landscape, for
which Duchamp's realistic drawing of *Moonlight on the Bay at
Basswood*, made in 1953, was no doubt the preliminary study
(plate 54)—a study that harks back to one of Duchamp's assisted
ready-mades, *La Pharmacie*, of 1914 (plate 55). The sky in the
peep-show, with its puffy clouds, is blue; and to the right in the

Plate 54. Duchamp,
*Moonlight on the Bay
at Basswood*. Drawing
in mixed media, 1953.
10 × 7¼ in.

background, discharging itself into the pond, is a little mechanical
waterfall, worked by electricity, which flows and flows with an
illuminated glitter—the only moving thing in the otherwise
deadly still landscape.

The title of this assemblage (it is signed and dated 1946–66) is:
Etant donnés: 1ᵉ la chute d'eau, 2ᵉ le gaz d'éclairage—('given: 1, the
waterfall; 2, the illuminating gas'). There is no manual to go with
Etant donnés . . ., as there was in the haphazard contents of the
Green Box that went with the *Large Glass*. All that went with it
when its parts came to Philadelphia was a do-it-yourself kit telling
the Museum authorities how to assemble it. But its primary
meaning is clear: the Bride is now at last well and truly impreg-
nated with gas and water laid on all floors—witness another
previously enigmatic device of Duchamp's of 1958 (plate 56).

I do not propose here to attempt any elaborate exegesis of the
work or to try to trace through its many cross-references to

84

Duchamp's other works: that has already been admirably begun by Anne d'Harnoncourt and Walter Hopps in a *Philadelphia Museum Bulletin* of 1969. They clearly show how the *Large Glass* and *Etant donnés* . . . were planned together from the beginning as counterparts one of the other, the latter being, as it were, the

Plate 55. Duchamp, *La Pharmacie*. Assisted ready-made, 1914. $10\frac{3}{4} \times 7\frac{1}{2}$ in.

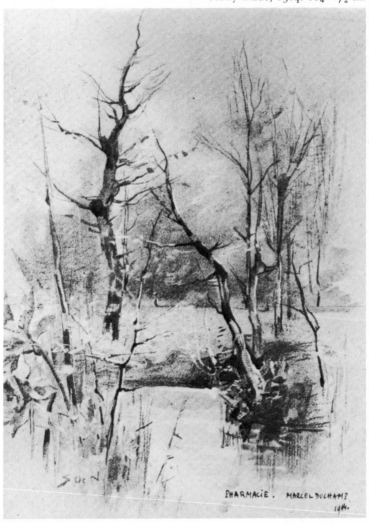

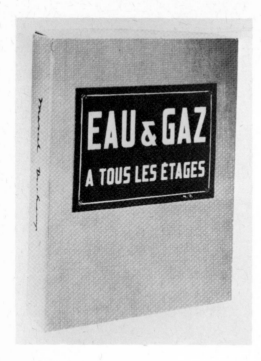

naturalistic matrix or mould of which the former was the mechanical and mental analogue. Thus, for example, the very title of *Etant donnés* . . . appears in full in one of the fragments in the Green Box—a fragment that was formerly thought to refer, however obscurely, to the *Large Glass*; and the waterfall—to take another cross-reference—is absent from the *Large Glass*, only to be imagined as part of the driving mechanism, but it appears at last in *Etant donnés* . . ., as it was conceived from the beginning.

What I want to end with, rather, is a consideration of the function—or better, perhaps, the plight—of the spectator confronted with this astonishing work. Judging from some of his writings Duchamp would appear to accord the spectator a very active function in the contemplation of his works. In a statement of 1959 he asserted that the spectator is a medium, unconscious on the aesthetic plane of what he is doing when he creates a work of art and ignorant of why he is doing it. 'All in all', he concluded, 'the creative act is not performed by the artist alone: the spectator brings the work in contact with the external world by decyphering and interpreting its inner qualifications, and thus

adds his contribution to the creative act.' On another occasion Duchamp described the spectator's encounter with a work of art as the 'spark' that 'gives birth to something, like electricity'; and on another he asserted that 'a work of art is dependent on the explosion made by the onlooker'. This sounds—especially when we remember Duchamp's early Dada affiliations—as if he was enunciating camel–whale doctrine. But in fact, like Hamlet with Polonius, he himself habitually taunts the luckless spectator of his work—not least in *Etant donnés* . . . The spectator with his eyes glued—like a devotee at an unholy confessional-box—to the holes in the door of *Etant donnés* . . . (unlike the spectator of the *Large Glass* who can see through it and, baffled in mind if not in sight, walk all around it at will) is given no freedom at all either to see more than Duchamp wants him to see, or to interpret what he sees in any terms but Duchamp's own impenetrably enigmatic

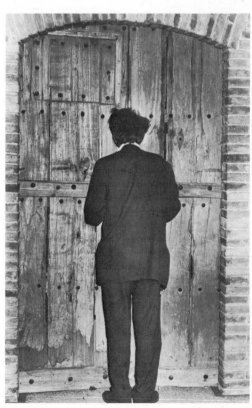

Plate 57. Duchamp,
Étant donnés: male
spectator, 1970

87

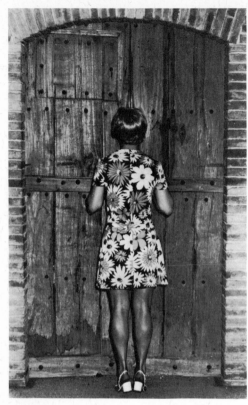

Plate 58. Duchamp, *Étant donnés*: female spectator

ones. That is to say, he cannot interpret at all: he can only look. His fate, like that of the poor baffled bachelors outside the door, is to be a *voyeur*. Plate 57 shows one such spectator—myself; and plate 58 another—a Bryn Mawr colleague of mine, born in Sydney ... *le voyeur anglais*, and *la voyeuse australienne*.

* ACKNOWLEDGEMENTS: I am deeply grateful to the University of Sydney, and to the Power Institute of Fine Arts and its Director Professor Bernard Smith, for inviting me to deliver this lecture, which is printed, with a few changes and alterations, more or less as it was spoken. I also owe warm thanks for generous information and criticism to a number of friends and colleagues, particularly Bernard Smith, Donald Brook, Daniel Thomas, the late Charles Brasch, David Sylvester, Marianne Martin, Howard Kee, Fritz Janschka, and Virginia Spate, none of whom, however, must be held a whit responsible for anything I have written, because I have sometimes obstinately stuck to views with which some of them by no means agree.

The lecture was first delivered at the University of Sydney on Friday 14 July 1970 and is here published for the first time.

IV. Some contemporary realisms

PATRICK HUTCHINGS

WITH REGARD to realisms, though I have chosen to talk about them, like the Bear in Thurber,[1] I can take them, or let them alone. That I have chosen to talk to you about realisms, indicates no wish to denigrate abstract idioms. Modern painters have chosen largely to leave realisms alone and this is an important fact about modern art, which one would not want to underrate. Nevertheless, I have chosen—quixotically it may seem in 1971— to talk about realisms. When smoke bombs have become 'smoke sculpture', it may seem altogether too late to talk about mimetic images in the Renaissance manner—but, notwithstanding, realism is the chosen topic.[2]

Why?

1.

Art imitates nature.
 ARISTOTLE.[3]

(1) For a very long time, art worked within a matrix of realism, that is within a matrix of the imitation of appearances. Relatively lately, it has given up this matrix. There is a long history behind realism. And perhaps something more than a history, too.

Notice that all that has been said is that 'art worked within a matrix of realism' not that art *was* 'the imitation of nature'. The Greek definition of art or 'fine art' simply as 'imitation' was over-determined. Having no word for 'art' in our sense, i.e. no word for fine art, the Greeks had to find the *specific difference* between arts like those of saddle-making, sandal-making, and flute-making and arts like statue-making. The specific difference of the fine arts, i.e. their being *mimetic or imitative*, became, formally at least, identified as the essence of art.[4] And what was a definition simply by genus and species became a full-dress essential definition, a putative 'real definition'.

'Art is the imitation of nature' never was really a satisfactory essential definition of art. And at the best, definitions are only definitions: they do not necessarily bind us, they do not necessarily fit the world, and they have to be shown to fit before we feel at all obliged to take them up. Aristotle, in a short and in some ways unhappy passage in the *Poetics*, Chapter IV, tries to make the definition of art as imitation stick, by appealing to facts, that is by showing that it is appropriate to the shape of the way things are. He writes:

It is clear that the general origin of poetry was due to two causes, each of them part of human nature. Imitation is natural to man from childhood, one of his advantages over the lower animals being this, that he is the most imitative creature in the world, and learns at first by imitation. And it is also natural for all to delight in works of imitation. The truth of this second point is shown by experience: though the objects themselves may be painful to see, we delight to view *the most realistic representations* of them in art. . . . The explanation is to be found in a further fact: to be learning something is the greatest of pleasures not only to the philosopher but also to the rest of mankind, however small their capacity for it; the reason of the delight in seeing the picture is that one is at the same time learning—gathering the meaning of things, e.g. that the man there is so-and-so; for if one has not seen the thing before, one's pleasure will not be in the picture as an imitation of it, but will be due to the execution or colouring or some similar cause.[5]

Now this is, probably, an over-developed definition of art, as *mimesis*, as 'the most realistic representations'. And Aristotle's notions of 'learning' here, and 'gathering the meanings' are so feeble that one supposes that the student who took down the *Poetics* on his tablets dozed a bit at this point in the lecture. Nevertheless, Aristotle's appeal to the facts carries a great deal of weight: we may find it, intuitively, attractive. And we may even find experimental evidence to back it up.

(2) In the *UNESCO Courier* for March 1971 there is a long piece called 'The General Public Judges Modern Art': this article gives an account of some popularity polls conducted by the Toronto Art Gallery—people were given groups of ten reproductions of paintings, and were asked to arrange them in order of preference. The groups of ten were all made up of paintings done between 1900 and 1960, though there was in each set one 'control' painting, one picture painted before 1900:

Works of art in the inquiry were nearly all by artists working between

1900 and 1960. In most sets there was at least one 'control' painting from an earlier period. *With few exceptions the control painting proved the most liked.* Millet's *The Angelus* [1859] was voted top favourite among the 220 paintings covered by the inquiry.[6]

Whatever else it may be, Millet's *Angelus* is 'realistic' in a sense acceptable to Aristotle.

What struck the museum directors and art experts who participated in the Toronto experiment, was the fifty-year or two-generation gap which it revealed between what the artists do and what the public likes. What would strike Aristotle, were he to be allowed a day off from the Elysian Fields to participate in a seminar on the Toronto experiment, is that public response bears out his definition of 'art' as *mimesis*, and of *mimesis* as 'realistic representation'. Or, bears it out to some degree, if not absolutely.

The Toronto poll was conducted with a number of sets of ten paintings; some of these sets are reproduced in the *UNESCO Courier*. Two of the controls which came out at the top of their sets, as reported on in the *Courier*, were Vermeer *The Artist in his Studio* and Cézanne *The Boy with the Red Waistcoat*. In one maverick set, the control came only seventh, though it was a Chardin, and the first place went to Carl Hoffer's *Young Woman with a Pitcher*. In one set, Millet's *Angelus*, though it scored highest place over the whole twenty-two sets used, was second to Renoir's *The Box at the Theatre*.

These results have to be interpreted rather carefully; they do not come out as clearly in Aristotle's favour as he would like: Aristotle's material point about our delight in 'the most realistic representations' is supported by the Toronto poll, but it is not unequivocally vindicated by it. Though the Vermeer which came out at the top of its group was the most realistic thing in it, and though '. . . the Toronto investigations concluded that "realism" spatial depth and clear outlines were strongly preferred',[7] the Hoffer which topped the maverick set was less 'realistic' in an ostensibly definable way, than are some of its competitors. The Chardin, Renoir's *Bal à Bougival*, and Degas's *Dancers on a Bench*—not to mention a hyper-realistic Grant Wood, *Woman with Plants*—are all more clearly mimetic than the Hoffer. And the Hoffer is no more 'realistic'—indeed it might be argued that it is less so—than the Paul Cézanne *Card Players*, which rated sixth, only one above the Chardin. Now one is inclined to conclude from this particular range of preferences:

 (i) that it is not the case that the public is of its nature quite as

naïvely prone to value realism as Aristotle's *Poetics* IV would
have us believe;

(ii) that the public has not always terribly good taste, since,
whatever the merits of the Hoffer, the Cézanne is much
much better than it.

What does emerge from the whole range of twenty-two ten-
card tests—and one says this with a sort of tentative confidence—
is that the public (though its taste is sometimes odd), shows a
consistent bias not—as Aristotle's *Poetics* IV would have it—
towards the most absolute kind of realism, but towards realism
as a *matrix*. Preferences within the set of realistic-matrix pictures
are then distributed on account of expression, association, charm,
or some other characteristics of a different sort or sorts from the
simply mimetic. Most instructive on all this is the set of pictures
displayed on p. 29 of the *UNESCO Courier*: the picture liked most
over the whole poll, Millet's *Angelus*, comes, here, only second,
to Renoir's *The Box at the Theatre*. The most realistic picture of
all, Manet's *Le Balcon* comes only fourth, and Grant Wood's
satiric *American Gothic*, hyper-realist as it is, comes only eighth.
Satire, according to the report of the poll, gets pictures disliked,
so this accounts perhaps for the low ratings of the Grant Wood.
But—paradoxically—Manet's *Le Balcon* is trumped by the savage
expressionist fury of Rouault's *The Three Judges*, which rates third,
while the blander and altogether more photographic *Balcon* is
rated fourth.

The over-all moral to be drawn seems to be:

(i) that lack of realism is a disvalue;

(ii) that realism, though it may be, by itself, a value, is more
often the necessary though not sufficient condition of value.
Of a set of paintings all more or less realistic, it is not neces-
sarily the most realistic that will be polled highest.

The public bears out in part, but in part only, what Aristotle says
in *Poetics* IV.

And the public vindicates the formula of art which I suggested
—that of art as being governed by a *matrix of mimesis*, with *mimesis*
as also a value, but not an absolute one. The Toronto demonstra-
tion of two-generation 'gap in taste', which puts the public back in
the days, still, of mimetic painting, may be of fundamental and not
simply of cultural importance. Aristotle may just have been right:
perhaps man *is* an imitation-loving animal: up to a point, at least.

But, those of you who are attending what you had hoped would
be a lecture on Contemporary Art, and not on public taste will be

becoming restive. Who, you may ask, who gives a damn for the public?

2. REALISM(E)S

Realism attempts to state a
point of view about recognizable
reality as we know it, to interpret,
to select, to inform and to show.
 MARIO AMAYA.[8]

In Canada in 1970 I saw an exhibition of *Realism(e)s* at the Royal Ontario Museum, Toronto—the same city as the UNESCO poll was taken in. This exhibition of *Realism(e)s* shows that quite a few Canadian artists care a good deal about the public, or anyhow about its predilection for *mimesis* as a matrix, and as a value. But though they care about realism as a mode and as a value, these artists are not as clear about what realism is, what it comes to, as their nineteenth-century predecessors would have been. Significantly, the exhibition was called, 'Realism, a survey', or more elegantly in French a '*sondage*'.

The *Réalism(e)s* show was at once a reassertion of the value of realism in art, and a *mise en question du réalisme*. The artists were anxious to meet a public's deep predilection for realism, and in several different minds as to what, now, constituted realism. Paintings like Hugh Mackenzie's *The Window*[9] (plate 59), or D. P. Brown's *The Wedding Tray*[10], identified realism with the David–Ingres–Manet tradition; updating it to *Easy Rider* time in Ken Danby's *Pulling Out*[11] (plate 60), but keeping close to its assumptions—assumptions, essentially, of the Florentine Renaissance. Yet other artists thought that only *the thing itself* could be real: Mark Prent of Montreal set up a crumpled, tyre-marked jacket on a piece of snow-covered road, in fibreglass and polyester resin, with real railing-off boards from the Police Department, and called it *Hit and Run*[12] (plate 61). The work was symbolic, but as far as possible the items in it were real and not imitated.

These two extremes, Mackenzie's *The Window* and Prent's piece of road, do not represent, quite, the absolute poles of the exhibition: Mackenzie and Brown were at the Renaissance-Realistic extreme, but at the other, at the extreme of the thing-itself-as-itself (and as-something-else-as-well), was an entry, not on show when I visited the Royal Ontario Museum, an entry by Michael Morris and Glenn Lewis—*a live cow*. Clearly a Gallery director is going to have difficulties with this sort of exhibit, but the animal was in

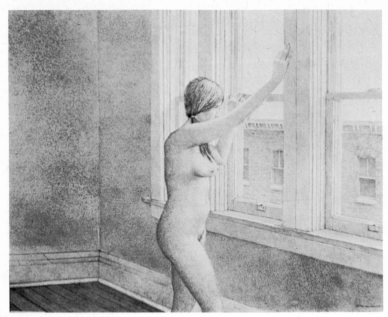

Plate 59. H. Mackenzie, *The Window*. Tempera, 21 × 25 cm.

Plate 60. K. Danby, *Pulling Out*. Egg tempera, 32 × 44 cm.

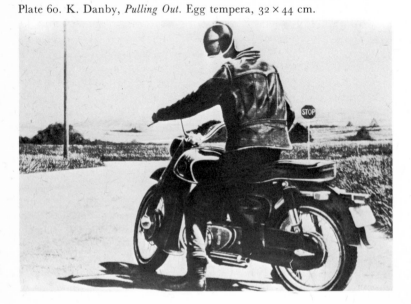

94

Plate 61. M. Prent, *Hit and Run*. Fibreglass and polyester resin, $77\frac{1}{2} \times 36 \times 5$ cm.

theory, anyhow, admissable. The show was one of *Réalism(e)s*, and it was undeniably a real cow. It was 'in' as a real cow; and, as the catalogue remarked, the cow was symbolic, too, as alluding to 'the favourite subject of so much earlier Canadian art'.[13]

The cow would have worried Aristotle; Mackenzie's cool, erotic, and altogether charming nude is clearly an imitation of a girl, but is a cow an imitation of itself?

Art for Aristotle was essentially imitation: and realism was for Aristotle the type or ideal of imitation. He had not thought—as

far as we know—of putting things themselves into art galleries to be themselves there—and perhaps too to stand for or allude to their fellows outside. But then, the Greeks did not go in for galleries. And a cow Du-champing away at its feed in the corner of a fine art exhibition is essentially a modern possibility. The Greeks had Muses, but no museums, and the ploy of isolating an actual everyday object in a museum, thereby changing its status from actuality into art, was not open even to the most revolutionary taste of the fifth and fourth centuries B.C. Had Aristotle, on leave from Elysium, found a cow where these two Canadian artists wanted to put it, he might have taken it for Io, the girlfriend of Zeus, who after she was turned into a heifer by an irate Hera, wandered the earth pursued by a gadfly.

Modern art conventions allow Robin Mackenzie's *Limbwood*,[14] an actual load of stove wood, or Mark Prent's roadblock, more willingly than they allow Hugh Mackenzie's or D. P. Brown's Renaissance realisms. Things being themselves—or very nearly themselves—like the cow Io, are more welcome as art post-DaDa and post Da-Da-Daddy-Duchamp, than are the meticulous pieces of twentieth-century *mimesis* which Aristotle would, undoubtedly, have admired as 'art'. Realism is now, in certain most reputable circles, more acceptable if it is literally literal than if it is mimetically literal.

Well: the account of how this came to be so would be the account of the whole modern movement—or movements—from the 1890s to now: and we cannot go into all this here.

But there is one well-worn commonplace which it is worth dusting off to look at again, especially since two of the items in the *Réalism(e)s* exhibition make it look less a commonplace and more a paradox. When I was young it was a truism of art history that the invention and the perfection of the camera had made the Renaissance mimetic tradition in painting more and more irrelevant; to the degree that photographically made images had become more and more common, exact realism had come, less and less, to matter. It is allowed that in the mid-nineteenth century photography was itself a kind of 'art': and as everyone knows in the 1850s Eugène Delacroix was sufficiently taken with the new medium to help Eugène Durieu pose one of the earliest albums of photographic nudes. But as one historian puts it: 'The truce between the camera and 'art' was an uneasy one, and would not long endure.'[15] There were *détentes* and even *ententes*, as when, later on in the century, the Impressionists were influenced by

photographs of trees and of crowds, caught in moments of agitation. But, the story goes, the camera eventually went its way, leaving art to go *its*, freed at last from the once meaningful but now otiose task of transcribing the outlines and the shadings of visual reality. The simple story puts it simply: art could now, post-1890, go abstract, and do its own new—and somehow truer —thing, because the base mechanical task of *mimesis* had been taken over, appropriately enough, by a machine.

Well the story is so simple that it is difficult not to suppose that it has some truth in it. But the Canadian *Réalism(e)s* exhibition, and one of the foremost Canadian painters in it, can complicate the tale sufficiently to make us look again at it, newly suspicious of such absolute simplicity.

One of the exhibits in the *Réalism(e)s* show was a series of photographs and souvenirs of *Subway Rides* in the Toronto and Montreal *Métros*, by William Vazan (plate 62).[16] A photograph is a realism. And it is a realism on Aristotelian and post-Dada terms, both. So perhaps we should not find such a predictable

Plate 62. W. Vazan, *Subway Rides*. Photographs, subway transfers and map: 2 parts, 34 × 38 cm. each

presence in the *Réalism(e)s* a paradox at all. Nor should we be surprised at exhibit 84 *Sink, Color Photo* by Michael Snow—a photograph, mounted on plastic, and hung among paintings of various sorts.

But if this *détente* between mimesis and modern, performative utterance art amounts to a positive *entente cordiale* with photographs 'in' to please everybody, we can produce harder cases, more calculated paradoxes.

John Chambers, whose *Dresser*[17] looked like a bleached photograph, though it was hand-made on tinted graphite paper, deliberately revives the photograph, and explicitly challenges the truisms that photographs are not fine art, and that they spell the end of *mimesis*. He stands these canards on their heads till they are dizzy, producing hand-made colour-photographs, and writing a philosophical essay in *artscanada* to explain the total reasonableness of his apparently odd behaviour. The paintings of Chambers, and his philosophical reflections, are important to anyone who wants to understand contemporary realism(e)s.

3.

Any theory of painting is a metaphysic.
 MAURICE MERLEAU-PONTY.[18]

John Chambers's 'metaphysic' is in fact a kind of phenomenology, and his current commitment to an exact, painstaking, realism must be understood in relation both to his highly conceptualized account of what he is about, and to his previous works which were, many of them, in a visionary, semi-surreal style. Where he painted, once, like a post surrealist Samuel Palmer,[19] he paints now like a Dutch artist of the seventeenth century—Jacob van Ruisdael for example[20]—suddenly presented with a modern colour camera, and in love with the very idea of it. Chambers's adoption of the photograph as a matrix for *mimesis* results from a very conscious—a very self-conscious—change of view about the nature of painting.

The photograph marks, for Chambers, not the end of mimetic art, but the beginning, not the *finis*, but the *telos* of *mimesis*; and, beyond that *telos*, a new era again.

In his dense, difficult, and sometimes obscure article entitled 'Perceptual Realism', John Chambers makes the paradoxical point that art, mimetic art, became absolutely *possible* only with the invention of the camera. The camera image was always the almost unattainable technical and aesthetic ideal; and now that

we have it as an achieved ideal, it has become, as a source of information, the proper basis for future mimetic art. Chambers writes:

Before the camera was invented painters developed a painting style to compensate for the lack of visual information available to them. A constantly changing scene with no way of freezing the instant offered the painter little alternative but to find some intentional means of expressing the unity he felt for the thing he was painting. Style filled the gap as it were, where the artist had no more specific references to go on. The personality of the artist conceived stylistic innovations that became his hallmark; where style deteriorated into mannerism painting derived from the lyrical ego and the mind-aesthetic rather than embodying the primary impact.[21]

And, for reasons which Chambers gives, into which we cannot here go exhaustively, 'the primary impact' must be seen to be more important to art than is the 'lyrical ego'. Mimesis, Chambers reckons, is more important in art than is expression. And inevitable though they may have been in the past, and inevitable as they still may be even now that we have the colour camera, style and expression are, as it were contingent, distortions which occur in the course of an ideally objective transcription of reality.

Chambers goes on a little later in his article, taking up the argument which we have just quoted:

The highly analogous appearance between the recurrent blooming characteristic of art and the advancing continuity of science allowed art and science to look like one and the same thing. Tintoretto's and Titian's and other heaven environmental paintings had convincing perspective of human forms and objects. But even before the camera, people still read painting as a photograph and even when the camera did take pictures it was generally considered that as far as pictorial representation went the foto could do it better. This generally 'fixed idea' about the function of art demanded that it entertain as well as inspire the imagination and employ a credible degree of realistic rendering in doing so.[22]

But, as I understand Chambers's thesis, the photograph cannot of itself 'do it better': the photograph can enable the twentieth-century *artist* to do better than his predecessors, because he has the photograph now as a—literal—matrix of imitation, and can work on from it. To put it shortly: the painter can, and ought to work from photographs. Chambers writes:

Integrating the experience with the description is a labour of analytical contemplation, or probing colour fotos for the relevant information they can yield to stimulate a reading of the experience back into the

description. The mental operation analyses and scans the information with a general as well as specific intent for the availability of effects of contrast, proportional relationships and colour articulation. If enough information is found and the foto is usable then it becomes the plan for a structure.[23]

The argument is not simply that the photographs are there, and might as well be used: it is that they ought to be used—and not just because they are *there*. Chambers talks of 'Integrating the experience with the description'. This is, for him, 'the labour of analytical contemplation': now 'experience' and 'description' are theory-impregnated terms for Chambers, and the value judgements about photographs and their use by painters derive from this theory-impregnation. What is the theory? Ultimately it seems to be a theory about truth and authenticity: 'The perception of the natural world and its objects, creatures and people is the source of truth about oneself because not only what we project but also what we receive is ourselves.'[24] What is received is true information about the world: and by becoming part of us it becomes part of our authentic being. This is an existentialist kind of gloss to Chambers's notions: and there is an older Aristotelian one which might reinforce it. Aristotle writes: 'The mind in a sense becomes the thing known.'[25] So what is known is—by this token—now part of the knower. But Aristotle can provide only a gloss. What Chambers is concerned with belongs, if to philosophy at all, then to a later tradition—a much later tradition than the frank realism of Aristotle. Chambers is, essentially, a kind of phenomenologist— either knowingly, or as M. Jourdain was, a *prositeur en parlant*.

Chambers is very much concerned with the objectivity of perception, and with its absoluteness: 'Any particular intention one has about the object is abandoned to allow the sensory grid to operate so that the object is 'given' within. The senses constellate to experience the impact as a total circuit, registering the entry as a complex, but in the particular way of each.'[26] This objectivity— which forces the 'abandonment of any particular intentions'— becomes part of the subject, and he is modified by objectivity, but in his own style: 'registering the entry . . . *in the particular way of each*'.

Those of us who are familiar with the outlines at least of phenomenology and existentialism, will recognize in Chambers's passage a restatement of a standard existentialist paradox: Though everything belongs to subjects—there being no other mode of experience except by subjects—and so everything belongs to each subject in 'the particular way of each', nevertheless the being

and meaning of objects are objective, prescinding from 'particular intentions' (that is from particular intensions). For the existentialist, the world is given as meaningful, and the meanings are primary-as-given. It is not a matter, in the first instance, of what something means to me as me or to you as you: it is a question of what it means *as itself*, i.e. to any subject, regardless of his idiosyncracies. We find, for example in Husserl and in Heidegger a strong strain of realism in the metaphysical sense of 'realism': and we find in these philosophers an attempt to avoid subjectivity, while affirming it. Where the irreduceable subjectivity of a Romantic poet or painter was cultivated by him in order to produce a unique and personal vision, the phenomenologists, without for a moment denying our uniqueness and our personalities, wish to affirm and to guarantee a common, objective, and even commonplace-objective world for us; a world unique only in the sense that it is 'one-off', but quite unidiosyncratic, quite public.

The paradox of existential phenomenology is that though all is at bottom given to and through subjects, subjectivity in the literary—or the vulgar philosophical—sense, can be avoided. We are not wrapped each in his own little private world; but we all inhabit a public one, a publicly intensional and meaningful one.

Chambers is, I think, in his reiterated use of the rather technical expression 'intention', and much more vividly in his work, making this kind of point about the absolute value to subjects of the objective being—or if you like paradoxes, of the objective-subjectivity-of-being—of the world we all inhabit.

The notions of Chambers are difficult, and I think deep: whether they are sufficient to justify theoretically Chambers's extreme 'Perceptual Realism' must remain an open question for the present. Anyhow, there are no real proofs in aesthetics—not philosophical or knock-down ones. There are only proofs of the sort that there are in cooking: the proof of the pudding. And what Chambers does seems to me to justify his theory quite as forcefully as his theory might justify it. Chambers's *The 401 Towards London No. 1* (plate 63) is a very beautiful painting—and its literalness is essential to its beauty.[27] This sort of neo-realism reminds me of Blake's famous remark: 'If the doors of perception were cleansed, everything would appear to man as it is, infinite.'[28] The ordinariness of the Ontario landscape is seen as ordinariness, but also with what St. Thomas and the medievals would have called 'the splendour of being'.

Or, if we are to talk in an existentialist phenemonologist's way, we may say that the meaningfulness of the landscape, its human

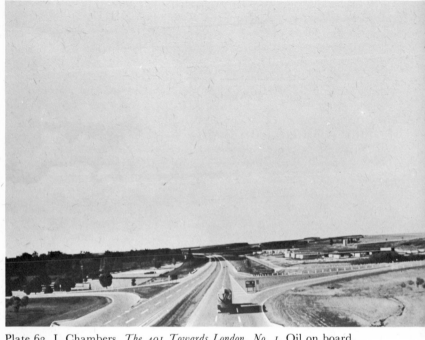

Plate 63. J. Chambers, *The 401 Towards London. No. 1*. Oil on board, 1968/9, 72 × 96 cm.

sense and significance, is heightened in the picture not by any subjective enthusiasm on the part of the painter, not by Chambers's being wildly enthusiastic about small factories or tarpaulin-swathed lorries, but by the landscape's being presented in all its actuality; and by its being presented with a certain lucidity which goes beyond the ordinary, without for a moment suggesting the extra-ordinary. This view of southern Ontario does not give us the *frisson* of something from the *pittura metafisica*: but there is in the picture of it a metaphysical dimension, commensurate, in an analogous way, to its reality.

The painting was constructed according to Chambers's theories and after a photograph. But the process of transcribing reality from mechanical images of it is no short cut for artists. The business is complex and painstaking, as this, necessarily long, description of it makes clear:

The usable foto is divided into quarter inch or half inch squares. The support (prepared wood or canvas) received a uni-color-tone surface of

oil paint approximating the colour-tone of the largest generalized colour area: the sky in '401'. It is also divided into squares corresponding to those in the foto. A primary division between earth and sky is made by a straight line using the squares to determine where the line is made. The sky portion is left the colour it is and the earth portion is painted darker to approximate the generalized colour-tone in the landscape. The intention of this approach is to reduce analytically all masses and their emergent forms to a primary colour-tone from which they evolve to weave the basic structure throughout the mass. Such a colour-tone is not the darkest but a middle dark which can itself be projected by the darkest areas and project from itself lighter ones. In any fragment the structuring procedure is the same as in the whole.

As the painting develops the squares have to be drawn in again and again. Subsequent masses of lighter value subdivide the two largest generalized masses and derive their own colour-tone orientation from them. In this way the structuring process gradually evolves into more minute divisions until through prolonged unifying and breaking up of colour areas, dimensional contrasts begin to emerge as defined objects. When this point is reached and realized the description has been intentionally analyzed and integrated with the experience.[29]

These notions of 'analysis' and of 'integration' have, given the whole description of what is going on, a curiously abstract, almost pedantic feel to them. But so they should have. Chambers's painting *The 401 Towards London No. 1* seems absolutely to vindicate the technique which produced it: a technique with all kinds of abstract notions behind it, and one grounded on ideas which need some kind of formal exposition. The theoretical essay has to be abstract: but its upshot is that pictures need to be concrete.

One feels in Chambers's total respect for visual appearances the obverse of the point Aristotle seems to be making in that extraordinary passage in the *De Anima* where he says, 'If the eye were an animal, its sight would be its soul.'[30] What the eye takes in as pure vision, has, for Chambers, a kind of unconditional value—the soul of vision is the 'vision' of reality, and this is simply valuable, in and for itself.

Chambers's pictures justify his technique: the technique may or may not justify the manifesto-like statements which Chambers makes towards the end of his article:

In general 'everyone' seems to enjoy scenes of vast sky and clouds and sunlit landscape. Its common recurrence on the windshield and in 'hand-painted' paintings and calendars is the kind of picture people feel easy with and don't mind hanging up at home. A bright sunny day makes people feel good because their subjective attitude is the filter through which natural or 'crude-oil' visuals are strained into 'being' something.

A gray-washed day of minimum contrast is likely to bring out irritations one didn't know were there. It is a thing of negative appeal: negative because the subject-evaluation filter says the gray way doesn't remove irritations or make one feel any better. Negative on both scenes, really, because neither is perceived from the outside; both are projected onto nature from within. What happens in general is that natural phenomena remain invisible to the conditioned mind. It prefers a substitute-stereotype to making personal contact with visible experience.

The gray dull scene may have impressed the sensibilities with an equivalent impact to the sunlit, contrasty one, but the short-circuit occurs where the mind interprets the impact as something it doesn't like or even something it does like *because* . . . *Because* is the mental process of aesthetics, at whatever level of sophistication, where kinds of appearances trigger conditioned aesthetic responses to fade out an otherwise potential perceptual impact. The impact on the perceiver looking through the visible to a general vision-awareness of the whole will register impartially an experience because it is not intercepted by the mind. The aesthetic concern converts and manipulates its *own* energy according to its particular needs. The spontaneous and primary nature of perception cannot speculate in values.[31]

If life already 'speculates in values' why, you may ask, should not art? Chambers's theory seems to go too far. Perhaps it does. But, within a certain limit it has point: and we can see—in his paintings—a justification for Chambers's austere wedding of the 'two systems of available technology': The 'organic' tradition of realistic painting, and the 'visual mechanical' possibilities which come out of the invention of colour-cameras.

For Chambers it is proper for art to be photographic in a sense more literal than metaphorical: and his paintings themselves show that his point of view, for all that old commonplaces might make it seem odd, is an eminently sensible one. The proof of his quixotic theory is in the paintings, and these are evidently and eminently good. That Chambers's views on perceptual realism may prove too much, altogether too much, I acknowledge: but then, so did the commonplace that the camera had killed *mimesis*. Chambers sets up a useful antithesis to *that* thesis. Chambers may be wrong in supposing style to be the mere static on the line of a process which takes reality and makes imitations of it. But those theorists who have thought that style or interpretation was all, and the inner vision altogether superior to the outer, may have to reflect again—if not because of what Chambers writes, at least because of what he *paints*. He paints better arguments for a realist phenomenology than many philosophers can pen; and he makes his point both *in* and *about* painting.

Painting awakens and carries to
its highest pitch a delirium which
is vision itself, for to see is
to have at a distance.
MAURICE MERLEAU-PONTY.[32]

What we have said so far has established a theme; of 'realistic representations'—Aristotle; and, of photographs—Chambers. The next group of painters at whom we are to look are photographic and realistic—and something more. As we look at these painters we must recall, now looking for a new metaphysical twist, Merleau-Ponty's remark that every 'theory of painting is a metaphysic'. Colville,[33] and the Mount Allison school to whom we turn are realistic to the degree—almost—of being photographic. However, their notions of *mimesis* are not phenomenological, like Chambers's, but intentional. And they are intentional in the very sense of intentionality/intensionality which Chambers rejects. This we must explain, as we go along.

Let us begin by looking at the obvious, and the obviously mimetic aspects of Colville and his group: when we have considered their 'delirium of vision' we may begin to appreciate how they, and Colville in particular, contrive, for all their surface realism, to reduce the 'distance at which things are had'. Painting of the surface can be superficial: it can also be deep.

Though the adjective 'photographic' has often been on the tips of critics' pens when they wrote about Alex Colville, it has never flowed off in its derogatory sense; nor should it, ever. Colville's work invites the epithet, but it compels a sensible critic to use the expression in a good sense. And I can recall two splendid phrases which transform 'photographic' while fitting it, very precisely, to Colville's work: Gene Baro writing of some of Colville's paintings in 1958 found this rather splendid phrase: 'Colville masters the poetic camera.'[34] The camera certainly does not master Colville. In 1970, writing about Colville's exhibition at the Marlborough Gallery, John Russell observed: '*Woman with Terrier* could be a snapshot taken with a Polaroid camera made in heaven.'[34] The 'made in heaven' nicely scotches the implied reproof of the 'Polaroid'. This must rank as one of the finest pieces of 'diplomatic' art criticism ever: and it does, as well, mark exactly something very important in Colville's work.

A number of critics have drawn attention to the film-still effect of Colville's pictures. And indeed the paintings resemble movie

frames in two obvious ways: in their composition; and in their freezing of moments, their arresting of time. Nor is the filmic quality something to be surprised at. Colville has lived almost all his life in Canadian small towns, in Amherst and Sackville in the Maritimes, and the film has been, as it is for most provincials, a very central cultural experience.

Colville's realism is instinctive: he regards himself as belonging to the great and old tradition of North American realism, which stretches back through Hopper, the Precisionists, and the rest, and through Eakins, to John Singleton Copley. But Colville's acquaintance with the indigenous tradition of North American Realism is indirect: it was not until his own personal style had evolved that he saw the works of the North American Realists in the original.

Colville describes himself as 'a graduate of the museum without walls', and from that museum he has taken what most attracted him: a painterly tradition of hard-edged, quasi-sculptural realism.[36] It is not surprising to be told that Colville's favourite paintings of the Renaissance are by Piero della Francesca and Masaccio: and one might have guessed that among the few originals which Alex Colville saw at an impressionable age were a small Piero in the Frick Collection, New York, and a pair of panels, *bottega di Mantegna* in Montreal.[37]

The deepest childhood influences on Colville will be sensed by those of you who belong to a generation fairly close to him. One feels, in the background of these paintings, the covers of the *Saturday Evening Post*[38] and the automobile advertisements of the 1920s and 1930s, seen in such glossy magazines as *McCall's* and *The National Geographic*. These are indeed Colville's avowed prime sources. And the *Saturday Evening Post* influence is a several-stranded one. Colville's style has the same concern for realism and for fine craftmanship as, for example, Norman Rockwell's. Again, Colville seems to accept the same values as Rockwell—values of a middle-class, prosperous, unexciting provincial kind of North American life. But the obvious similarities are set off by obvious dissimilarities: while Rockwell, painting essentially for magazine covers, is cute, whimsical, and determinedly folksy, Colville is hieratic and cool. Colville is really much more serious about the small-town values than Rockwell, and he paints more serious pictures—immeasurably more serious.

The most exciting thing that ever happened in Colville's rather uneventful life—a life that he has indeed chosen to keep placid and provincial—was his war service, which he spent as a war artist

attached to the Canadian Army. This war service gave him a couple of days in Paris in 1945, and of those days he was able to spend one in the Louvre. What Colville saw there answered to certain deep preoccupations that he had always had, and which the war had sharpened for him. It was not painting which caught Colville's attention in the Louvre, but sculpture: Egyptian sculpture, with its timeless quality, its sense of permanence. For a modern North American to be fascinated by an essentially funerary art seems odd: and that he should take from it a matrix on which to build up images of contemporary life seems paradoxical. But the paradox is easily resolved: like the Egyptians before him, Colville wants to give permanence to the fleeting. He wants to memorialize the events of everyday life in his own part of Canada, sending them off down the stream of time recorded—frozen—in perfect, typical moments. As much as any Egyptian with his head full of a magical theology of immortality, Colville wants to save the quotidian from time. And he saves it in an 'Egyptian' way.

The secret of Egyptian art is, the Egyptologists tell us, a system of geometry which had for the ancients a kind of mystical significance;[39] and it is one which happens to have, for the human animal, a permanent and very positive aesthetic significance.

The Egyptians made great use of the golden section the ratio $1::1\cdot618$, and it was the measure, the calculation behind Egyptian sculpture which, instinctively, appealed to Colville.

The Louvre Egyptian objects (i) crystallized for Colville a notion of art as memorialization—a notion which had always been in his mind—and (ii) they showed a method by which fleeting, passing things could be given a kind of affective solidarity and permanence.

Colville did not read up the Egyptologists' treatises on Egyptian proportion—and it was not till after he had painted his first important picture that he began to study textbooks on Greek, Renaissance, and modern uses of the golden section. But Colville's first important work, *Nude with Dummy*[40] (plate 64) 1950, has an instinctive use of the golden section which is uncannily accurate. The golden section system here is a very simple one: the edge-lines of the picture are cut at the ϕ-point, giving lines respectively of $1::1\cdot618$. If one cuts *The Nude with Dummy* empirically by the triangle method for finding ϕ, one discovers that the major parts of the composition fall on ϕ-point grid lines.

Colville says that none of this was done by conscious calculation: but he admits that it must have been done by subconscious measure-

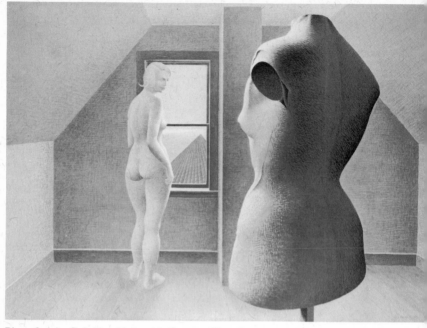

Plate 64. A. Colville, *Nude with Dummy*. Glazed gum emulsion on
gessoed masonite, 61 × 81 cm.

ment. Many painters find the golden section points by instinct—
but Colville's composition is uncannily exact for one done by
instinct. The grid lines fit as if predetermined, and even the pro-
portions of the window turn out to be a version of the golden section
scheme.

Colville had—a nice domestic detail—been renovating his
own wooden house in Sackville for some months before he did
the painting, and he had become fascinated by measurement and
computation. This 'home-made Bauhaus experiment', as Colville
calls it, served as a catalyst, giving him a preconscious if not
conscious insight into the principles of geometric composition,
and enabling him to record the domestic incident of his wife and
her dress-maker's dummy in a monumental, mathematical way.

There is an interesting confluence here of the domestic incident—
typical of Colville whose whole *oeuvre* records life in his beloved
Maritime Provinces—with the large principles of geometric design
in accordance with golden section rules, itself brought about by
something as homely as the artist's renovating his own house. The

attic—the scene of the picture—was where, with saw and steel-tape measure, Colville picked up the craft of practical computation: he discovered in his own loft the way to make use of the measured order that he felt behind the Egyptian antiquities in the Louvre: and so he found a way to give a lucid kind of permanence to the fleeting scenes that occurred in his attic.

As a footnote to this domesticity one may record that when Colville came, later, to build himself a little seaside cottage at Wolfville, Nova Scotia, it was built not simply with his own acquired intuitive skill, but on a very conscious use of Le Corbusier's *Modulor*—a version of the golden section system—as were, later on, some of his paintings.

One of Colville's earliest patrons, Lincoln Kerstein, sent him a couple of books on the Renaissance painters' use of the golden section; and after 1955 Colville became very consciously attached to the practice of basing paintings on geometry. The pictures have, all of them, grids of architecture behind them, sometimes complex, sometimes simple.

It is interesting to look at one or two examples in detail. One of Colville's most realistic and evocative paintings is *To Prince Edward Island* [41] (plates 65, 66, 67). The symbolism is obvious enough: the feminine sea, and the woman, instinctive, insightful, who stares straight out through us, like a Sybil; the man, active, a deviser of mechanisms, relaxing on the bench while the ship, a complex machine, the fruit of endless calculation and codified experience, carries him over the sea.

The picture, and the symbolism, could even be so obvious as to be uninteresting: but there is a tough, monumental feel behind the picture, and a glance at Colville's composition-sketch shows us the bones beneath the enamelled skin. This double-triangle system produces certain, inevitable, tensions: and the point of intersection between the two triangles is, literally, a crux: This crux falls exactly in the middle of the woman's brow. All the masses of the picture bear on this point: it is made the psychological centre of the composition and of the symbolism. This is not a diffuse semi-photographic realism: but a calculated, considered one. The picture is made, like a Renaissance picture, to assert in its structure what it announces in its symbolism, what it 'says' in its 'anecdote'.

Chambers talks of the difficulty which the artist had before the invention of the photograph in finding a way for expressing 'the unity he felt for the thing he was painting' (see above, p. 99; and, as Chambers says, the means which the Renaissance painters

Plate 65. A. Colville. *To Prince Edward Island*. Acrylic polymer emulsion, 61 × 91·5

Plate 66. A. Colville, diagram of Plate 65

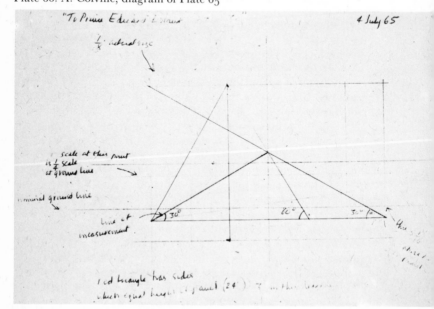

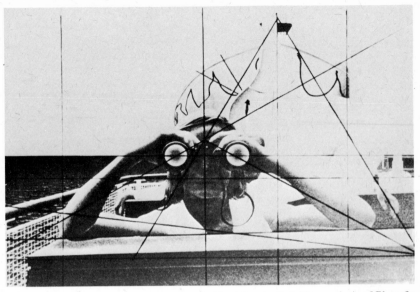

Plate 67. A. Colville, analysis of Plate 65

found was an 'intentional means'. Colville embraces, emphatically, this intentionalism/intensionalism: He structures reality on a geometrical grid, in order to assure himself that the pictures will be read for the precise reality which they represent. Ordinary— pure—experience may be ambiguous: points of view change. Colville leads us, gently but inexorably, to a certain point of view— visual, psychological, and in a sense too, 'ontological'.

By looking at the most photographic elements in Colville, and by seeing the geometry underneath these 'heavenly Polaroids', one can come at the meaning behind them: (i) one can come at the first sense, of his celebrative realism, which takes ordinary, everyday actions very seriously as things of value; and (ii) one can come at the deeper sense of his ontological fascination, his passion for being and quiddity. If you want to see the point of Colville's photographic style, then it is essential to realize how far from photography it is, in its genesis.

Looking at a picture like *Swimming Race*[42] with its splendid arrested movement, one might be tempted to suppose that it had been composed with the aid of high-speed photography—an action photograph from a newspaper sports-page matches it splendidly. But in fact Colville's attitude to the use of the camera

is quite different from Chambers's, and he is very irritated when it is suggested that he uses photographs. These arrested moments are produced, in all their tough realism, from extensive studies, sketches, and composition plans, which owe nothing to the camera, and everything to Colville's eye and hand. The photographic effect is absolutely hand-made: and the sketch of diving girls which lies behind *Swimming Race*, and which still hangs on Colville's daughter's bedroom wall, is fluid, impressionistic, almost futuristic in Matta's way. It would appeal much more to certain kinds of doctrinaire modern taste, than would the final picture itself.

Realism is for Colville, as it is for Chambers, a value in itself: but the rationale is subtly different. Colville values realism for the sake of his public. People like to recognize objects and places in paintings. And there are two senses of 'recognition': (i) people like to know what is represented, what is 'going on' in a picture, to *recognize* in this flat, literal, sense; and (ii) they like to see in a picture memorials, celebrations, of their own lives, of events from the common provincial round.

Colville, like many painters before him, sees this double recognition as a value and as a *raison d'être* for works of art. Colville is a celebrative realist. This is the surface sense of his pictures: a celebration of life. But the matter goes deeper: to mark the quality of his own work Colville sometimes uses the word 'ontological', a word which he has selected, very aptly, from his omnivorous reading. Colville's work is about *being*, the being-there and the being-thus of things. Besides using the word 'ontological', Colville uses a remark by one of his favourite authors to make his point: 'I remember reading recently that Günter Grass, the novelist, speaking of symbolism, said that when he wrote of potatoes he was interested in potatoes—This expresses as well as may be my [own] concern for the actual.'[43] Colville paints with an intensity which one might call metaphysical: he concentrates on what is before him with a sharply focussed energy which makes ordinary things into meditation objects.

This intensity of concentration can be felt behind Colville's latest painting, *January*,[44] which is a kind of companion piece to *To Prince Edward Island*. There is a complex and at the same time straightforward symbolism in this painting—in the name itself which puns on the figures looking two ways (plate 68). And this picture is *To Prince Edward Island*, with the roles of the man and woman now reversed: she is looking back on the way already travelled, he is looking with veiled, but we sense determined, eyes, forward to the future. And there is, behind the composition, an

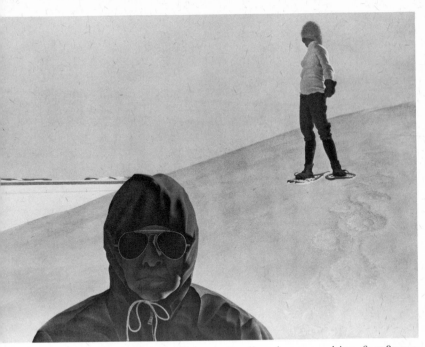

Plate 68. A. Colville, *January*. Acrylic polymer emulsion, 61 × 81 cm.

Plate 69. A. Colville, drawing of snow-shoes for *January*

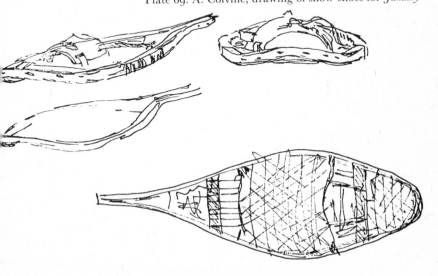

elaborate geometrical structure, which can be seen in the studio sketch, and felt in the finished work.

But most instructive of all are the particular sketches of details which stand behind the final picture. These are less about visual appearances, one somehow feels, than about what the poet G. M. Hopkins would have called *inscapes, quiddities, whatness-es*. The final painting can show the snow shoes only in terms of a certain particular foreshortening. But Colville has looked at them from four points of view, to decide not just what they look like, but what they are like—what they *are* indeed, without the 'like' (plate 69). The studies and the final images of Colville are concerned as much with the way things are, as with the way they appear. Colville is, to borrow again from Merleau-Ponty, concerned with 'the inside of the outside'.[45] His ontologism is the expression of his being taken up, as it were, with the musculature, even of the inanimate. Getting inside the object is Colville's way of reducing 'the distance at which it is had'.

The snow glasses have been analysed for both their internal and their external geometry: and, crucially, for their essential what-ness (plate 70).

The lyrical, masterly, sketches of the landscape have reduced it to its essence, a diagonal, and a horizon: and his essence has been double distilled in the final painting where the two lines are made to cut at a vertical line which runs, though masked, through the median of the man's head. The two sketches have resolved into a meaningful synthesis: a synthesis which establishes exactly the relation of the man to the place.

The feelings for whatness and for celebration are two merging aspects of Colville's work: he has, as someone said of Ingres 'a voracious eye',[46] and the intensity of his concentration in his erotic—*Snow, June Noon* for example—images is no more than his usual intensity. The erotic dramatizes the immense *appetite* of the man, not just for the looks of things, but for the being behind the looks, the being, part of whose being it is, to look like this.

Colville is true to being, first: then to appearances. And his 'photographic' realism assays visual reality for us. For all that it looks superficially bland and exact, it is a realism of interpreted reality, and offers its interpretation of reality. But the point of view of the rendering is not arbitrary—as all visual points of view must to some degree be—so much as logical. Colville looks at things according to the logic of those things: and the logic is one of being. He paints onto-logically.

There is, of course, a pun here: but, like an aesthetic idea, it

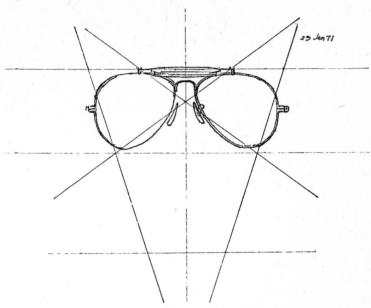

Plate 70. A. Colville, drawing of snow-glasses for *January*

has, in its ambiguity, a number of points. Look, analytically, at a Colville, and the points emerge—sharp and clear.

Colville is in effect the doyen of a school—the Mt. Allison School—though he does not like attention drawn to the fact. The crisp, exquisite realist Christopher Pratt is a pupil of his, and a number of other, younger, painters have been influenced by him. D. P. Brown, Ken Danby, and Hugh Mackenzie all have strong affinities, both in style, and in the medium, even, with Colville. But Alex Colville is not interested in having a group associated with him, and is extraordinarily reticent about his influence on other painters. He makes no claim to have 'redis-covered' realism: for him it has always been there, in the old Renaissance tradition, and in the newer North American one. And a 'school', Colville feels, is too pompous, and too limiting a notion. The point about the modern Canadian realists is not so much the way in which they resemble one another, as the ways in which they differ. Colville will not have the highly characteristic gradations of style and sensibility to be found within the movement blurred by having them·related *to* a movement: for him there is not one, nor any school, only painters painting.

115

Christopher Pratt [47] is a sometime pupil of Colville's, and his hard, crystalline clarity owes much to his teacher, and much to the cold Newfoundland air. Though his nudes are more decorative than Colville's, and more clearly in the tradition of aesthetic voyeurism than are Colville's intense, voracious, pictures, his buildings and landscapes are harder, cooler, and more geometric. There is here a similarity of vision, but a marked difference of feeling: and in his more extreme formalizations, Pratt goes beyond Colville in ordering the world on a geometric grid. Behind his realism one sees the shadow—almost—of Piet Mondrian.

Hugh MacKenzie [48] shares Colville's visual voracity; this is especially evident in his splendid nude in *The Window*. This picture is the one which I kept coming back to at the *Realism(e)s* exhibition, partly for its quality and finish, and partly for the way in which it illustrates the ontology of Canadian contemporary realisms. The artist's eye has rendered up every nuance of the figure and of the flesh tone of the cool, detached, intensely seductive young woman. But the obsessive vision has shifted away from the merely erotic possibilities of the scene to take in as equally compelling, visually, the window case and the details of the façade of the buildings opposite. The eye devours not only the beautiful, icy, girl, but the cold, precise geometry of window-frame mouldings, and the placing of pairs of brackets under a roofline. The architecture comes, such is the intensity of the rendering of it, to compete with the girl for our attention. She is casually present: It asserts a kind of existential permanence proper to itself.

MacKenzie's work has a sociological dimension too: he paints, as does Colville, scenes from contemporary life, two boys playing with *The Bamboo Poles* for example: and the scene is caught in a tight web of lines, the contingencies of life 'justified' by the geometry of design.

Ken Danby, [49] the last of our Canadian contemporary realists, provides a link with Andrew Wyeth, the great American master of a realism at once meticulous and romantic: a master whose influence and teaching Danby acknowledges. The romantic strain of Wyeth can be seen in many of Danby's pictures, the sense of nostalgia for an agricultural past, for a green countryside with red wagons and old men *On the Rail Fence*.

Most of the Danbys are softer than are Colvilles or Pratts: the surface of the tempera is as hard, but the feel is more lyrical. The pictures are a shade less ontological, and more full of memory. They are about the object as it is now, but they refer us to its past as much as to its presence. The sketches of boys on bicycles remind

us more forcefully than do even the Colvilles, of the sentiment as well as the finish of *Saturday Evening Post* covers.

Yet—and here is our paradox—it is Danby who painted the *Easy Rider* picture—*Pulling Out*—in the *Realism(e)s* exhibition. The nostalgia cracks; we are brought up face to face with a moment of our own time, in a hard and uncompromising image.

Contemporary Canadian realisms are all of them a function of regionalism, and connoisseurs of the Canadian scene can place the landscapes very precisely. But the regionalism, whilst it is resolutely provincial, is not restrictive. The painters are not mere topographers of their own landscapes, physical and sentimental: they have developed a vision which has a validity outside its own place.

Colville once told me his theory about provincialism and art in the twentieth century, and it runs like this: the provincials can still have their own insights, their own authentic vision—and so can make something. Artists in the big cities, and on the international scene, can only paint with eyes tutored by fashion. Big city and international painters are gregarious, and may be in danger of influencing one another blindly—like Fabre's caterpillars, playing follow my leader in endless circles. The provincial, because he sees less, can see more of it, and more intensely.

'Provincial' for Colville has a good sense. And a provincial in the bad sense is for him, 'A guy who doesn't want to be where he is, and paints as though he were someplace else'. Colville and the Canadian realists are not provincials in the bad sense: they like being where they are, and they paint with passion what they see there. The result is not mere local chronicle, but a clarity and intensity which issue in a new ontological style of painting. A universal style of *quiddity*-painting comes out of small towns in Ontario, New Brunswick, and Newfoundland: but what comes out of the small towns is a big style. Ontological realism has a point to make: the provincials have a large vision.

5. JEFFREY SMART

What is composed of act and
potency participates in good-
ness to the extent that it
participates in act.
 ST. THOMAS AQUINAS. [50]

Are realisms in this part of the twentieth century still realisms, or

are they, essentially, now, something else? What is there, still, for realism to be about?

The first of these questions may be answered, as we go along, by looking at what one contemporary realism is not; the second will be answered, again as we go along—and we have had quite a lot of the hike already. But before we try to make a half-systematic review of the notions that we have botanized through so far, let us consider both what a realism is not, and what it is.

There is a remark of Jeffrey Smart's which he made to clarify his own work and intentions, but which might be extended back to cover as well the other painters whose pictures we have been considering in this lecture. Smart said:

> A man on horseback is logical,
> But in a satellite he is surreal.[51]

Surrealism for Smart lies in the world, and not in pictures—not in his pictures anyhow.

Faced with contemporary realisms, some critics—and some otherwise sensitive people—feel at a loss for a label; and some even, one suspects, feel at a loss for a reaction. There happens to be a label, and there happens to be a kind of ready-made reaction which goes along with it; and contemporary realisms of Smart's kind—or Colville's, or, even of Chambers's—get called *surrealism*. This will not do.

Realisms cannot be taken as surrealism just like that; and Smart's insistence that it is the world which is surreal, not his paintings of it, should redirect our attention to the intention of his work, and throw some light on the situation(s) of contemporary realisms.

What are Smart's concerns? They are, I think: on the surface, with the enigma of things—with their surreal real-life oddness; and at bottom with the being, simply, of things.

Let us begin with the first layer, the enigmatic. This is where Smart obviously begins, himself, with the crooked smile on the face of the world.

A man is surreal in a satellite or even on an *autostrada*, because he is displaced. A man on a horse has a kind of natural 'logic'. On a motorway, or in an industrial landscape, he has an artificial one. To find the man, to place him, you must understand the artifices with which he is surrounded. Smart paints Italy, more rarely Australia. But the place is, in a sense, irrelevant: Smart is concerned not with topography but with man's finding himself, wherever he may be.

The woman who stands at *The End of the Autostrada*[51] is enigmatic, isolated, and symbolic (plate 71). Here we have, again as we have often in Colville, a frame from a film, something by Antonioni perhaps. And we have, too, an image of the present condition of Western man. An elevated phrase, 'the present condition of Western man', but it will do. And that this picture is an image of what the phrase stands for is evident—or if it is not evident it can soon be demonstrated.

Housman states the essence of the human situation—what Heidegger would call our existential 'thrown-ness'—in a couplet:

> I, a stranger, and afraid
> In a world I never made. [53]

Smart's pictures accept this piece of anguish. And they go on as well to paint another moral: we are strangers and afraid even in the parts of the world which we have made. We are strangers and

Plate 71. J. Smart, *The End of the Autostrada*. $31\frac{1}{2} \times 39$ in.

afraid; and we are the proprietors, the makers of it all, and very much at home. It is this sort of contradiction which comes out in Smart; and it is the sort of contradiction which we recognize in our lives.

One is tempted to use the expression 'alienation' here to mark man's love–hate attitude towards one's own, very necessary works. But 'alienation' is not the right word to use for the sense of Smart's images—and would not be even if it were not worn quite smooth and senseless by excessive popularity. In a recent letter Smart wrote: 'Brett Whiteley asked me quite seriously whether I was knocking modern life and saying "Look how bloody awful it has all become". I felt almost ashamed to tell him I was just an old style artist painting the things that moved me. . . .'[54] What moves Smart, often, is the *surreality* of the real world, the mixture of things which man has made in with things which nature has made; the mixture of things from different periods of time, from different life-styles, the ambivalence of things.

Ambivalence: an *autostrada* is splendid and splendidly useful if you are in a car. It is daunting, inimical (I will not, on principle, say 'alienating'), if you are on foot. It is terribly alien, this motor-way, if you find yourself dwarfed, like Smart's woman, by the giant sign which means '*Autostrada* ends at 750 metres'. This is a useful ideogram, but it belongs to a world of speed and distance quite incommensurate with the speeds and distances any person can walk. Ideograms should not be so large, so thin, so present; mere symbols bigger than people. But sometimes they are, and for perfectly decent reasons, too.

In all his pictures Jeffrey Smart records and clarifies. He produces emblems, visual metaphors which at once imitate and interpret reality. And Smart's kind of *pittura metafisica* turns sometmes, almost, into metaphysics as in his *House at Portuense* (plate 72), where the division of the canvas into two equal parts expresses a profound sense of the incommensurability of the objects represented in them. The incommensurables are plausible, even natural-istic: the great surreal *collage*, with the blow-up of a Leonardo head, is a wall or embankment covered with posters. It can and does exist in the same world as the Renaissance-style *palazzo*. But it has not the same rule of measure. The two Renaissance things, the poster and the building, are as much at odds with one another as are the *palazzo* and the electronic scanner on its roof.

The measure, the module, of the building is the girl. She leans serene and relaxed, smiling in ironic imitation of the Leonardo angel, on top of the immoderate, the gargantuan wall. The lighting

Plate 72. J. Smart, *House at Portuense*. 28 × 24 in.

of the painting stresses the relation between the girl and the building; the smile relates the girl and the angel. The human body is the module of the *palazzo*; intellect—whose symbol is the smile—is the measure of the scanner.

Leonardo, who painted the angel, designed machines as well. Leonardo contrived nothing quite as sophisticated as the radar apparatus, of course, but all 'philosophical engines' are to be designed and grasped by the one human ingenuity. The situation which the girl takes so serenely is essentially problematic: can she

grasp it? Can she define herself in relation to it? Can she overcome it, as Leonardo might, reborn into the twentieth century, overcome the conceptual problems which the scanner symbolizes?

Conjunctions like this, of wall, poster, building, machine occur; but what do they mean? How do we find our way though surreal environments, environments where one kind of reality impinges on another?

The girl in this picture is living in 'divided and distinguished worlds', worlds which have not been reconciled in one principle. Why, then, is she so assured? Has she comprehended them? Or is she a symbol of the hope that they may be comprehended? 'All being is, as being, intelligible.' But not instantly, except in an angelic mind.

Italy with its layers of the past, its perfect Renaissance cities like Florence and Siena in which one must really go about on foot, and its *autostrade* which need to be taken in a G.T., is surreal. And this surreality, this displacement of context by context, is both a fact and and an image of the situation of contemporary man.

It is not difficult to read many of Jeffrey Smart's paintings in this sort of way: they are about daily oddnesses. But one must look deeper again, past the smile to the face itself, if that is possible; beyond the look of things to what things at bottom, are.

Saving Jeffrey Smart from the 'surrealist' tag by stressing a kind of nervous existentialism in him one must, still, beware of sacrificing the profounder aspects of his painting to the more obvious. Smart says: '. . . my pictures usually have their origins in something beautiful which I have seen, something which has stirred me and haunts me until I have painted it . . .,'[55] and behind Smart's painting lies a delight in, and what he himself calls a 'homage' to, the object which stirred him.

This 'homage' to things comes out in Smart's most recent works, for example in *Guided Tour* (plate 73), with the gallery-going girl seen through a Soto screen. This painting, despite the loving turquoise of the phonoguide earphone wire, is not, essentially, ironic. Smart wrote to me:'I have a fear that you thought I was trying to be ironic in painting *Guided Tour*. All *that* comes later, when people ask "What is it?" '[56] At the first impulse it is beauty, not irony, which takes Smart. The transition from the heavy red painting on the gallery wall through the innocent—and one supposes rather silly—little pink girl, to the modulated, sophisticated, white of the Soto screen, is the real topic of the picture. Human beings, going about their odd occupations, occasionally pose themselves

Plate 73. J. Smart, *Guided Tour*. 79 × 100 cm.

as decoratively as this. Smart responds equally to the beautiful and to the odd, and sees the beautiful in—through—the odd. His recollection of the genesis of this painting is quite lyrical: '*Guided Tour* was seen in the Museum of Modern Art in Paris. And I saw a large simple abstract through a screen, with a figure moving through it all. It was very beautiful, the way the light was held between the two things.'[57] Sometimes what moves Smart is beauty, in an old fashioned sense; sometimes something odd and beautiful, at once.

There is a feeling of the altogether odd about the girl on the Jantzen advertisement, forever diving towards an indifferent and unaware *Mr. T. S. Eugenides on a Rooftop, Athens*.[58] But the image is striking and haunting and odd, only in the real-life–surrealist way. It is, as an image, beautiful rather than comic or ironic; it is a delight in the surrealisms, the curious juxtapositions of the world, and not a *poème objet* about them. Smart is simply delighted by what he sees, and he will have us delight with him.

There is no irony at all in Smart's buoyant image of the cubist flat-balconies, and none in the picture's title *Holiday*.[59] This Roman woman dozing quite alone, she and the washing on the line on the left the only human and humane things in a world of crystalline geometry, is not complaining; nor is Smart complaining for her. She takes the sun; and those beautiful cubes 'take the sun' too. For all the repetitions of the balconies, there is no monotony here, only a rational arrangement for managing lives in a crowded place. But, if you do want the place to yourself, you have to wait for a holiday in summer, when everyone else has gone to the lido.

In this picture, as in *Housing Project* with its beautiful contrast of pattern—pure pattern, almost—and distance, Smart is delighting in what he sees. And if he is making any comment on the reality behind this finely tessellated appearance, it is more probably a favourable than an unfavourable one. Smart has nothing against housing projects: nor has he—one suspects—a Corbusier-style, prophetic belief in them either.

Beneath the existentialism of many of his works, and emerging more and more in his latest things, is Smart's acceptance of the world as it is: not too intolerable, its anguish identical now simply with the fact of its being: nothing to be dramatized in it. From a kind of existential *angst* about being, Smart seems to be coming to an almost Christian enthusiasm for it; a great reader of the Anglo-Catholic poet T. S. Eliot, Smart knows that the Scholastics thought that the *transcendentals*, *being the good* and *the beautiful*, were all, in technical language, 'convertible'; that is, for any one any other could meaningfully be substituted. And Smart does not disagree with this: he even shares, to some degree, the insight behind the forbidding systematic metaphysics.

This all comes out in Smart's very latest picture: *The Plastic Garden at the Petrol Station* (plate 74). Here the commercial eye-catchers, the plastic abstract 'flowers' are seen as beautiful as their designer meant them to be—or more beautiful. Smart takes the *Plastic Garden* absolutely seriously: no irony, no sophisticated reservations. He just looks, and sees something: half abstract, half common-placely realistic, and absolutely entrancing. He shows it back to us in an image which is resolutely literal, the big dun trucks on the left are not edited out. They are left there, faintly discordant though they may be.

The literal image is entrancing, because it is entranced. Smart wrote a phrase in a recent letter which sums up the ontology of his paintings: 'When I am painting [some beautiful object which

Plate 74. J. Smart, *The Plastic Garden at the Petrol Station*. 80 × 80 cm.

has haunted me] I feel I'm doing no more than homage to it, *in very much the same way you Christians praise your Lord.*'[60]

Smart is not, as far as one can tell, a professing Christian; but again he is not an idolator. He does not worship being, but he rejoices in it, holds it in regard. He is, in this, at one with Christians, and very much at one with Christian philosophers.

6. CONCLUSION

The realisms at which we have looked in detail are—as I said they would be—Renaissance-style ones: imitations of appearances. Aristotle said that people like this sort of thing, and the Toronto poll seems to show it to be so. There is, perhaps, always a public for realism.

But has realism any aesthetic validity, still, in the twentieth century? That this is a silly question, or one expecting the answer '*Of course!*' should be obvious from the slides which we have seen.

Neither as a technique, nor as an intensional, affective aesthetic mode, is realism dead. And, I have deliberately selected for you rather uncompromising realists, excluding pop-artists, and people like David Hockney and Patrick Caulfield whose 'topic' is often the mode of representation, rather than the thing represented. The accent has been on painters who give us 'the most realistic representations' of things in art.

Chambers, with his 'perceptual realism', can be seen, on reflection, as a kind of ideal Aristotelian, the perfect painter of *Poetics* IV. He demands, with his insistence on a photographic matrix, and on the 'embodying of the primary impact' of perception, a visual reality, a world of appearances, recorded without interpretation. He would paint the objective-meaning world of the phenomenologists, eschewing all personal nuance, all emotional colouring. This is a quixotic ideal—but it produces rather fine pictures. *The 401 Towards London No. 1* captures objectivity—and, if you like, recaptures the objectivity that was, essentially, the ideal of the seventeenth-century Dutch masters of sky and landscape, such as van Ruisdael.

But absolute objectivity is an ideal—a theoretical ideal—in aesthetics. And in painting it is, as I have suggested, a matrix, then a value: it is an exercise, then as an asymtote, a kind of final value. Colville and the Mount Allison school give us objective, realistic, 'photographic' painting; but unlike Chambers, they do not offer us interpreted reality. Theirs is, on the contrary, a realism structured more tightly than reality—'primary impact'—and made more crystalline and more significant than life.

It all depends where you think it best to go for reality: Chambers, austerely, sticks to the surfaces of things, to sheer visual appearance; Colville, as toughly and resolutely, goes for structures and for *quiddities*, in the manner of an old-fashioned metaphysician looking for the reality beneath the appearance. But like the most sophisicated of the old metaphysicians, the still viable ones, Aristotle, St. Thomas, Duns Scotus, the Scholastics, Colville knows that part of the reality of such things—a perfectly real part of their reality, if we may be tautologous—is their appearance. What they *are* makes them *look* as they do. Colville then, *par excellence*, paints ontologically, where this entails painting realistically.

Smart, of the painters whom I have—so eclectically—presented to you, has the most *fantasia*: but he does not take credit for it. He gives credit for it to, blames it on to, the world. The world is like this, *poco fantastico*. And its surreal juxtapositions are not just

surface things, they at once are, and are emblematic of, human doubts, anguishes, puzzlements, thrown-nesses. But, coming at the reality of the world by way of its quirks, Smart finds something to rejoice in, beneath its lopsided smile: *The Plastic Garden at the Petrol Station: omne ens est bonum.*

Even if all realisms were as objective and as doctrinairely unnuanced as Chambers's, realism would still be a live mode. Nuanced, taken as matrix and mode both, it cannot fail to be alive. What the artist does in imitating nature is very like what we each of us do in living our lives. It has all been done before, we cannot be original. As the French poet said:

He who plants cabbages *imitates*,[61]

but each planting-time, each bit of life or imitation, aesthetic or real, this has validity, interest, authenticity. Or it may have. It is all up to whoever is doing it.

The painters at whom we have looked have something in common besides their realism—and their realism is, perhaps, a function of this common element: *affirmation*. They all affirm the world, its appearances, the values of a certain life style, quirks of townscape, the being of things. And it is this 'yea'- rather than 'nay'-saying which may be as surprising to some as is their photographic painting. Who can still approve of the world, of life? Well some people can—and these painters do. Speaking humanistically, there is at bottom, perhaps, no obligation to approve of the world and of life. At most such positive acceptance is a heuristic, a regulative principle. But if you are a painter and do feel an enthusiasm for reality, then realism is a very appropriate mode in which to express your valuing of what-there-is.

I have said nothing in favour of the *things-themselves* in the *Realism(e)s* exhibition. Why? Not because I hate, dislike, ignore them; I *love* them, especially the cow Io! But simply because they are, in effect, gestures of a new orthodoxy. And I have taken a brief, tonight, for an old one.

The things-themselves are, too, essentially, things which make sense only given the institutions of the older orthodoxy. Art as the imitation of nature makes sense both ways: as a continuing mode; and as a mode to be—modishly—contradicted.

Imitation enjoys a privileged primacy: first in Aristotle's 'biological' sense, 'we learn our first lessons by imitation'; and secondly, by being the major matrix of the artistic expression of most cultures. *Mimesis* is the thing against which reactions define themselves. The instinct to delight in imitations is, in a sense, as

much the basis—by the principle of difference—for our delight in the non-representational, as it is the basis for our delight in the *mimetic*.

And there is one final argument: contemporary art may— quite contingently—be non-realistic: but realistic art, the imitation of the world, can always be contemporary. After all, the world is.

* ACKNOWLEDGEMENTS: To the Power Institute of Fine Art, University of Sydney, as the final and efficient causes of this lecture, my thanks for inviting me to give it.

To the following persons and institutions who have been part of the formal and material causality:

Mrs. Anita Aarons of the Ontario Art Gallery, who went to extraordinary pains to shoot a complete documentation of the *Realism(e)s 70* exhibition for the author.

artscanada and Mr. Jack Chambers for permission to reproduce the quotations from Jack Chambers' article 'Perceptual Realism' and for the loan of block of/ photograph of Chambers' *The 401 Towards London No. 1*.

The *Canada Council* for their generous hospitality to the author at the *AICA-NADA 70* Conference.

Mr. Alex Colville, for slides, conversation, hospitality and endless patience with letters and enquiries.

The *Canadian High Commission in Australia*, and to Mr. John Sims of the *Trade Commission* who arranged loans of slides from *The National Gallery of Canada, Montreal Museum of Fine Arts, Art Gallery of Ontario* and *The Gallery Moos*.

Mr. Jeffery Smart, for slides, hospitality and patient correspondence.

The Montréal *Musée des Beaux Arts* and Mr. Mario Amaya for permission to quote and to reproduce plates from the *Realism(e)s* catalogue.

Mr. R. Webber, photographer at the University of Western Australia, for many slides, some at very short notice.

And, finally, to the various Chairmen who introduced the Lecture and the lecturer: Professor Bernard Smith in Sydney, Mr. R. Kingsland in Canberra, Dr. Gertrude Langer in Brisbane, Professor Joseph Burke in Melbourne, Mr. W. F. Ellis and Mr. Payne in Launceston, Mr. T. D. Sprod in Hobart, and Dr. Earle Hackett in Adelaide, and to Miss Felicity Moore and Mrs. Suzanne Hayes who arranged the *Arts Council of Australia* tour of the lecture so ably.

NOTES

¹ 'The Bear Who Let It Alone' by James Thurber, in *The Thurber Carnival*, London, Hamish·Hamilton, 1945/60, pp. 252–3. Rereading this profound fable I find it has a moral in it for people on both sides of the present—or of almost any—question.

² Sometime before the Power Lecture for 1971 was given there had been, I was credibly informed, a conceptual-art occurrence in Sydney, in which a young man swallowed a threadworm—or perhaps a threadworm's egg—in an art gallery, so constituting his action a work of art.

For the purposes of the 1971 Power Lecture at least the present writer is at one with Aristotle on both art's *species* and its *genus*: and at one with Plato that art is, essentially, a production of something (see e.g. *Laws* 889). Performative-utterance-art presents a less ancient and more contestable concept than do *making* and *imitating*.

³ *Art imitates nature*: see, for example, *Meterologica* 381b: 'Now broiling and boiling are artificial processes, but the same general kind of thing, as we said, is found in nature too. The affections produced are similar though they lack a name; for art imitates nature. For instance the concoction of food in the body is like boiling, for it takes place in a hot and moist medium and the agent is the heat of the body. So, too, certain forms of indigestion are like imperfect boiling. And it is not true that animals are generated in the concoction of food as some say.' For the purposes of the present lecture, Aristotle's *Poetics* IV is allowed to stand as his first and his last word on *mimesis*: but this is, of course, a gross oversimplification. The *Poetics* IV phrase about 'the most realistic representations' is parasitic upon—and may even be thought by some to be embarrassing to—a whole metaphysic of imitation which Aristotle sketches in his various treatises.

⁴ *Imitation as species*, see Plato, *Sophist* 218d–219d and 235c–237. See also *Laws* 889, cited above. The notion of *mimesis* has for Plato a thoroughly bad sense. It is interesting to notice that what he has to say in *Sophist* 236 is indeed based on facts about art—i.e. about statue-making: what he has to say, e.g. in *Republic* 596 ff. is purely metaphysical. However, though the facts about 'skied' statues are as Plato says in the *Sophist* they are, his implication that the *eikon* is really only a *phantasma* seems to rest on too naïve a notion of what it would be for a work of sculpture to be a proper or true likeness. His 'So, artists, leaving the truth to take care of itself . . .', *Sophist* 236, begs the question splendidly. What indeed *is* truth in this context? The question deserves more attention than Plato gives it in the *Sophist* or the *Republic*.

⁵ *Poetics* IV, Bywater's translation. Italics and omission mine.

⁶ *UNESCO Courier*, Mar. 1971, 'The General Public Judges Modern Art, Findings of an Inquiry', pp. 4–34. The first account of the poll may be found in *Museum*, Vol. XXII, No. 3/4, 1969. The present lecture draws on the *Courier* account.

⁷ Ibid., p. 8.

⁸ See catalogue *Realism(e)s survey/sondage, 70*: The Montreal Museum of Fine Arts/Le Musée des Beaux-Arts de Montréal/8 May–7 June 1970, Art Gallery of Ontario, 7 Aug.–6 Sept. 1970 (un-numbered pages). Preface by Mario Amaya, pp. (3–7), q.v.

The lecture was illustrated with some 180 slides, copies of which are in the Power Institute Collection: the *Realism(e)s* segment was documented with some 50-odd slides run through at 10 seconds each: the polarity between *mimetic* and literal realisms was made, visually, by repeating Mackenzie's *The Window* four times, and by showing Danby's *Pulling Out* both before and after Prent's *Hit and Run* (summer and winter versions): Brown's *The Wedding Tray* was used three times—in colour twice. A sequence, Robin Mackenzie's *Limbwood*, Hugh Mackenzie's *The Window*, *Limbwood*, *Hit and Run*, *Pulling Out* was used to make, visually, the point about a polarity of realisms made conceptually in the lecture itself.

⁹ See *Realism(e)s* catalogue, item 46.

¹⁰ *Realism(e)s* catalogue, item 4.

¹¹ *Pulling Out*, see *Realism(e)s* catalogue, item 11.

¹² For the winter version there is polyester snow: the summer version, which I saw, has no snow. The work is intended, one supposes, to be modified with the seasons. It is to this degree unprecedentedly mimetic, though its mode is that of the-realism-of-the-thing-itself. Given the spirit of the *Realism(e)s* show, this paradox is no doubt calculated. *Realism(e)s* catalogue, item 66.

¹³ *Realism(e)s* catalogue, *Preface*, p (5).

¹⁴ *Limbwood*, *Realism(e)s* catalogue, item 47.

¹⁵ *The History of the Nude in Photography*, Peter Lacy and Anthony La Rotonda, London, Corgi, 1969, p. 27.

¹⁶ *Subway Rides* in *Realism(e)s* catalogue, item 91.

¹⁷ *Realism(e)s* catalogue, item 7. Slide 51.

¹⁸ *The Primacy of Perception*, Maurice Merleau-Ponty, ed. James M. Edie, Northwestern University Press, 1964, 'Eye and Mind', p. 171.

¹⁹ Chambers and Palmer: cf., especially *Messenger Juggling Seed* (1962) (reproduced in the Retrospective Catalogue item 36 cited below, note 21); *Olga near Arva* (1963) (Cat. cit. item 44); and *Unravished Bride* (1961) (Cat. cit. item 31).

As can be seen from the Retrospective Catalogue, the evolution of Chambers's style is more complex than the simple move from his visionary to his hyper-realistic pictures, mentioned in the text. *Sunday Morning No. 2* (1969–70) (Cat. cit.: cover colour plate) should be compared and contrasted not only with Chambers's visionary pictures on the one hand, but on the other with *Saturday Evening Post* covers. Both contrasts are instructive.

²⁰ There is in fact a fine van Ruisdael, *The Bleaching Grounds at Haarlem*, in the Montreal Museum of Fine Arts. This might possibly be one of Chambers's influences. It certainly has affinities with his *401 Towards London No. 1*, but the parallel does not, of course, prove any causal relation.

²¹ *Artscanada*, No. 136/7, Oct. 1969, p. 8, col. 1.

There is a very useful documentation on Chambers in the catalogue of his retrospective exhibition, Vancouver Art Gallery, 23 Sept.–18 Oct. 1970/Art Gallery of Ontario, 7 Nov.–6 Dec. 1970. This catalogue contains invaluable remarks by the artist.

²² *Artscanada*, p. 8, cols. 1–2.

²³ Ibid., p. 8, col. 3.

²⁴ Ibid., p. 7, col. 1.

²⁵ *De Anima*, 429b.

²⁶ Chambers, op. cit., p. 7, col. 2.

²⁷ The best available reproduction of *The 401 Towards London No. 1* is the gatefold plate in this issue of *artscanada*. (There is a less good one in the Studio International special issue *Canadian Art Today*, 42/6, 1970, p. 65.)

²⁸ *The Marriage of Heaven and Hell*, in *The Poetry and Prose of William Blake*, ed. Geoffrey Keynes, London, Nonesuch, 1941, p. 187.

²⁹ Chambers, op. cit., pp. 12–13.

³⁰ *De Anima*, 412b.

³¹ Chambers, op. cit., p. 13, col. 1.

³² *The Primacy of Perception*, 'Eye and Mind', ed. cit., p. 166.

³³ On Alex Colville, see 'The Magic Realism of Alex Colville' by Helen J. Dow, in *The Art Journal*, Vol. XXIV, No. 4, summer 1965, pp. 318–29; 'The Celebrative Realism of Alex Colville' by P. Æ. Hutchings, in *Westerly*, 2/65, Aug. 1965, pp. 55–65; 'Realism, Surrealism and Celebration' by P. Æ. Hutchings, in *The National Gallery of Canada/Bulletin/de la Galerie national du Canada*, Vol. IV, No. 2, 8/1966, pp. 16–28 and 30. Since this lecture was delivered Helen Dow's *The Art of Alex Colville*, Toronto, 1972, McGraw-Hill-Ryerson, has been published. It illustrates virtually his complete *oeuvre*.

The slides shown were: as a *sorbet*, Ingres *Mme d'Haussonville; Stop for Cows* (1967), *Cow and Calf* (1969), *Woman and Terrier* (1963), *Truck Stop* (1966), *Pacific* (1967), *Road Work* (1969), *January* (1971), *Running Dog* (1962), *Child and Dog* (1952), *Visitors are Invited to Register* (1954), *Crow Up Early* (1966), *Boat and Marker* (1964), *Skater* (1964), *Woman at Clotheslines* (1956), *Church and Horse* (1964), *Sign and Harrier*

(1970), *Ravens at the Dump* (1965), *My Father with his Dog* (1968)—these were flashed for some 10 seconds each. To illustrate the text the following slides were shown: *Nude with Dummy* (1950), ditto with simple ϕ grid, *To Prince Edward Island* (1965), ditto artist's geometric schema from notebook, and schema superimposed on picture, *Swimming Race* (1958), action photo of girl diving, rough analysis of *Swimming Race; January* and nine slides of sketchbook studies for the painting. All of these slides were by courtesy of the artist. A number of slides are available from the National Gallery of Canada Ottawa.

[34] *Arts*, Vol. XXXVIII, 1958, p. 53.

[35] *Sunday Times*, 18 Jan. 1970. *Woman with a Terrier* is reproduced in colour in 'He Paints a World You've Never Seen' by Murray Barnard, in the *Star Weekly*, Toronto, 27 Aug. 1966, q.v. See also Dow, op. cit., 1972.

[36] '. . . In my opinion painting should be considered excellent in proportion as it approaches the effect of relief', Michelangelo: cf. *Michelangelo a Self Portrait*, ed. R. J. Clements, N.Y., 1963, Prentice Hall, pp. 8 and 9.

[37] The Frick Piero *St. Simon the Apostle* is reproduced in *Masterpieces of The Frick Collection*, D. M. Grier and E. Munhall, N.Y., 1970, Frick, London, Thames & Hudson, p. 97. The Mantegna *Dido* and *Judith* are reproduced in the *Catalogue* of the Montreal Museum of Fine Arts, Montreal, 1960, p. 42.

[38] *The Norman Rockwell Album*, N.Y., Doubleday, 1961, contains a fine selection of the *Post* covers, and a very frank, perceptive, and self-critical essay by Rockwell on his own work. His self-evaluation is as courageous as his illustrations are craftsmanlike.

[39] See *An Introduction to Egyptian Art* by Boris de Rachewiltz, trans. R. H. Booth-royd, London, Spring Books, 1960, pp. 24 ff. For a detailed analysis see *Geometry in Egyptian Art* by E. C. Kielland, London, Tiranti, 1955.

[40] The analytical grid here is of the kind that one sometimes finds in art-appreciation books, drawn over Seurat paintings: the rule is simply to cut the edges of the picture surface at ϕ and see whether any important elements of the composition fall on lines connecting ϕ points.

[41] Reproduced in colour in the *Star Weekly* article cited above, q.v., and in Dow, 1972.

[42] *Swimming Race* is reproduced in colour in Hutchings's article in *Westerly* cited above; and in the *Nat. Gall. Canada Bulletin*, cited above, in black and white, and in Dow, 1972.

[43] *Letter* to P. AE Hutchings, 25 Sept. 1965.

[44] The text refers to a colour slide of the painting, and to a series of nine sketches for details of the picture which we have not, unfortunately, space to reproduce here, See Dow, 1972.

[45] *The Primacy of Perception*, p. 164. The phrase 'the inside of the outside' is used in Merleau-Ponty in a more complex way than we use it. Consider:

'The word "image" is in bad repute because we have thoughtlessly believed that a design was a tracing, a copy, a second thing, and that the mental image was such a design, belonging among our private bric-a-brac. But if in fact it is nothing of the kind, then neither the design nor the painting belongs to the in-itself any more than the image does. They are the inside of the outside and the outside of the inside, which the duplicity of feeling (*le sentir*) makes possible and without which we would never understand the quasi presence and imminent visibility which make up the whole problem of the imaginary. The picture and the actor's mimicry are not devices to be borrowed from the real world in order to signify prosaic things which are absent. For the imaginary is much nearer to, and much farther away from, the actual—nearer because it is in my body as a diagram of

the life of the actual, with all its pulp and carnal obverse (*son envers charnel*) exposed to view for the first time. In this sense, Giacometti says energetically, "What interests me in all paintings is resemblance—that is, what is resemblance for me: something which makes me discover more of the world."'

[46] The phrase 'a voracious eye' is an interpretative misremembering of René Huyghe's remark: 'Ingres extracts maximum brilliance from every tone, often at the price of discordance: *his strongest emotion is of sensual avidity*, where that of Delacroix is compassion', *Art and The Spirit of Man* by René Huyghe, London, Thames & Hudson, 1962, p. 44, italics mine.

[47] See Catalogue of an exhibition at the Galerie Godard Lefort, 1400 Sherbrooke Ouest, Montreal, 15 Apr.–1 May 1970. Exhibition organized by Peter Bell, Curator, Art Gallery, Memorial University, St. John's, Newfoundland.

[48] See *Realism(e)s* catalogue, item 46, plate. Slides shown were of *Self Portrait* (1965), *The Bamboo Poles* (n.d.), and *The Window*.

[49] See the Catalogue of the Ken Danby exhibition at the Gallery Moos, 138 Yorkville Ave., Toronto 5, Canada, Dec. 1967. Essay by Paul Duval.

[50] *Compendium of Theology*, St. Thomas Aquinas, trans. Cyril Vollert S.J., St. Louis and London, Herder, 1952, Ch. 115, pp. 119–20. See also in *Opusculum XIV*, Exposition *de Divinis Nominibus*, liv, lect. 5.

[51] Communicated to me by Smart. See 'Jeffrey Smart' by Sandra McGrath, *Art and Australia*, Vol. VII, No. 1, June 1969, pp. 32–9; Catalogue to the Jeffrey Smart exhibition, Leicester Galleries, London, June 1970, by P. Æ. Hutchings; 'Control Tower, by Jeffrey Smart' by John Baily, in *Bulletin of the Art Gallery of South Australia*, Vol. XXXII, No. 2, Oct. 1970, pp. 3–5 and 7.

It is significant that Mario Amaya should begin his Preface to the *Realism(e)s* catalogue with the sentence: 'In our Century, the term "realism" (either used as a proper noun or joined to an adjective such as in Sur-Realism, Super Realism, Magic Realism, etc.), has on the whole come to mean an approach to painting recognizable things with more or less perceptual objectivity.' What one must do is disentangle these realisms of 'perceptual objectivity' from sur-realisms. Smart is most articulate on this point—as a painter in the first place, and as a commentator on his own pictures in the second.

[52] *The End of the Autostrada* is reproduced in colour in Sandra McGrath's article cited above.

[53] *Last Poems*, IX, by A. E. Housman.

[54] Letter to P. Æ. Hutchings, 16 July 1971.

[55] Ibid.

[56] Ibid.

[57] Ibid.

[58] *Mr. T. S. Eugenides on a Rooftop, Athens* slide.

[59] *Holiday* slide.

[60] Letter cited above.

[61] Rien n'appartient à rien, toute appartient à tous.
 Il faut être ignorant comme un maître d'école
 Pour se flatter de dire une seule parole
 Que personne ici-bas n'ait pu dire avant vous.
 C'est imiter quelqu'un que de planter des choux.

 De Musset, *Namouna*. Chant II, 9.

The lecture was first delivered in the University of Sydney on Monday 6 September 1971 and is here published for the first time.

V. Style now

RICHARD WOLLHEIM

I

'STYLE NOW'. The title of this lecture—or my choice of it—would seem to stand in need of explanation. That explanation I shall try to provide as we go along. For there are a number of reasons why, at this juncture, I should want to take up the problem of style. Some of these reasons are quite subjective, and stem from my present interests. Others are quite a bit more objective and relate either to current intellectual inquiry or to the condition of the visual arts today. Rather, therefore, than try to present these reasons at the outset, I shall introduce them into the discussion as and when they seem relevant. I should like to express my deep gratitude to the Power Institute for its invitation to deliver this lecture, and so for the opportunity to review these issues in a new and challenging environment.

2

Let me start with the last of the reasons that I suggested for my choice of topic: the condition of the visual arts today.

I do not have to remind you that there exists a whole band of writers and thinkers—more numerous perhaps than those who live by art—who live by telling us that art is in a state of crisis: nor shall I burden you with the various diagnoses and remedies that have been proposed for this crisis. Myself I am some way from being convinced on this score. But I must say this: that long before I became involved—or entangled—in the theoretical issues I want to take up in this lecture, it seemed to me very plausible to think that, if there is a crisis in the visual arts today, or, if you prefer, in so far as there is a crisis in the visual arts today, this comes from the particular difficulties that confront the contemporary painter in the formation of a style. These difficulties have ultimately their source in the market-place, in the alliance of dealer and client. For wide open to new influences, new forms, new ideas though this alliance may be, on one matter it is quite insistent, and that is that a painter with whom it involves itself

should have learnt to impose upon his work an immediate and instantaneous look of its own. This, it seems to me, is the most powerful pressure under which the contemporary painter labours. He is forced, we might say, to seek recognition through the recognizability of his work. And recognizability is not merely not the same as, in some cases it is quite inimical to, the existence of a style.

This last point is, I am aware, not obvious. Indeed to some it may seem counter-intuitive. To establish for it a modicum of plausibility will involve determining some of the central characteristics of style. This is what I shall now try to do. Then at the very end of this lecture I shall return quite briefly to the issue I have raised, which was one but only one of the reasons I had for wanting to talk about style. And I hope that what I meanwhile will have found to say about style will have an interest of its own.

3

To determine the first characteristic of style as I see it, let me start with a rather simple fact: a fact about our attitude towards painting. For me it is an incontestable fact, and I am reasonably confident that it will seem so at least to some of you. If it does not seem so to you, I may say something that will alter your perception. Or if—which I think more likely—you are initially inclined to take it as an incontestable fact, then shy away from it in fear of its implications, I hope I shall give you reason to see that its implications aren't that fearsome. The fact is this: that in so far as we are interested in paintings, what we are interested in is the paintings of painters. Or better, perhaps, in so far as we are interested in paintings as paintings, what we are interested in is the paintings of painters. Of course, on occasions, we are also interested in, or may also be interested in, the paintings of schizophrenics, of art-school applicants, of chimpanzees, of world politicians, of our own children. But on any such occasion, I would wish to say, we are not interested in the painting as a painting. We look to the painting in order to diagnose sickness, to discover promise, to validate a theory, to elicit biographical information, or simply because it is by whom it is. And though I would be the first to agree—as against a mistaken but quite widespread 'purism' in criticism—that, when we are interested in a painting as a painting, we may quite legitimately draw on history, on biography, on evaluation, it seems to me quite inconsistent with this kind of interest—let us call it an aesthetic interest—that we should go to the painting just to get from it such information. So the fact that

the paintings of non-painters should interest us in a large variety of ways, emotional, sentimental, doesn't go against the fact that I've taken as my starting-point—that it is only the paintings of painters that can interest us as paintings.

And this, let me emphasize, is both in itself and in the use to which I put it in the course of my argument, a fact specifically about painting, in that it does not rest for its acceptability upon some more general fact about the arts, which may, or may not, be so. In other words, what I have said about the limits of our aesthetic interest in painting does not oblige me to think that an aesthetic interest must be similarly confined to the poems of poets, to the novels of novelists, to the music of composers. In point of fact, my own view on this matter, for which I shall not be able to argue, is that the arts can be arranged on some kind of a spectrum, according to the degree to which habituation and aesthetic interest go together. At one end of this spectrum there lies painting, at the other the novel, and points in between are occupied by music, poetry, sculpture. But I am not, of course, asking you to accept any of this. I have brought it up only to show that what I claim to be a fact about painting I claim as a fact specifically about painting, and I am not just using painting to assert some more general thesis.

To the question—the next to arise—why it should be that the only paintings that interest us as paintings are the work of painters, the most obvious answer would be. Because they are much better. It takes a painter to turn out a good painting. However, I doubt if this is the right answer. Or if it is the right answer—and there may be a very broad way of taking it such that it is—I am quite sure that to put it this way conceals at least as much of the truth as it reveals.

For, in the first place, it seems not to be generally true, as the answer assumes, that we take an interest only in good paintings. Of course, life is short, art is voluminous, and there comes a point when we should be wasting our time looking at the third- or even at the second-rate. But my feeling would be that, if someone looked exclusively at good paintings, found nothing of interest in anything else, we should fairly soon come to doubt whether he was really interested in painting at all. I leave that thought with you. Secondly, it isn't true—as once again the answer assumes—that the question whether a painting is good or not can be settled independently of whether it is or isn't by a painter. Consider a situation which we may well have found ourselves in: We are shown a painting, we think we recognize the artist, we then learn

that it is our host's one and only shot. Our evaluation is bound to change. Of course, this might be due to snobbery, but it needn't be, for even if we are free from any such weakness, the opinion that we hold of the picture is almost bound to shift.

But to understand this case, with which I shall stay for a moment, contrast what happens here with what happens in another kind of case to which it bears a marked superficial resemblance. And that is when we learn that a painting is not by one painter but by another. A painting, we learn, is not by Gris but is by one of those painters who turned Cubism into an academic discipline. For here too there is room for a shift of opinion, and the shift need not be, though of course it could be, due to snobbery. For what might happen is that, now knowing what we know about the painting's authorship, we are able to perceive demerits in it that were previously masked from us. On the basis of this change in out perception, our opinion legitimately shifts. We don't simply *say* that it is less good—that would indeed be snobbery—we *see* that it is less good.

But when we learn, not that the painting is by a painter other than whom we thought it by, but that it is not by a painter at all, the situation is in several respects different. One: the shift in opinion is now mandatory. Our old opinion just cannot, in such a case, survive the revelation—whereas in the other case we might, mightn't we, go on to think that for one splendid moment in his life Gleizes managed to paint as well as Gris. Two: our opinion, when it shifts, will, characteristically, not go either up or down. It will go more like sideways. In other words, we shall lose all willingness to pass judgment on the painting, and if, nevertheless, we are pressed to do so, we shall feel the unfairness of the pressure. And three: the shift in our opinion—the lateral move out of evaluation—will be based not on a change in our perceptions but, rather, on a loss of confidence in what we perceive. We shall no longer know what weight to attach to what shows up on the canvas. We shall feel ourselves in no position to say how much of what is there is intentional, and how much is accidental. Or how much of what is accidental is just sheer accident, and how much was allowed and encouraged to happen as it did. Or how much of what is intentional came about because there seemed nothing better to do, and how much came about because it seemed the thing to do or what had to be done.

If all this is roughly true, and I am at this stage aiming at no more than approximation to truth, we can see how misleading it is to say that the work of someone who isn't a painter will fail

to interest us because it is too bad. It looks rather as though there is no way open to us of saying whether it is good or bad. And the reason for this lies not with something present in the painting that then spoils or mars it, but rather with something absent from the person who painted it. An omniscient critic confronted by the bad painting of a painter might be able to say how it could be rectified; confronted by the painting of a non-painter, he could only say how he or she might be rectified.

But what would he say? For what is it that the non-painter necessarily lacks, and that the painter may possess? The suggestion I shall make this evening will not, I am sure, surprise you. It is that the crucial difference between the painter and the non-painter lies in the fact that the formation of a style is open to the one, but not to the other. Likewise it is the exercise of a formed style that is the precondition of our aesthetic interest in painting.

But to say this is to give little away until something further is said about what style is: until more of its characteristics, over and above this one, are collected. Two problems, considered and put together, may advance our understanding.

4

In the domain of art-history the concept of style is widely used: so much so that it might seem to provide a natural starting-point for any inquiry into the nature of style. Yet I suggest that any sustained reading in the conventional literature of art history is likely to leave one with the feeling that, far from its being the case, as I've maintained, that style is somehow crucial to the question of aesthetic interest, the very notion of style is fit only to be scrapped. For the literature provides us, on a scale to which quotation could not do justice, with characterizations of one and the same style which are demonstrably inconsistent. Sometimes the inconsistencies are overt: when one art-historian denies what another asserts. Sometimes the inconsistencies are covert: when the characterizations seem merely to be different, but each lays claim to completeness. Either way round, what are we to make of a notion which can give rise to such diversity of opinion on almost any occasion of its application? What claims can it lay to clarity or distinctness?

Recently a suggestion has been made which could account for the situation I have just described, and account for it not just in that it would explain how it came about, but also in that it would to some degree legitimize it. The author of the suggestion is a philosopher, Morris Weitz,[1] and Weitz argues that we are worried

about the existing state of stylistic analysis only because our expectations are all wrong. We look for a style-characterization that would catch the essence or true nature of a style and, when different characterizations of the same style conflict, we conclude that at least one must be wrong. But this is to miss the point of stylistic analysis, which is, in effect, a way that art-historians have of classifying pictures or features of pictures into groups that they happen to find convenient. And what is convenient for one art-historian may well not be convenient for another. For the two may differ in their point of view and, differing in point of view, will differ also in the respects in which they find it significant that paintings resemble, alternatively are unlike, one another. Once we understand this, we shall no longer be troubled by the seeming inconsistencies between style-characterizations. Indeed we shall come to recognize the phenomenon for what it is: a symptom of the continuing vitality of art-historical inquiry. It is evidence of the fact that art-historians are able to see their material in different perspectives, from new positions of vantage, and so preserve the freshness, the vivacity of the material itself. Stylistic concepts are not only, in Weitz's quasi-technical usage of the term, 'irreducibly vague'; they are also, he contends, 'beneficially vague'.[2] And, as we come to appreciate this, our interest will at the same time shift from the style-characterizations themselves to what lies behind them: to the different points of view occupied by art-historians, and to the different 'style-giving reasons' which they correspondingly find adequate.

I have introduced Weitz's suggestion as a way of dealing with one charge that can be brought against conventional style-characterizations: that they are often mutually inconsistent. But it is worth pointing out that it simultaneously goes some way to meeting another charge that can be brought against them: that they are internally incoherent. So often they read like mere inventories of pictorial features that have been brought together in a haphazard way without unity or system. For to this objection Weitz would have the reply that style-characterizations have, if not an explicit, then an implicit, unity, a unity which derives from the point of view of the art-historian. If the features that compose them seem at first quite unconnected, what they have in common is that they are those features which simultaneously come into focus when viewed from a single, specific point.

Yet I find Weitz's suggestion ultimately untenable. The rescue operation it carries out in the interest of style is too costly, and, if I have spent time upon it, it is in order to understand what the

concept of style cannot afford to give up even to gain philosophical respectability. For what Weitz's argument denies to style is the character of being generative. Style on such a view—and the view in one form or another is very common—has nothing to contribute to the making or construction of a painting. The view must deny this: for if one did think that style was something operative, how could one be satisfied with a characterization of style that was made exclusively from the art-historian's, or any other purely external, point of view? ('External' meaning in this context external to the painter himself.)

An analogy might be useful. Let us imagine some anthropologists who are attempting to survey over a fairly extensive territory a diverse array of utterances and inscriptions and to classify these according to the language they are in. Now, one way they might proceed would be to regard the classification as determined entirely by questions of convenience. In that case, since it is natural to assume that different anthropologists would have different senses of what was convenient, a likely outcome is that there would be disagreement about where one language began and another ended, and also, of course, disagreement about how any one language should be characterized—how, as we should say, its grammar should be constructed. And, as the case has been set out, all these disagreements would be acceptable if, but only if, they could be traced to disagreement on pragmatic issues or the method of classification. But suppose that the anthropologists came to think that the variety of the utterances and inscriptions they were attempting to survey could, in part at least, be explained by reference to the different languages they were in, or that the grammar of those languages had been operative in the production of the utterances and inscriptions; then, it seems, they would have to change the way in which they proceeded. No longer would it be possible for them to treat all outstanding issues between them as though they were mere matters of convenience. For these issues, or some of them, would have now to be recognized as being or as involving matters of fact, and both in distinguishing one language from another and in setting out the grammar of each, our anthropologists would have to respect this constraint: that their classification would have to correspond to the intuitions of the native speakers of the various languages.

That this second way of proceeding is the right way in respect of language classification and language analysis is, I take it, quite obvious, and my point (as against Weitz) would be that the same procedure is called for in the matter of pictorial style. For I

139

would claim that style is generative in the production of paintings in much the same way as grammar is generative in the production of utterances and inscriptions. And as direct confirmation of this, there is, interestingly enough, one significant context in which we admit this. And that is when we judge the work of a painter, either over a period of time or in a given painting, to be mixed or transitional in style: for in making such a judgment, we thereby impute an element of tension, or indecision to the work—tension or indecision which may be harmful or may be creative. But the tension or indecision is in the work—such is the implication of what we say; whereas on a Weitz-like view of the matter, it need only be in us. On a view like his, our judgment would show either that we could not sort out our categories or that we could not make up our minds.

To sum up my position *vis-à-vis* that of Weitz, I should say that, though he is right to think that all style-characterizations include a point of view, he is wrong to think that the point of view should be the art-historian's rather than the artist's. And he goes wrong because he fails to appreciate the generative role of style in art. But to say that style is generative—which I shall now assert as the second characteristic of style—is open to misunderstanding, and I want briefly to dissociate myself from two possible misunderstandings. In the first place, I have said nothing to suggest that the painter has explicit knowledge of, or could bring into consciousness, the operations that constitute his style. I am sure in fact that he could not; I am sure—to put it another way— that the artist could not anticipate the art-historian in a significant part of his work. Secondly, if the procedures that constitute a painter's style turn out to be complex and highly structured, it does not follow that the painter in each and every exercise of his competence runs through these procedures, either consciously or otherwise. There are many cases where a skill, like computing, depends upon the acquisition of elaborate operations, and in employing this skill we consequently draw upon these procedures, but not by means of an internal rehearsal of them.

I said that there were two problems which, when considered and put together, might advance our understanding of pictorial style. Let me now turn to the second problem: which starts at one remove back from our topic.

5

Ernst Gombrich is a thinker to whom not only I, but anyone seriously interested in the theory of the arts, must be deeply in-

debted. A problem to which Gombrich has returned on a number of occasions—most notably in the last chapter of *Art and Illusion* and in some of the essays that make up *Meditations on a Hobby Horse*[3]—is that of expression, and of the undoubted power of paintings to express human feelings, moods, or emotions. What Gombrich has found to say on this problem is complex and defies ready summary. But a contention that he has consistently advanced is that, in order to understand the expressive significance of a painting, we need to know the alternatives (that is, the equi-probable alternatives) that were open to the painter and between which the painting before us therefore represents a specific choice on the painter's part. What the painter did on the surface of his canvas he did in preference to certain other things he might equally well have done: and we must learn what those other things were before we can say what the painting expresses. The expressive meaning of the painting lies, we might say, not just in its being what it is—say A: it lies in its being what-it-is-rather-than-another-thing—say A-rather-than-B-or-C-or-D-or-E, where B to E are the kinds of thing that it was equally open to this painter to have done or made. In the following quotation Gombrich tries to clinch the point by making us see how one and the same feature of a work of art could, if drawn or selected from different sets of alternatives, have quite different significance:

What strikes us as a dissonance in Haydn [he writes] might pass un-noticed in a post-Wagnerian context and even the *fortissimo* of a string quartet may have fewer decibels than the pianissimo of a large symphony orchestra. Our ability to interpret the emotional impact of one or the other depends on our understanding that this is the most dissonant or the loudest end of the scale within which the composer operated.[4]

Or again, Gombrich asks us to consider the very different impact that Mondrian's *Broadway Boogie Woogie* might make on us if we were to learn that it was the work not of a painter given to severe geometrical designs but one to whom animation or turbulent forms came more naturally: say, Severini.[5] Whatever we make of the detail of this example, indeed of either example, the point comes across: the expressive meaning lies in the choice in which the painting originates.

Gombrich's theory of expression gives rise to difficulties because, at any rate at times, he seems to suggest that, for us to grasp what a painting expresses, it is not only necessary to know the alternatives out of which the painting, or the various features of the painting, were selected; but that to know this is sufficient. When

we know this, we thereby know what the painting expresses. In this lecture I shall pass over all difficulties that arise from this source,[6] and concentrate on one problem which exists not just for Gombrich but for anyone who thinks—as indeed I do—that the existence of alternatives is a corollary of expression. And the problem is this: How are we, given some part of the output of a particular painter, to determine the range of alternatives out of which that which we have before us is a selection? How are we on the basis of his *oeuvre* to reconstruct his repertoire?

The first point to recognize is that this problem remains, however much (or however little) we have of the *oeuvre* under inspection. For, even if we have the whole of the *oeuvre* before us, it is always possible that we do not have the whole of the repertoire; for there might be some fraction of the repertoire that the painter never employed. This would happen, of course, if there were certain feelings or moods or emotions that the painter never had occasion to express. These mental states (to use a blanket term) never having called for expression, no use would have been found for the corresponding part of the repertoire.

So it follows that, if we want to reconstruct the repertoire from a portion of the *oeuvre*—small, large, total—what we need to know as a preliminary is whether we have the whole or less than the whole of the repertoire before us. And initially this might seem easy enough. But reflection shows that, as Gombrich has laid out the issue, such knowledge is unobtainable. For the only way we could have of finding out whether the part of the painter's work that we have before us exhibits the whole of his repertoire is to determine whether he has expressed the full range of mental states open to him, or whether there were some he never had occasion to express. But to determine whether he expressed the full range of mental states, we need to determine what mental states he did express. And this, on Gombrich's view, we cannot determine until we know the repertoire—which is just what we want to find out. So we move round in an unbreakable circle.

I think that there is a way of breaking out of this circle, though it would require an alteration to Gombrich's account. But such an alteration is, I think, required on general grounds as well as to meet this particular problem. The alteration consists in substituting for the notion of the repertoire a more powerful notion. For the notion of the repertoire does not imply any linkage or significant interrelationship between the alternatives that constitute it. The repertoire collects its constituents like a shopping-list. The alteration I propose would be that we substitute for this

142

notion a stronger notion—let me call it for the moment that of the repertoire-plus—which further insists that the constituent alternatives fall together or form a unity. With such a notion the problem of our knowledge of the repertoire begins to admit of solution. For now the possibility is open that, from a fair sample of the painter's work, we should be able to reconstruct the full range of alternatives with which he operated. What opens up this possibility is, of course, the whole in which the alternatives are united. And in addition to resolving this problem, the introduction of the repertoire-plus has the advantage that it gives a more realistic picture of the structure within which the painter normally works. All I have now to do is to introduce for the new notion an old word which seems to express it better than the clumsy locution to which I have resorted. That word (need I say?) is 'style'.[7] But in simultaneously strengthening Gombrich's conception and introducing a new word for it, I have elicited a third characteristic of style: that style permits expression. Gombrich in his account of expression makes difficulties for himself by using a weaker conception of style than either his arguments or the facts of the case necessitate.

6

I now want to pause and review the situation. I shall assume that the concept of style as I have identified it in these three contexts is one and the same concept: an assumption whose acceptability or otherwise must depend on its consequences.

So far the following characteristics of pictorial style have emerged: First, style is the precondition of our aesthetic interest in a painting; it is only a painting in a formed style that can— though of course it may not—interest us as a painting. Secondly, style is generative; or, to put it somewhat differently, style is something that the painter internalizes. Thirdly, style permits expression.

Now, the first two characteristics clearly go together, in that the first suggests the second. For, if style were purely classificatory or assigned from an altogether external point of view, it is obscure how its possession could set the painter significantly apart from the non-painter; or, to put it more precisely, how style-possession could explain why the work of the one has an aesthetic interest denied to the work of the other. (Indeed, as we have seen, on the classificatory view, the assignment of a style to a painter would seem to be as much a fact about us, who make the classification, as about the painter, who is classified.)

However, if on one (the classificatory) view of style we don't see how its possession *could* account for aesthetic interest, there still remains the question how on the other (the generative) view it actually *does*. And here I must take up the third characteristic of style: that it permits expression. The point, which I put—rather obscurely, you may have felt—by saying that we don't know what weight to attach to what shows up on the canvas of the non-painter might now be rephrased as: We don't know how far we are entitled to find it expressive; we cannot say whether it speaks to us.

But that style permits expression is so far simply a view I have taken over from Gombrich. What reason is there to accept it? I shall not answer this question directly. For though I think that the Gombrich thesis is right in its central intention, I think that the account he proposes of how style permits expression is defective. So what I shall do is to adjust the account, and then hope that the revised picture we are offered of the relations between the two will have an intuitive acceptability. For, according to Gombrich, style permits expression in that style is a set of alternatives; and this suffices in that expression is a choice within a set of alternatives. Very roughly, I want to suggest that this reverses the order of things, which is that style gives rise to alternatives because it permits expression. But since this is rough, let me explain.

I think that style permits expression in two broadly distinct ways, both of which are present in the work of most painters, though to varying degrees. In the first place, since style consists in a systematic way of elaborating or operating on content, it has the consequence that different contents can receive clear and articulated formulation. In many cases the expressive significance of a work will reside straightforwardly in the content. In the absence of style, content would not come through, it would not be preserved; and so style permits expression by allowing the painter to do just this. Secondly, style is linked to expression more immediately, and that is because the style itself may be expressive. Expressive significance now resides not just in the content but in what specifically happens to the content. It is no longer the *fact* of elaboration, it is the *manner* of elaboration, that leads to expression. In *Guernica*, it is the assurance with which Picasso constructs the painting that allows us to collect the content: and along the way we pick up more expression from the type, shape, and combination of the elements.

It is worth observing that, though these two ways in which

style permits expression are complementary, there is also, potentially at any rate, a tension between them—a tension that has left its mark, if obscurely, in many theoretical discussions of style. For the first way encourages the view that style is omnivorous, that it can absorb everything, or that in any given style anything can be stated. The second way, however, encourages a more selective or fastidious view of style: so that different styles are appropriate to different content, and in any given style not everything can be stated.

I think that an account such as I have given of the relations between style and expression not only gives us a better insight into expression in painting, it also fits in better with what we know already about style. For it might be said that intrinsic to Gombrich's unrevised thesis is a view of style that is essentially lexical—a view, that is to say, that equates style with a set or list of items, if of a very diversified kind. A style is like a vocabulary. But the view of style implicit in the revision that I have provided of Gombrich's thesis presents style less as a set of items, more as something that determines that set. Style, in other words, turns up in my view more as something law-like or regulative. And this view of style fits in better, I think, with one characteristic of style that I have already reviewed—namely, that style is generative—and also with another characteristic which I have mentioned but not reviewed—that style has a unity. For that unity it is now possible to locate in something like a coherent set of rules, though how to define a coherent, as opposed to a merely consistent, set of rules remains a problem. (In point of fact, I doubt if the unity of a style, or indeed a style itself, can be fully characterized until we place an expressive interpretation on it.) And the view of style as law-like or regulative also fits in well with yet another, a fifth, characteristic of style which I shall mention now, but not again. And that is this: that in the internalization of pictorial style a crucial role is played by physical or psychomotor control. Style modifies the laws of bodily behaviour. To adapt a famous saying of the modern world: Style begins at the end of a hand.

We now need to ask, What is the nature or character of the rules in which style consists? The rest of this lecture will attempt, if obliquely, to answer this question. But first, let me now return—now that we have so many of the characteristics of style laid out before us—to a remark, made earlier, and which may have seemed odd at the time. I said, you will remember, that we should not expect much illumination from the conventional literature of art-history. I meant that remark: that is, I intended a distinction

within the literature. For I think that the characterization of style that I have been proposing fits in very significantly with what has been said, or suggested, within the other, the 'unconventional' literature of art-history. I refer to the work of such powerful thinkers as Wölfflin, Riegl, or Paul Frankl: to whom I owe a great debt.

<div align="center">7</div>

At this point, I want to change course in my argument. In doing so I shall give a fresh significance to the title, and I hope a further justification to the topic, of this lecture.

Of recent years, as you will know, some far better than I, important advances have been made in our understanding of language through the systematic development of theoretical linguistics. Of course, there has been much distinguished work in this field, but I am thinking particularly of the work associated with Noam Chomsky and his collaborators. Transformational grammar is only one strand in contemporary linguistics, but to many, including myself, it offers the most exciting and illuminating perspective on the subject. More recently, in the last six or seven years, scholars of literature have drawn on transformational grammar to explore what traditionally have been dark areas in critical theory. One of these areas is that of literary style; 'stylistics' is not a new word in critical terminology, but it would be fair to say that the subject has of late been opened up in a way that offers new promise.[8]

Let me try to explain how transformational grammar has been applied to the problem of literary style. According to generative grammar—a subject broader than transformational grammar— a grammar (that is, the grammar of a given language) is thought of as a device or mechanism for producing, or from which may be derived, all those sentences of that language which, independently, we think of as grammatical. What makes a grammar transformational is that it accounts for the derivation of grammatical sentences in two phases. Only the second phase is of concern to us. In this phase we start off with underlying strings of elements which aren't words but are more abstract than that. We operate on those strings or deep structures by means of rules called 'transformation rules', and we get what are recognizably sentences or surface structures. Now one feature of any such rule is that, relative to a given underlying string, it is either obligatory or optional. Obligatory, if we have to apply the rule in order to derive a sentence; optional, if there is a choice of rules, any one

of which will get us a sentence. It is precisely at this point that the application of transformational grammar to literary style has occurred; for the argument has been that a writer's style can, in part at any rate, be understood in terms of the optional rules he characteristically employs. So, Richard Ohmann, in a highly suggestive essay entitled 'Generative Grammars and the Concept of Literary Style',[9] has attempted to account for the style of Faulkner, Hemingway, and D. H. Lawrence by exhibiting their consistent preference for certain optional transformations— for instance, the use in Faulkner of the relative clause transformation and the conjunctive transformation—and he provided a check on this hypothesis by taking passages from these writers and then systematically reversing these transformations or using other optional transformations, so that we could observe how, under such a simple procedure, most of the features which a sensitive reader would intuitively identify as characteristic of the style of the writer in question are obliterated. Of course, the style-characterizations with which Ohmann's argument is concerned are still very broad, but he justifiably points out how far they take us, considering the minimal grammatical apparatus that they invoke.

The suggestion that I should like to make—and for the purposes of this lecture it will remain strictly on the level of a suggestion— is that it might well be possible and profitable to extend to the problem of pictorial style the techniques and procedures that appear to offer so much within literary inquiry. But where I say 'possible' and 'profitable', each of these words, it must be recognized, could serve as the heading for a lengthy discussion. For note at the outset a most obvious difference between applying a transformational analysis, on the one hand to literary, on the other hand to pictorial, style. And that is that in the first case, but not in the second, the proposed analysis occurs within a heavily prepared context. For it is against the background of thinking that language use in general can be explained in terms of transformational grammar that the attempt is undertaken to account for certain special and idiosyncratic uses of language by appeal to some fragment of such a grammar. But nothing analogous exists in the case of painting.

Let me first make certain that I have put this last point clearly. If a critic applies transformational grammar to the elucidation of literary style, he will do so on the basis of a pair of beliefs to which he subscribes: first, he will believe that there is a grammar of a transformational kind that fits the language concerned; but,

secondly, he will also believe, more generally, that all grammars must be transformational in character. Or, to put the matter the other way round, he will judge the transformational grammar with which he works to be *descriptively* adequate, in its fit to the language it is about, and also *explanatorily* adequate, in its fit to the theory that is about it.[10] Now it may be that an account of painting that is going to fit the facts will turn out to be transformational in character. And it may also turn out that any such account, or indeed any such account of any of the arts, must be transformational in character; that is, that we shall have a theory of art to show this. But as yet we know none of this, and we cannot assume it. More specifically, we cannot assume the first on the basis of the second. Indeed, I should tend to think that, if we ever do establish any general findings about what, say, painting must be like, it is at least as probable that we shall establish them through an understanding of what pictorial style is as that we shall be able to appeal to these general findings in our efforts to understand style.

And that is why the issues of *possibility* and *profitability* loom so large in considering a transformational approach to pictorial style. First, then, what are the preconditions of such an approach? Specific to the approach is the conviction that the terminal objects under inquiry—that is, the physical paintings—can be accounted for as the output of a two-stage process, the second stage of which consists in the operation upon an abstract base by means of transformation rules. And the most important single feature that a transformation rule exhibits is that it applies to an object *in virtue of its structure*. Sometimes the effect of applying a transformation rule is that structure changes as we move from base to terminal object, sometimes structure remains constant, but always the operation of the rule takes account only of structural aspects.[11] From this it follows that the two most general preconditions for a transformational approach are, first, that we should have adequate motivation for postulating in the domain of painting a distinction between base objects and surface objects, and, secondly, that we should have an acceptable method for picking out structure or applying structural descriptions at both levels.

In the case of language, the most powerful motive for distinguishing levels, deep and surface, is the issue of ambiguity.[12] For, though some ambiguities can be resolved straightforwardly on the surface by introducing brackets—for instance, the sentence: 'I saw the little girl's dress' can be disambiguated by (as it were) punctuating the sentence—other cases of ambiguity require us to

postulate for the different interpretations different underlying sources or, as the phrase goes, different transformational histories. For instance, the now notorious 'Flying planes can be dangerous' can be disambiguated by referring either to a string containing the equivalent of 'planes which are flying' or to a different string containing the equivalent of 'someone flies planes'. And a related, and perhaps a more generalized, motivation is the desire to bring out the close connections that obviously exist between certain sentences, but where this closeness of connection cannot be exhibited by a matching of surface structures e.g. (though this relates to an earlier formulation of the theory) the active and passive versions of a sentence. Now I suggest that a similar motivation holds good in the domain of pictures. Certainly I can think of cases where paintings, if they aren't identical, look very similar, and yet they are to be understood in very different ways. For instance, the colour experimental works of Josef Albers and the stark paintings of certain minimalists like Ad Reinhardt. And I am inclined to think that an explanation of the differences (or, more accurately, differences despite similarity) in terms of derivational history is quite promising. And perhaps the introduction of deep pictorial structures does justice to what certain earlier thinkers had in mind when they conceived of physical paintings as derived from 'mental' paintings or some such shadow entities.

On the very complex question, whether we can, in any kind of principled way, assign structural descriptions to paintings on surface and deep levels, the biggest issue is what categories we are to use within such descriptions. What, in other words, is to correspond in these pictorial descriptions to, say, 'Noun-phrase', 'Verb-phrase' in linguistic descriptions? Any categories that we use must satisfy various conditions. They must be free from arbitrariness: they must between them be capable of codifying all the necessary information for stylistic analysis: and they must strike the appropriate balance between the specific and the abstract. Each of these conditions can, of course, give rise itself to problems of interpretation. What does it mean, for instance, to say that the categories must not be arbitrary? An answer that I should propose is that they should be categories that also play a substantive role in any adequate account that we may give of our perceptual processes, or more particularly, of those perceptual processes involved in looking at pictures.

A preliminary list of possible categories might read something like this: Form; Ground; Colour; Depth; Edge; Point of view. And each of these categories might dominate, or have as subsidiary to

it, more specific categories. And now note about my list one initially surprising feature: that it contains an ineliminable reference to representation—not, of course, to figurative representation but to representation more broadly conceived. For depth, for instance, enters into a painting only through the representation of depth.[13] Now is it right to have this reference to representation within the most general categories employed in structural description, or is this too constricting? Or, again, might not the right thing be to treat representation as standard, and then to account for the apparently rare cases of non-representation as coming about through the application of structure-dependent rules which operate upon underlying structures and eliminate, or all but eliminate, representation? I feel that these questions are not idle, and the issue that provokes us to raise them is therefore plausibly crucial to painting.

So much for the possibility of a transformational approach to pictorial style: what of its profitability? Given the absence of what I have called a well-prepared context for it, why should we prefer this approach to others? (Of course, this is a slightly absurd way to put the question, for it suggests that there is a multiplicity of approaches open to us between which we can choose; whereas, as I see it, we are lucky even to have a straw at which to grab.)

The first advantage of a transformational approach that I can see is that it might permit us a sharper sense of the distinction between the stylistic and the non-stylistic aspects of a painting: say, content, or technique. Now this might strike you as disingenuous since I have already said that in selecting the correct categories that we are to use within structural descriptions we need to make sure that we have those by means of which all the information necessary for stylistic analysis can be codified. So doesn't this mean that the issue of what is and what isn't style or a stylistic aspect of a painting is settled at this point: and, moreover, settled there by a decision on our part? But, if my understanding of a transformational approach is right, its attraction is that it offers us a double check. For it is one thing to set up the appropriate categories, and another, though very closely related thing, to apply them. And the advantage of a transformational approach is that, within it, the question of how the categories that appear in structural descriptions are actually applied to paintings, or what features they are allowed to pick out, is settled beyond residual doubt only when we see what features of paintings can be operated on by structure-dependent rules. An example: I gave in my suggested list of pictorial categories Colour. That seems

to imply that the colour in a painting is part of the style. Now, the sense in which this is so, and the sense in which this isn't, is brought out when we recognize how colour can be, and how it can't be, modified by transformation rules. So the application of such a rule might, for instance, have the effect of equalizing the tonality between colour expanses, or, again, of breaking down such expanses into their additive constituents, but an effect that such a rule couldn't have would be the reversal of colour between expanses quite arbitrarily picked out on the surface. For any rule that effected this would not be structure-dependent; for it wouldn't operate on the pictorial array in virtue of its structure. And that helps us to see how colour may be, and how it can't be, part of style.

And this leads on directly to a second advantage of a trans-formational approach, and that is its appeal to structure and structural considerations. For this seems to give us not only, as I've just said, a powerful way of discriminating between style and the rest, but a way that seems intuitively correct. It fits in with our natural conviction that style can be assessed only in the context of the whole painting: or, if style can sometimes be discerned in a detail, this is only because the detail is (as it were) structure-fraught.[14]

Thirdly, a transformation approach seems well calculated to bring out a, or perhaps the, kind of complexity typical of painting. And that is complexity that can be exhibited as a direct function of the length of the derivational history of the painting, where this history seems like something we have a natural power to discern. Indeed, I take it that, if we are not to be credited with some such power of discernment, a transformational approach would have no explanatory value. Now, I hope that I can convey the kind of thing I have in mind through a couple of examples. In late Cézanne and much Matisse we encounter a kind of complexity which could be at least partly accounted for by the operation on an abstractly conceived figure-ground array of a certain rule—a rule that has the effect of successively retrieving the ground in such a way as to make it approximate to, or of equal weight with, the figure. Or in some of the finest works of Mark Rothko, do we not observe a complexity which can be attributed once again to the operation on a figure-ground array, though this time of a rule that suppresses or deletes, though not altogether without trace, the ground?

I leave this fragmentary discussion of a transformational approach to pictorial style on a question mark.

8

And now I should like, in conclusion, to return to the issue which was the first to engage me this evening: the condition of the visual arts today. That I connected with the topic—or, more specifically, with the title—of this lecture by saying that it was a conviction of mine of some standing that, if there is a crisis in the visual arts today, it comes about from the peculiar difficulties that confront the contemporary painter in the formation of a style. And these difficulties I in turn connected—you will remember—with the pressures under which the painter finds himself to give to his work an immediate and instantaneous look of its own: pressures which I suggested were ultimately economic in character, deriving from the position of art in the market-place of today.

Now, I hope that I have said enough to indicate why I think that anything that systematically forms an obstacle to the formation of style on the part of a painter could readily bring the visual arts into a critical condition. But that there should be—in the way in which my argument assumes—an antagonism or conflict between the demand for recognizability made of a painter's work and the formation of a style may still seem problematic. The antagonism is certainly not self-evident, but I hope that I have, in the course of this lecture, said something to make it too seem more plausible. For it is implicit in the conception of style that I have been advancing that whether different paintings in the same style will have the same look will depend on the content that is elaborated within the paintings. If that differs, so may the look of the work. And this difference in look may very well just be what the young painter cannot afford.

But, it might be said, is this not to take too narrow a view of the matter? For does not style itself provide a ground of recognizability? Now it is certainly true that the paintings of a painter with a formed style are recognizable in virtue of their style; but only when, and by those by whom, the style itself has been recognized. And there is nothing in what I have said, and nothing in the facts of the case, to suggest that the recognition is any more simple or instantaneous a process than the formation of a style. From a certain point of view, by a certain time-scale, both processes are accomplished, I suppose, with a rapidity that says something interesting about the congruence of the art of painting and human nature. But that point of view, that time-scale, are not those of the *avant-garde* dealer or his clients greedy for profit or power. And if the style has not been recognized, then it is not necessarily true that paintings in one and the same style will look

recognizably alike. Hence the constant danger that for style and its formation will be substituted what might be called the trademark and its imposition on the painter's wares.

With what tragic consequences for our society we can only glimpse. I have spoken of Picasso's *Guernica*. It would be a hideous irony of history if in the very year when, to our total incredulity or indifference, over the rural areas of South-East Asia, a hundred Guernicas are perpetrated a day, the resources are wanting to project even one upon a pictorial surface.[15]

NOTES

[1] Morris Weitz, 'Genre and Style' in *Contemporary Philosophic Thought: The International Philosophy Year Conferences at Brockport*, Vol. III, *Perspectives in Education, Religion, and the Arts* (Albany, N.Y.), pp. 183–218; cf. James S. Ackerman, 'Western Art History' in James S. Ackerman and Rhys Carpenter, *Art and Archaeology* (Englewood Cliffs, N.J., 1963), pp. 164–86.

[2] Weitz, op. cit., p. 211.

[3] E. H. Gombrich, *Art and Illusion* (London, 1960; 2nd ed., 1962), and *Meditations on a Hobby Horse* (London, 1963).

[4] *Meditations on a Hobby Horse*, p. 62.

[5] *Art and Illusion* (2nd ed.), pp. 331–3.

[6] I have discussed these issues in Richard Wollheim, *Art and its Objects* (New York, 1968; London, 1970), secs. 18, 28–9.

[7] In 'Style' in the *International Encyclopaedia of the Social Sciences*, ed. David L. Sills (New York, 1968) Gombrich explicitly connects the word 'style' and the preconditions of expression as he conceives them.

[8] For the best general picture of this work see *Linguistics and Literary Style*, ed. Donald Freeman (New York, 1970).

[9] Reprinted in *Linguistics and Literary Style*.

[10] See Noam Chomsky, *Current Issues in Linguistic Theory* (The Hague, 1964); also his *Aspects of the Theory of Syntax* (Cambridge, Mass., 1965), I, paras 4, 6.

[11] See Noam Chomsky, *Syntactic Structures* (The Hague, 1957), 5.5, and 'On the Notion "Rule of Grammar"', reprinted in *The Structure of Language*, ed. Jerry A. Fodor and Jerrold J. Katz (Englewood Cliffs, N.J., 1964).

[12] Noam Chomsky, 'Three Models for the Description of Language', *R.E. Transactions on Information Theory* (1956), reprinted in *Readings in Mathematical Psychology*, Vol. II, ed. R. D. Luce, R. Bush, and E. Galonter (New York, 1965).

[13] Cf. Richard Wollheim, *On Drawing an Object* (London, 1965) reprinted in his *On Art and the Mind* (London, 1973); also *Art and its Objects*, sec. 12.

[14] This point seems to have been appreciated by Wölfflin: see Heinrich Wölfflin, *Principles of Art History*, trans. M. D. Hottinger (London, 1932), p. 6.

[15] These last words were written in June 1972 when the U.S. bombing of North Vietnam and the N.L.F.-controlled areas of South Vietnam had reached a new intensity.

The lecture was first delivered at the University of Sydney on Friday 23 June 1972 and is here published for the first time.

VI. The shape of colour

PATRICK HERON

THE FACT that painting comes before criticism is a fact of which many are today increasingly unaware. No one can doubt that the present time is the age of the dominance of 'the media'. Television, films, glossy reproductions can circle the globe in a trice—arriving on the other side of the world months and even years before those cumbersome objects, the painted canvases on their stretchers, can catch up with the distorted image of themselves which 'the media' have distributed in advance. Yet there remains a world of difference between the direct experience, with your own two eyes, of the physical surface of the painted canvas in your presence and that superficial knowledge of the same picture which 'the media' have already projected at you. This overwhelming preponderance of the reproduction over the original is very far from being that unmixed blessing which art popularizers have assumed. In fact, it is the direct cause of two situations of near-disaster in present-day painting: because filmed or printed versions of a painting outnumber that physical rectangle of the original canvas by a million to one, we tend to equate the broadest and haziest outlines of a pictorial image with the painting itself, confusing what is only a skeletal or diagrammatic summing-up, or break-down, of a painting with the painting on the canvas. Secondly, because our experience of pictorial images is in this way so drastically restricted to the enormously simplified images of paintings-in-reproduction we tend only to see, and therefore only to discuss or look for, these oversimplified formal schemes which are all that the photograph or film of a painting managed to present. Confronted at last by the literally unanalysable formal richness of the original canvas, we insist on reading back into it only those wildly oversimplified values which were all that a camera could extract from that infinitely subtle expanse of pigment. Still two further misfortunes arise. Whole schools of painting now exist in which, although they do not know it, the painter paints his paintings with certain desired *reproductions* as the end in view. In other words, the reproductions are nowadays often

actually less boring than the original canvases. Finally, perhaps the most destructive spin-off from this entire situation is this: not content, in effect, with reversing the status and the roles of the original and the reproduction—the painting of the canvas becoming merely the first stage in the achievement of one million reproductions—our era tends also to reverse (in America, at least) the roles of painting and criticism, of painter and critic.

Art criticism used to be an interpretative activity, it was a verbal commentary which took place after the event; it was essentially retrospective by nature and it commented on a non-verbal *visual* activity—an activity which had already taken place. By contrast, painting used to be the result of an essentially non-verbal consciousness or perception which was simply not susceptible of verbal communication. All this is changed. With the ascendancy of the reproduction has come also the ascendancy of the verbal commentary—so that we only see what we *read* that we are seeing, and not what our eyes would, by their own unaided intuitive visual explorations of visual reality, present to us if un-interfered with by art-critical *verbal* diktats. Yet a system of verbalized conceptual art criticism now everywhere threatens the autonomy of our purely visual experience. Increasingly we see what we read, we paint what we are told that we see: increasingly the act of painting is becoming subservient to the verbalized conceptual rules which critics imagine they have themselves derived in the first place from the realm of the purely visual. When Roger Fry, fifty years ago in England, in defence of the visual values of painting, declared war on 'the literary', he was concerned to oppose interest in the subject-matter of figurative painting, and to proclaim that, no matter what the subject of such paintings might be, the only valid content of any visual work of art was the quality and nature of the abstract components of which it was in fact made up. That 'All Art is Abstract' was indeed the title of some debates I undertook for the Arts Council over twenty years ago. The enormous irony of the present situation is that the totally dead and academic nature of so much international nonfigurative painting now owes most of its support to this self-same literary or verbal mode of consciousness—but this time the verbalizing takes as its subject-matter the abstract components of painting themselves. And this time, too, there are unprecedented organizational pressures interfering with that intuitive freedom of the eye which is the painter's birthright and his *raison d'être*. In any exact sense, we should always remember that good painting is simply beyond analysis; or rather, that the truth of any visual

analysis of painting expressed in words, is always fragmentary; and is always in any case something perceived after the event. Yet—again in America—we've become aware of a state of affairs in which criticism directs painting; in which the would-be creative activity, namely painting, appears always to seek in advance its own validation and justification in those over-explanatory rationales in which New York critics excel. In New York certainly, criticism comes before painting.

All of which, you may now be feeling, effectively demolishes any excuses I might have given myself for ever opening my mouth again. I'm horribly aware that the risk I take in saying anything at all about painting is that the verbalized perception concerning this or that visual fact will henceforth superimpose itself upon the original sensation—which was of course visual. For this reason I would never write a word about my present activity as a painter. To talk about how one is painting at the moment would be fatally to disrupt what one is in the middle of doing. On the other hand, it would be false to pretend to be dumb: we've seen enough of the cult of inarticulateness among artists. I have therefore always stressed that the statements I've made about my work have been unavoidably retrospective. One can only be verbally analytical at a remove in time: one can discuss what one did five or fifteen years ago because the passage of time has given it an objectivity, and one can focus on it. I said *verbally* analytical; and perhaps you're already thinking I'm bringing the words 'verbal' and 'verbally' rather excessively or indiscriminately into this argument? But I am exceedingly anxious, right here at the start, to disentangle all thinking which finds its articulation in words from that other kind of thinking which finds its articulation through the endless organization and reorganization of elements which have their sole existence in the realm of the visual, the seen. For instance, verbal thinking naturally equates the very idea of analysis with a process which results in the stringing together of words. It does not occur to the verbally conscious, perhaps, that if I say I am 'analysing a painting' I do not necessarily mean that I am going to speak or write about that painting. For the painter, analysis of painting takes place in silence, no words being uttered; the analytical process goes on behind his eyes as they scan and cross over, and recross again and again, the purely visual phenomena that that painting is presenting to the retinas of his eyes. Yet the fact remains that I can, if I try very hard, interrupt this silent activity of looking—which is the mode of consciousness most natural to me, most effortless for me—I can

rudely shatter it by the mere switch-over to words and speech: the mere fact of 'putting into words', as we say, itself brings to an end that purely visual reverie or meditation. Every time I have interrupted the equally silent activity of pushing and pulling the substance of colour across the surface of a canvas by uttering an indication in words of what I'm doing with that colour—every time, the mere existence of the descriptive words and phrases has arrested the silent visual process of which the painting was the record. The verbal equivalent of the pictorial realities may be highly accurate; it may be intensely evocative of the painting or the visual sensations concerned; and if one *is* writing or speaking about a painting one naturally strives to do just this—to find words which are *so* evocative, so accurately descriptive, that the listener has the illusion that he is seeing the painting, that it is visually present to his mind, with all the force of hallucination. Great art criticism does just this to us. And that precisely is why it is so dangerous. Verbal description stops visual meditation in its tracks—and the more brilliant and profound that description is the more deadly its effect in freezing or arresting the instinctive flow of the purely visual thinking which, in the painter, first produces the painting and, in the spectator, lies at the heart of his experience of the painting. In a catalogue note for my exhibition last year at the Whitechapel Gallery, London, I therefore said:

... if one still speaks or writes occasionally about one's painting it is always in the hope that what one is saying in words will actually release people from the word-bound concepts of language itself, opening up for them instead the purely visual experience of the eye, which words can *evoke* but never *define*. I wish my words about painting to militate against mere verbal consciousness. Too much painting today arises out of verbal consciousness: too much painting springs out of and is dictated by a conceptual consciousness which is verbal in origin and utterly unintuitive.

So now, having used words to put words in their place and firmly delimit their credibility and status in relation to painting and the world of the eye, I'll proceed. But ... 'I gotta use words when I talk to you', to quote T. S. Eliot. So, in spite of myself, I shall continue this lecture in the English language ...

One of the more curious dichotomies, when you come to think of it, is our mental tendency to divide *colourshape*, or *colourform*, into colour *and* form or shape *and* colour, as though one could have colour without shape or a shape without colour. As far as the experience of our human eyes is concerned—and that, exclusively, is *the* experience which concerns a painter above all

others—colour is shape and shape is colour. As far as pure visual sensation goes, colour and shape are always one and the same thing. What we call shape is something that begins to be apparent because there is a place where one colour ends and another begins —and this meeting-place of colours becomes, in our consciousness, an edge, a line, an outline, a profile, a boundary, or frontier between two differing colour-areas. I am gazing at an area of apricot-ochre: this apricot-ochre area is opaque but luminous and flattish; my eye rapidly traverses this flattish opaque apricot expanse and arrives at a frontier along which the apricot-ochre ceases and a field of violet-blue takes over: this meeting-point of apricot-ochre and violet-blue becomes in our consciousness a thing in its own right, a thing we call 'a line'; and this line—a thing created solely in our vision by the continuousness of the meeting-points of those two fields of ochre and blue—this particular line 'defines', as our verbal language would put it, the edge of a cloud in the sky.

In attempting to relate my visual experience of that cloud's edge in this way—breaking it down into a sequence, a sequence of successive acts of developing recognition—I was trying to demonstrate the distance separating pure visual sensation of colour, at one end of the process, and the final arrival at a mere concept at the other. We as it were distil our conceptual knowledge—*from* sensation—through the sort of stages I've suggested in describing my eyes' encounter with a patch of apricot-ochre. But by the time my mind was in possession of the concept 'a cloud in a blue sky', my full consciousness had ceased to focus itself upon the purely visual experience of an apricot-ochre opacity edging itself into mutual definition against an opposing area of violet blue. There is thus always a rivalry between sensation as such and concepts as such. Apricot edging against violet: that was the sensation. A line between apricot and violet: that was half-way between a sensation and a concept. A cloud in the sky: now we've travelled all the way to a concept—and as that concept spreads itself inside the mind, at that very second sensation switches itself off, and momentarily—while you think your thought about that cloud—you are a blind man, seeing nothing, although your eyes stay open. This is why concepts, and also symbols, are the enemy of painting, which has as its unique domain the realm of pure visual sensation. Painting should start in that multi-coloured, and at first amorphous, texture of coloured light which is what fills your vision, from eyelid to eyelid, when you open your eyes. The finished painting should also end in pure sensation of colour—

having passed into the realm of the conceptual in the process, and come out again at the other side. What happens to it in the process will be the subject of the rest of this talk, in which I shall draw on examples of my work during the last sixteen years. But first we have to consider another vital factor in the visual language of the painter—the factor of space.

During the late forties, as art critic of the *New Statesman*, I was frequently criticized for what was thought to be my obsession with pictorial space: indeed, in 1950 I was given the sack! I had frequently asserted that a great painter was one who succeeded in creating a new species of pictorial space. In 1953 I organized an exhibition in London for which, after weeks of thought, I managed to think of a title—'Space in Colour'. Today, this hardly sounds startling. Yet for me it still holds the clue to the greatest satisfactions that the purely pictorial experience can offer us. In the 'Space in Colour' catalogue I said:

In painting, space and form are not actual, as they are in sculpture, but illusory. Painting, indeed, is essentially an art of illusion ... But the secret of good painting—of whatever age or school ... lies in its adjustment of an inescapable dualism: on the one hand there is the illusion, indeed the *sensation*, of depth; and on the other there is the physical reality of the flat picture-surface. Good painting creates an experience which *contains* both. It creates a sensation of voluminous spatial reality which is so intimately bound up with the flatnesses of the design at the surface that it may be said to exist only in terms of such pictorial flatness.

And then I went on to say:

Colour is the utterly indispensable means for realising the various species of pictorial space ... But the existence of pictorial space implies the partial obliteration of the canvas's surface from our consciousness. This is the role of colour: to push back or bring forward the required section of the design. The advance or recession of different colours in juxtaposition is a physical property of colour: it is a physical impossibility to paint shapes on a surface, using different colours ... and avoid the illusion of the recession of parts of that surface.

The passages I have just read from my 'Space in Colour' catalogue of 1953 still sum up what I believe to be basic to the grammar of painting, of whatever style or period. As far as I'm concerned they still describe the fundamental nature, the physical effect upon us, of painting in general, of painting as such. My next quotations come from further statements which I have made from time to time about my own preoccupations. By October 1958, when I had already moved away from the experience of my colour

stripe paintings (both vertical and horizontal—I made the first of them in March 1957, which was nearly five years before those of Morris Louis), I wrote that 'My main interest, in my painting has always been in colour, space and light . . . and space in colour is *the subject* of my painting today to the exclusion of everything else. But the space must never be *too* deep, or the colour too flat. Each painting has to adjust depth to surface in a new and unique manner.'[1] Four years now went by before I again committed myself in words, this time in a small one-page statement called 'A Note on my Painting: 1962', part of which appeared in the catalogue of an exhibition I had in Zurich, and also in *Art International.* Part of what I said on this occasion went as follows

For a very long time, now, I have realised that my overriding interest is *colour.* Colour is both the subject and the means; the form and the content; the image and the meaning, in my painting today . . . It is obvious that colour is now the *only* direction in which painting can travel. Painting has still a continent left to explore, in the direction of colour (and in no other direction) . . . It seems obvious to me that we are still only at the beginning of our discovery and enjoyment of the superbly exciting facts of the world of colour. One reels at the colour possibilities now; the varied and contrasting intensities, opacities, transparencies; the seeming density and weight, warmth, coolness, vibrancy; or the superbly inert 'dull' colours—such as the marvellously uneventful expanses of the surface of an old green door in the sunlight. Or the terrific zing of a violet vibration . . . a violent violet flower, with five petals, suspended against the receptive furry green of leaves in a greenhouse!

That was ten years ago and the critics took exception to my assertion that 'It is obvious that colour is now the *only* direction in which painting can travel.' Obviously, statistics can rebut any statement couched in terms as provocatively exclusive as this: my intention was simply to point to what I conceived as being the central area of inquiry or exploration in painting for a decade or two to come. One of these decades has now passed: yet the emphasis on consciousness of colour in its own right shows no sign of abating or dating yet. Indeed the colour revolution has spread an enormous influence outwards from painting into every department of fashion and of the lifestyle and general design areas of our time: even automobiles now roll off the assembly lines in violet, lemon yellows, irridescent emerald greens, and terrific oranges and reds. However, I need one further autobiographical quotation to reinforce the link between colour and space. In 'Colour in my Painting: 1969' (published in *Studio International*)

I said

Because painting is exclusively concerned with the *seen*, as distinct from *the known*, pictorial space and pictorial colour are virtually synonymous. That is to say, for the human eye there is no space without its colour; and no colour that does not create its own space. When you open your eyes, the texture of the entire visual field . . . consists of one thing: and that thing is *colour*. Variations in this colour texture (which sight reveals to us) are indications that *form* exists: but colour is there first, in that it is the medium through which form is communicated visually. And so, in manipulating colour, painting is organising the very stuff of which sight or vision consists.

In saying that, of course, the claim I am making for painting could not be more enormous. I am saying that painting organizes our sight, dictates the way we see everything that we do see—which means nothing less than our entire environment. Painting alters the look of the world for us. I am not talking now of our practical vision, that 'blind' use of the eyes whereby we touch, manipulate, gauge the size of every material object or space of which we make use in our daily living. I am referring, on the contrary, to our contemplative vision, to the sort of seeing we employ the moment we start to think about 'the look of' a thing—of any thing, in fact, that comes within our visual range. People always think that the natural world looks literally *like* the paintings of whatever school was dominant forty years before: for years after the death of Monet educated people unconsciously projected a patchwork of torn and liquid blobs—the brush-touches of Monet—into the faces, tea cups, walls or trees around them, unconsciously *equating* the ragged paint-textures of Impressionism with reality. What is true is that all great movements in painting produce a pattern of abstraction (and all art is abstract, don't forget)—a pattern which we then read back into natural appearances. After Cézanne, the roundest apple flaked visibly before our eyes into rigid facets; after Picasso, the softest breast divided itself diagonally along a rigid line; after Mondrian, the cityscape fell into a grid as we looked out of the window. Nor was this all. Having structured our natural vision into accordance with its own unique geometry, its own particular abstraction, so that we saw all objects and all spatial relationships as if through a grid designed by Cézanne or Mondrian—having done this, painting then also causes us to project the formal abstract relationships identified with a great painter or a great movement—to project them back into the visible world in terms of all the things that are man-made—architecture, furniture, machines, even the curves of the kerb-

stones of new roads. To sum up, painting first influences our physiological perception (the way we see) and, secondly, it profoundly affects the shape or design we impose on our environment through the creation of all human artefacts. Painting's role in civilization is that of man's laboratory for the disinterested exploration of visual appearances as such, an exploration carried out uninhibited by any practical demands whatsoever. The painter is and always has been in search of one thing only: and that is, a new abstract configuration, a new but purely formal significance, a new pattern emerging out of the very mechanics of physical vision itself, a new shape in the organization of colour.

Painting's most potent discoveries, in pursuit of these purely aesthetic goals, have all been arrived at by the most stunningly economical means—namely, the staining and marking with pigment of a two-dimensional flat surface bounded by two vertical and two horizontal edges. Certain novelties of format in recent years, such as 'shaped canvases' (meaning those whose boundaries have departed from the purely rectangular) or 'dimensional painting' have in my view (with very few exceptions) failed significantly to carry forward the language of painting, a language still based in that physical illusionism generated by colour out of a flat surface which I have attempted to define as space in colour. Shaped canvases, in abandoning rectangular formats, sacrifice that insulation from surrounding walls that painting needs in order to operate with formal intensity from within its own bounding edges. The shaped canvas disperses itself, as it were, out into the architectural setting which houses it, and thus dispersed declines into a merely architectural feature or decoration. Dimensional paintings, on the other hand, tend to degenerate into painted objects (and I would say in passing that nearly all recent brightly painted sculpture leads up a cul-de-sac, betraying an amateurish ignorance of the nature and operation of colour itself, on the one hand, and a belittling regard for the mysteries of the actual three-dimensional reality of any solid object—which is the realm of sculpture—on the other).[2]

I said just now that '. . . the entire visual field . . . consists of one thing: and that thing is *colour*'. I've also suggested that 'Colour is the utterly indispensable means for realizing . . . pictorial space'. Actually, colour—meaning physical pigment itself—is the sole means of the painter: the whole historic art of painting arises out of this purely physical fact—that differing colours juxtaposed on a flat surface pull and twist against each other, and in so doing create sensations, or illusions, of space. Painting is nothing more

than the organization of colour. But all sensation of colour is relative; by which I mean that one's awareness of the colour of a colour is dependent almost entirely upon a second colour being present. If your entire visual field is occupied by one colour—you will very rapidly become desensitized to it. Let us say you are standing only two feet away from an enormous and evenly painted red wall—your eye will so rapidly be 'saturated' by the vibration of redness that you will in a matter of seconds cease to be aware of the precise redness of that red. But raise a pink hand, holding a blue handkerchief up before this red wall and the redness of its red instantly springs back to life, together with the blueness of the blue and the pinkness of the pink! All of which may sound obvious. But I am trying at this point to clarify two sensations. First, a colour is most intense when it is delimited; and the sharper the boundaries or frontiers or linear edges which delimit it are, the more intense that colour will be. And this intensification is of course due to the fact that that edge, or frontier, is only there because another colour exists beyond it—it is literally the frontier where *two* colours meet: that meeting defines it. And where two colours meet there is always intense activity. Secondly, along all such mutual frontiers between differing colours there is always enormous distortion of one colour by the other. I have placed a disc of one red on a field of another red, and found the red of the disc cooling off almost into green!

I was asked the other day when it was that I first used colour at full strength. Any direct question about my work is always a slight shock; I have to pull myself together—and actually to *think*—before answering: and the reason for this, I suppose, is that painting is more the result of feeling and intuition than of any sheerly intellectual or ratiocinative process. So it is rather to my own surprise that I realize that the answer to that question is—in the late forties, when my work was figurative, and was generally observed to be registering the influence of Braque (about whom I had written at length in 1946). Anyway, it is true that my still lifes and interiors of 1948—52 were constructed with flat area-planes of reds, blues, and yellows applied at full strength, just as they came from the tube. These full-strength colour-areas were slotted into a network of linear drawing: and it was this drawing which was to some extent Braque-like and which brought the figurative element into the paintings; but the colour was totally unlike Braque; Braque was a grave tonalist. It was closer to Matisse, whose great *Red Studio*, of 1911, I used to make pilgrimage visits to see at the Redfern Gallery in 1943-4, and which probably

influenced me more than any other single painting. However by 1955–6 the figurative grid of drawing fell away, leaving me only with a patchwork of floating, ragged, islanded colour-areas: each area being created by, and identified with, a single movement of a fluent brushstroke. My exhibition of 1956 was categorized *tachist*. But in my case the strokes, or *taches*, increasingly assumed a vertical direction, so that each canvas, in the end, consisted solely of large isolated vertical brushstrokes. In early 1957, feeling, I think, that the allover emphasis and the uniform looseness and the too-mechanical scribbles of what the French called tachism and the Americans action-painting needed to be harnessed slightly more rigidly again to the edges of the canvas, I allowed my arm to extend a number of these vertical brushstrokes until they made contact with the top and the bottom edges of the canvas. *Scarlet Verticals: March 1957* (plate 75) is an example. In this painting four or five of these rigid vertical brushstrokes succeed in connecting with the top and bottom edges, and in so doing achieve the character of

Plate 75. *Scarlet Verticals: March 1957*. Oil on canvas, 40 × 50 in. First exhib: Redfern Metavisual, April 1957

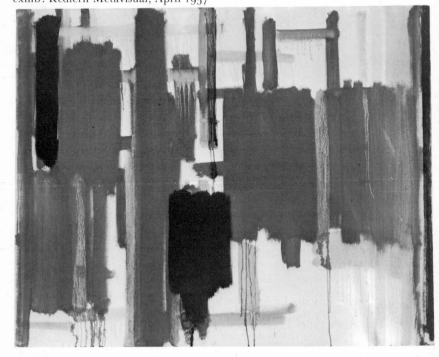

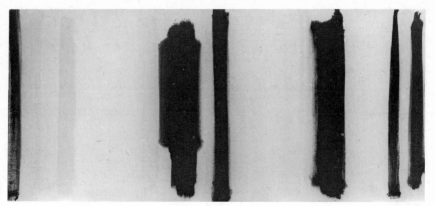

Plate 76. *Vertical Light: March 1957*. Oil on canvas, 22 × 48 in. First exhib: Redfern Gallery, London, February 1958

stripes or bands.

It was therefore a natural step—and a very short one—to proceed from this painting to canvases whose total image consisted solely of these long vertical strokes, in differing colours, all reaching more or less from top to bottom of the picture format. It was during this same month, March 1957, that I therefore arrived at the first of a series of paintings which were later to be known as colour stripe paintings; one of these was *Vertical Light: March 1957* (plate 76). Although these were the first stripe paintings to be painted anywhere, I was unaware at the time of having invented a new pictorial formula: something called 'colour stripe painting' did not exist at the time, even as a concept. My canvases like *Vertical Light* were simply *paintings* to me, and paintings which seemed to differ only slightly from their immediate predecessors in my own development (plate 77). At this time, I may say, we knew nothing in England of Barnett Newman, who had been omitted from the first famous appearance, at the Tate in January 1956, of the first generation New York painters. But Newman's division of a very opaque ground by one or two very rigid, hard-edged *bands* or *strips* is in any case far removed from my own far more numerous and brilliantly coloured *stripes*, strung out in clusters of twenty or thirty, and occupying the entire format from edge to edge—or from top to bottom, because my horizontal stripe paintings first came in the following month, April, 1957.

I said earlier on that there is always a rivalry between sensation and concept. Because I always want, in my painting, to probe visual sensation, to extend sensation, and to rescue my work from

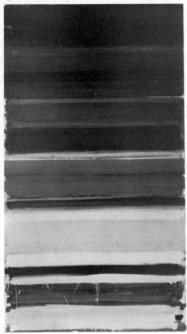

Plate 77. *Horizontal Stripe Painting: November 1957–January 1958*. Oil on canvas, 110 × 60 in. Commissioned by the late E. C. Gregory, installed at Lund-Humphries, February 1958
Plate 78. *Red Ground: May 1957*. Oil on canvas, 72 × 36 in. First exhib: Redfern Gallery, London, February 1958

crystallizing into concepts (however good), I hope always to keep it on the move. During 1957, in addition to measuring colour against colour in the very basic format of the stripes, I also allowed vertical and horizontal bands and stripes to overlap and inter-penetrate in the same canvas. A painting like *Red Ground: May 1957* (plate 78) shows something of the results of this—a sort of fractured tartan: it is a canvas composed entirely of the fragments of vertical or horizontal bands caught, as it were, at the moment of floating apart. There is a suggestion that the soft-edged squares originated at the point where horizontal and vertical bands of colour overlap—as in a tartan. Before long, however, these soft-edged squares were to replace the bands and stripes entirely, as the predominant units of composition in my work; and, in fact, between 1959 and 1963 I did little else but juggle with them, sometimes filling the entire picture-area with them, sometimes

whittling them down to one—a single soft square floating *in*, rather than *on*, a huge ground: either edging up into one of the corners or moving, almost visibly, along one of the canvas's edges as if drawn by a magnet. And it was at this time that something first happened which I see has gone on happening, at intervals, ever since, namely, the sweeping or sucking to one side of the canvas of all the individual formal units so that they end up clustered along, or piled up against, the right-hand edge, leaving three-quarters of the picture-area empty of incident. *Black Painting— Red, Brown, Olive: July 1959* (plate 79) is one of the first instances of this—that is, of the orientation of all the separately recognizable elements towards the right-hand edge of the canvas. To quote once more from 'Colour in my Painting: 1969', I said '. . . the reason why the stripes sufficed, as the formal vehicle of the colour, was precisely that they were so very uncomplicated *as shapes*. I realized that the emptier the general format was, the more ex-clusive the concentration upon the experience of colour itself. With stripes one was free to deal *only* with the interaction between varying *quantities* of varied colours, measured as expanses or areas.'

Plate 79. *Black Painting—Red, Brown, Olive: July 1959.* Oil on canvas, 38 × 48 in. Grand Prize Winner, John Moore's Liverpool Exhibition II, November 1959

I also said '. . . I used to feel that I was not "designing" a canvas so much as allowing varied quantities of colour to come to terms with each other. The soft-edged colour-areas existed not so much in their own right, as formal shapes; instead, they came into being (or so it seemed) in order to *accommodate* colour as such: I had the feeling that "colour determines the actual shapes, or areas, which balance one another . . . in my painting".'

That last phrase comes from the 1962 statement; at that time it was literally true that the pushing around, with a big brush, of a certain *quantity* of a colour, was the means I used for arriving at the so-called shapes. One physically *moved* the rival areas of colour in relation to each other—and the big brush moved rapidly—until they met and collided; colour-areas thus mutually defined one another by edging into each other physically; the expansion or contraction of adjacent areas was the mode or the means whereby one eventually arrived at the final configuration—the total image which was itself the painting. In pictures like this *Black Painting*, therefore, colour was quite literally determining the form or shape of all the shapes or areas in the picture. The shape of colour, at this moment in my painting, was something I arrived at by allowing differing quantities of colour, of the liquid pigment itself, to expand and contract, to swim with or against one another under the tutelage of a swiftly moving soft blunt brush, nudging, scribbling, gliding, pushing, or pulling the paint across the surface. Originally this *Black Painting* was chock-a-block with soft round-cornered squares or lozenge-shapes or irregular discs; but gradually the flattening tide of matt black rose and obliterated island after island until it had pushed its way across two-thirds of the surface. Those remaining islands sought the edge. And *always* in my painting, at all periods, the *edges* of the canvas have been all-important. In 1959 an American critic, who believed at the time only in the centralized, symmetrical format, complained of just this character-istic in my work: why did I 'reach for the edges'? I had to point out to him *the importance of the* edges: I had to explain that the four sides of a canvas are the first four formal statements in the painting concerned; and that pictorial activity becomes more intense in the areas adjacent to the painting's physical edges.[3] In other paintings at this time I did allow, as I have indicated, the tidal wave of a single colour to sweep away all but one small round-cornered square (or squarified disc). I remember resisting the logic of letting that last square sink also under the flood of a single colour —which would have left one with a painting consisting of a single colour-plane only. But after American painting of the early fifties,

with its emphasis on emptiness, I felt the urgent need for a move towards 'the re-complication of the picture surface'. Years later, in an article entitled 'The Ascendancy of London in the Sixties', published by *Studio International* in December 1966, I said, writing of the first generation New York painters, that:

... [they] never really advanced beyond the formats which each had arrived at by 1950: instead, they seem to have 'gone into production' ... Perhaps this absence of development was inevitable, given the special nature of their revolutionary style: their great innovations were, after all, connected with a sweeping away of detail and of all complex divisions of the picture-surface—that is to say, their discoveries involved a systematic advance towards the extremes of flatness, emptiness and bigness. Since they achieved these extremes, almost at a bound, and since they were unwilling to reverse engines and go in the only direction left open to them (i.e. towards some sort of *re-complication* of the picture-surface), they have had to stand still. It fell to us British to begin the trek back into pictorial complexity and away from that arid 'openness' which, in two generations of Americans ... has become at last an academic emptiness.

Continuing, in this same article, on the role of the British 'middle-generation' painters, I also pointed to

... our rejection of the quite incredibly widespread addiction—amongst American painters of more than one school—to the *symmetrical* format, the symmetrical image set down bang in the centre of the canvas. This symmetry, or centre-dominated format, has become a vast academic cult, evident even in the best Americans. The British 'middle generation' *never* fell for this: we never abandoned the belief that painting should *resolve* asymmetric, unequal, disparate formal ingredients into a state of architectonic harmony which, while remaining asymmetrical, nevertheless constitutes a state of perfect balance, or equilibrium. That obvious 'unity', of image or format, which the American cultivation of the symmetrical canvas ... produces so easily—this is a unity not worth having. Indeed, it has short-circuited the whole process of pictorial statement, which should involve an elaborate, intuitive adjustment and readjustment of initially warring and disparate elements, until they finally click into the condition of *balance*.[4]

In passing, let me say that this intuitive achievement of balance in asymmetry is a distinguishing characteristic of all the major British 'middle-generation' painters—Peter Lanyon, William Scott, Roger Hilton, Alan Davie, Terry Frost, Prunella Clough, Bryan Wynter, and John Wells, for instance. And it is worth noting, by the way, that a number of well-known American painters have recently attempted to free themselves of the tyranny of

symmetry—and in so doing have come very noticeably under the influence of the British 'middle-generation'. Equally, one cannot help noticing, as a general characteristic, that the Americans seem nearly always to be dominated by ratiocination—as opposed to intuition. Even when at their most spontaneous, as in much Abstract Expressionist painting, their so-called spontaneity is too often in fact an intellectually apprehended and controlled formula standing for 'the spontaneous'. Nevertheless, in spite of this general indictment, American painting did have its great moment of spontaneous inventiveness—just before 1950: and I speak as one of the first of those outside America to have hailed and acclaimed that moment and that achievement in print.[5]

The shape of colour. For linguistic convenience and brevity one often makes use of a word the implications of which are wholly inaccurate for one's real purpose. To use the word 'ground' to describe what is in fact merely the largest colour-area in a painting of mine is convenient; but it is misleading—for the following reason. 'Ground' implies a pictorially passive area; a mere space, even a vacuum, in which—or against which—more positive shapes are set. Any painting in which the largest colour-area feels like a curtain or back-drop against which more formally definite or active forms or shapes are set; any painting where the largest area appears as an emptiness, a sky, a formally neutral environment or mere setting for a number of more individual shapes—this is a failure from my point of view. I believe absolutely in what I call the formal equality of all parts of the painting. To me, no section of the picture-surface *should be less of a shape* than any other. To me, there is *no* 'ground' in a good painting. The criterion of *shape* applies every bit as much to the largest colour-area in a painting— the so-called 'ground'—as to the smaller ones. It was my hope and belief that all of the black area in *Black Painting* had formed itself into a *single* plane whose linear boundaries or edges, whose linear limits, made of it a single, coherent formal unit. If you imagine that black area held against a white wall with all the non-black area-shapes fret-sawed out—would that remaining black silhouette retain the formal unity and completeness of a fully integrated image in its own right? For me, it would have to; and so too would the much 'emptier' orange area in *Orange Painting (Brown, Ochre and Black): January 1962* (plate 80). If these large areas did not have the same formal completeness *as* area-shapes as the much smaller areas, then the painting would fail to meet that, to me, absolutely central criterion of the good painting—namely, the equality of parts, the equality or evenness of the pressure or

Plate 80. *Orange Painting (Brown, Ochre and Black): January 1962*. Oil on canvas, 48 × 60 in. First exhib: Bertha Schaefer Gallery, New York, April 1962

movement which all its component shapes must mutually exert upon each other.

Pictures like this *Orange Painting*, painted in January 1962, marked—as it turned out—the end of a development in two respects. With their softness of touch, with the painterly fuzziness of the boundaries between colour-areas (soft like haloes of light), they proved to be the end of seven years of 'soft' painting—painting in which 'colour had determined the shape' of the shapes, painting in which *drawing* as such was not visible—although it was implied in the disposition of the masses or colour-areas. But in 1963 drawing re-entered my work: I found myself suddenly using rough charcoal sticks to demarcate or draw-in the boundaries or frontiers of all the colour-areas, on a white ground; and before applying any paint to the canvas at all. I found myself doing this incredibly unpainterly thing—making a drawing and then painting it in! And the perversity of it all was that I had only just written in 'A note on my painting: 1962', the following sentence: 'I do not find myself "designing" a canvas: I do not "draw" the lozenge-shaped areas or the soft squares.' The apparent con-

trariness of one's impulses as a painter was very clearly demon-strated to me by this episode. But perhaps this inconsistency was more apparent than real? What I had just said in words, about not drawing or designing, was a fairly accurate comment on what had been happening in my painting *up to that moment*: I now think there's little doubt that, by finally expressing the point in words, I actually de-fused whatever remained of my interest in those soft-edged areas, whose shapes had indeed 'materialised under my brush when I started to try to saturate the surface of the canvas with . . . varying quantities of this colour or that', as I put it in that same 1962 statement.

1963, then, was the moment when the linear reappeared in my painting. But what does *linear* mean in my case? No lines as such survive in a finished painting of mine. By linear I am referring to that network or grid of frontiers which divide the colour-areas throughout the picture surface. A line, in my paintings of 1963 and onwards, has no individual existence: it is simply the mutually definitive divide separating two adjacent colour-areas. In an essay on Braque,[6] in 1946, I said 'Every line operating within the strict economy of this design defines in at least two directions simultaneously, describing and terminating whatever lies to the right and the left of it. The reading which is momentarily the strongest will be the one relevant to the side from which our eye approaches.' Although I said this of Braque, it is my profound belief that this equal two-way definition of all dividing lines, all pronounced divisions between forms or colours, is characteristic of the best painting of any age. The so-called space between the arm and the hip in a nude by Michelangelo is itself a shape, on the picture-surface, every bit as definite and positive and complete as the shape of the arm or the torso to either side of it. In other words, the outline of that hip is a line which defines with equal intensity in two directions simultaneously. All paintings are thus like a jig-saw: every area-shape—like the pieces in a jigsaw—must be formally complete in itself and at the same time must be wholly accommodating to all the other contingent pieces surrounding it. All its edges mutually define both the piece itself and one side of an adjacent piece. But when your eye is fixed on one piece, you read that piece's outlines, or frontiers, as defining that piece only. The moment your eye crosses over into the next piece— the frontier line you have just crossed becomes readable in reverse. This is what I meant by Braque's lines definining areas in two directions simultaneously.

In this account of my pursuit of the shape or shapes of colour I

have just referred to the arrival of the linear in my canvases. But I am getting this back-to-front—it is another distortion of a complex *visual* situation due to the fact that it is in *words* that I am attempting to account for it. The truth is, this linear grid which re-entered my works in 1963 was not sought or looked for by me for its own sake. On the contrary, it was the inevitable by-product of the achievement of two other conditions—both new—in my pursuit of yet stronger and more intense sensations of colour. These were a hardening and sharpening of the actual frontiers between colour-areas; and a desire to deprive that dominant 'ground' area of its monopoly of all the canvas's edges by allowing many of the smaller areas to flow outwards, so that they too occupied whole lengths of the picture's edge. To describe this the wrong way—I could say I began to divide up the ground, with the divisions now running to the four sides of the canvas and making use of them, of course. Throughout 1963 and 1964 the nature of these divisions, in terms of shape, was that they were rectilinear and circular: lop-sided discs and wobbly squares and rectangles interpenetrating, rather like a Nicholson whose rigidity was dissolving: *Blue in Black, White*

Plate 81. *Blue in Black, White in Yellow: June 1964.* Gouache on paper, 22 × 31 in. First exhib: Waddington Galleries, London, December 1964

Plate 82. *Yellows and Reds with Violet Edge: April 1965.* Oil on canvas, 60 × 66 in. First exhib: Bertha Schaefer Gallery, New York, October 1965

in Yellow: June 1964 (plate 81) is a typical gouache of this phase. Unlike Ben Nicholson I have never in my life drawn a straight line or a purely circular circle or disc. To my eye, at least, an absolutely straight line or colour-edge, and a pure arc or circle, both seem destructive of the flatness of the picture-surface: both seem to me to rise up off it, or to sink back too deeply into it— a fact which the logic of Nicholson's own shallow reliefs perhaps bears out? I have certainly come to feel that such unity of the total picture-surface as I may arrive at is somehow dependent upon the wobbliness and irregularity of the drawing of all the frontiers separating my colour-areas. If one looks at the irregular discs in *Yellows and Reds with Violet Edge: April 1965* (plate 82) it seems to me that it is possible to feel that while the colour of each operates

174

quite violently, in a spatial sense, pulling them out and pushing them back a matter of feet, it would seem—what finally ties them down into a much tighter spatial relationship with each other, and with the other shapes, is the uneven nature of their outlines or edges. The 'wobbly hard-edge' which is a feature of all my work since 1965 has itself become the source, or vehicle I should perhaps say, of what still looks to me to be a limitless variety of spatial ambiguities or mysteries. Most obvious of these spatial ambiguities or contraditions are those cases where the 'drawing' of the outline of a colour-area implies recession but its colour generates the opposite sensation of something protruding—or vice versa. For instance, there is a small wafer of Chinese vermilion, in the middle left of this painting, the outlines of which suggest that it is neatly tucked in behind the deep violet area, where it encloses the pale lemon disc. Yet the red of that vermilion brings this wafer towards me, in front of the violet edge. The spatial evocation of the colour, and the spatial evocation of the lines or edges are thus at odds at this point.

Incidentally, when this picture was first exhibited in New York,

Plate 83. *Dark Purple and Ceruleum: May 1965*. Oil on canvas, 60 × 84 in. First exhib: Bertha Schaefer Gallery, New York, October 1965

in 1965, it was attacked by a well-known critic as representing 'a retreat to Cubism'! In particular, it was attacked for its 'overlapping forms'. Obviously, in 1965, its mere complexity was incomprehensible: although in the same show I included *Dark Purple and Ceruleum: May 1965* (plate 83) which was less complex. But colour-areas are not forms. There is no residual hint or vestige of the solidity of real objects in my colour-areas—as there always is in Cubist planes of colour. Indeed, the space-creating power of these colour-areas exists precisely because they are totally non-figurative.

In attempting, now, to sum up the direction my work has taken since painting canvases like *Yellows and Reds with Violet Edge: April 1965*, I imagine I can put my finger on two related characteristics or obsessions. First, I have given my hand (indeed, the whole of my arm) a free rein in the drawing of the wobbly hard-edge frontiers; and these have got further and further away from the underlying or implied regularity of the rectilinear plus the circular configuration of 1963. And incidentally, once I am screwed up to making the attack, I usually draw in the entire scheme for a thirteen-foot canvas in a matter of a few seconds only. And secondly, I find myself searching endlessly for new relational proportions as between colours or colour-areas. For instance, in 1969 I arrived at a series of very large paintings—fifteen feet long, or thirteen or eleven feet—*Cadmium with Violet, Scarlet, Emerald, Lemon and Venetian: 1969* (plate 84) is an example. Looking back, the object here seems to have been to see how far a few of the familiar elements could be stretched out sideways, into this long horizontal composition (and there's a word, 'composition', we needn't run away from) without that *largest* area of cadmium red disintegrating back into that vacuous background of neutral nothingness which I so much despise! I used to say, as far back as 1959, that what one was looking for, in stretching out a single colour-plane across four-fifths of a canvas, was a full emptiness or an empty fullness. In these very long, very large paintings of 1969 and after, I think one has added to that earlier requirement of 'full emptiness' this new one: to see how *big* a colour-area can become physically while still retaining a visible compactness in its image, a tightness in its design and organization that remains totally readable, despite the expanded scale of that design, of those images. How far could one *expand* one's colour-areas without appearing to be *distending* any or all of them? I have painted a version of this thirteen-foot *Cadmium with Violet*, with the same colours but on a format only nine inches long. One of the mysteries of scale which seeing the two versions

Plate 84. *Cadmium with Violet, Scarlet, Emerald, Lemon and Venetian: 1969.* Oil on canvas, 78 × 156 in. First exhib: Waddington Galleries, London, January 1970

together would demonstrate is to do with what I call the physicality of mere size: the plain physical impact of a large painting, the sheerly quantitative bombardment by the vibrations of really big areas of colour—these constitute a totally new factor. It was simply a fact that in painting large one was entering a field of physical sensation which just was not given off by smaller paintings.

It used to be felt that two adjacent areas of flat but differing colours—say a red or a blue—would always take up a fixed spatial position in relation to one another along the line dividing them. It used to be said that the red would always appear to come in front of the blue. My own experience suggests that this is quite untrue. When your eye alights on the sharp linear frontier separating two colour-areas your sensation that one of those colours is 'nearer' to you than the other—this sensation, this conviction that space-in-depth *separates* the two colour-areas is overwhelmingly definite as a sensation. Its cause, however, is enormously difficult to pin-point. In these large recent paintings such as this *Cadmium with Violet* one is extremely conscious, as one's eye moves along the frontiers of the various areas, that these areas actually alternate with one another (as one's eye moves) in seeming to be *behind* or *in front of* one another—according to whatever loop or angle in the frontier one happens to be focusing upon. For instance, the cadmium red ground (if you'll excuse the term) does not appear to be uniformly either behind or in front of the more orange 'harbour-

Plate 85. *Dark Red, Scarlet and Venetian: February 1972*. Oil on canvas, 78 × 108 in. First exhib: Whitechapel Art Gallery, June 1972

Plate 86. *Complicated Green and Violet: March 1972*. Oil on canvas, 72 × 120 in. First exhib: Whitechapel Art Gallery, June 1972

Plate 87. *Big Cobalt Violet: May 1972*. Oil on canvas, 82 × 180 in. First exhib: Whitechapel Art Gallery, June 1972

shape' which extends downwards from the top right-hand corner of the painting. On the contrary, as your eye slides round those outlines the cadmium and the orange appear to keep exchanging their spatial positions. In 'Colour in my Painting: 1969' I said 'Complexity of the spatial illusion generated along the frontier where two colours meet is . . . enormously increased if the linear character of those frontiers is irregular, freely drawn, intuitively arrived at'. It is the totally regular, the perfectly geometric lines between colours in the movement known as Op Art which distinguishes it entirely from my own—despite our shared interest in optical after-images, and so on. The after-image is for me merely a welcome by-product, not a calculated end-product.

But perhaps the most startling thought that came to me during this recent period of very large paintings—paintings like *Dark Red, Scarlet and Venetian: February 1972* (plate 85), where once again the right-hand edge has attracted to itself all the complex elements in the painting, leaving these to be balanced only by the heavy emptiness of the red which entirely fills two-thirds of the canvas on the left—perhaps the most unexpected conscious thought was this . . . the linear character of the frontiers can change the colour of colours. This is how I put it in 'Colour in my Painting: 1969':

. . . the meeting-lines between areas of colour are utterly crucial to our apprehension of the actual hue of those areas: the linear character of these frontiers cannot avoid changing our sensation of the colour of those areas. Hence a jagged line separating two reds will make them cooler or hotter, pinker or more orange, than a smoothly looping or

179

rippling line. *The line changes the colour of the colours on either side of it.* This being so, it follows that it is the *linear* character that I give to the frontiers between colour-areas that finally determines the apparent colour of my colours.

I end by saying that I've no idea how my next large paintings are going to look. I can tell you that the last to date are the most complex of all: *Complicated Green and Violet: March 1972* and *Big Cobalt Violet: May 1972* (plates 86, 87) are the most complex canvases I've painted since 1955. The mileage of their frontiers between colours is certainly the greatest yet. And in *Big Cobalt Violet* there are no fewer than three instances of the linear 'over-lapping' of areas. Yet even as I contemplate the complex inter-locking of emerald and scarlet in this painting, I am seized yet again by a sense of the inadequacy, of the inevitable inaccuracy of my own words; once again, there is a need to qualify what I have only just said . . . It is not the 'line' which changes the colour of the colours, it is *the shape of the area* on one side of the line which distorts the colour on the other side, and vice versa. In the drawing of that line—with all its hazards—lies the search for the shape of colour.

NOTES
[1] See 'Two Reception Rooms' in *Architecture and Building*, Oct. 1958.
[2] I discussed the problem of the shaped canvas, and of open, coloured sculpture, in 'Two Cultures', published in *Studio International*, Dec. 1970.
[3] I have recorded this episode in my Introduction to the catalogue of an exhibition of Bonnard drawings which toured museums in the United States in 1972–3. *Colour and Abstraction in the Drawings of Bonnard* was the title of the essay. The exhibition, *Bonnard—Drawings from 1893–1946*, arranged by The American Federation of Arts, came from the collection of Kyra Gerard and Alfred Ayrton.
[4] 'Symmetry in Painting: An Academic Formula' was the title of a lecture I gave at the Institute of Contemporary Arts, London, on 16 Dec. 1970.
[5] See my articles: 'The Americans at the Tate Gallery' in *Arts* (New York), Mar. 1956, and 'Five Americans' in *Arts* (New York), May 1958.
[6] 'Braque', published in the *New English Weekly*, 4 July 1946.

The lecture was first delivered at the University of Sydney on Friday 22 June and was published in *Studio International*, February, 1974.

Index